A LIVING
LENS

A LIVING LENS

PHOTOGRAPHS OF
JEWISH LIFE FROM THE PAGES
OF THE *FORWARD*

Alana Newhouse

EDITOR

Chana Pollack

ARCHIVIST

FORWARD BOOKS

W. W. NORTON & COMPANY
NEW YORK • LONDON

Manufacturing by Mondadori A.M.E. Publishing CTD
Book design by Chris Welch Design
Production manager: Andrew Marasia

Library of Congress Cataloging-in-Publication Data

A living lens : photographs of Jewish life from the pages of the Forward
/ Alana Newhouse, editor ; Chana Pollack, archivist. — 1st ed.
p. cm.
ISBN-13: 978-0-393-06269-4 (hardcover)
ISBN-10: 0-393-06269-4 (hardcover)
1. Jews—New York (State)—New York—Social conditions. 2. Jews—New York (State)—
New York—Social conditions—Pictorial works. 3. Immigrants—New York (State)—New York
—Social conditions. 4. Immigrants—New York (State)—New York—Social conditions—
Pictorial works. 5. Jews—United States—Social conditions. 6. Jews—United States—Social
conditions—Pictorial works. 7. New York (N.Y.)—Ethnic relations. 8. New York (N.Y.)—Ethnic
relations—Pictorial works. 9. Forverts. 10. Forverts—Pictorial works. I. Newhouse, Alana. II.
Pollack, Chana. III. Forverts.
F128.9.J5L58 2007
305.892'40747—dc22

2006032478

W. W. Norton & Company, Inc.
500 Fifth Avenue, New York, N.Y. 10110
www.wwnorton.com

W. W. Norton & Company Ltd.
Castle House, 75/76 Wells Street, London W1T 3QT

1 2 3 4 5 6 7 8 9 0

Contents

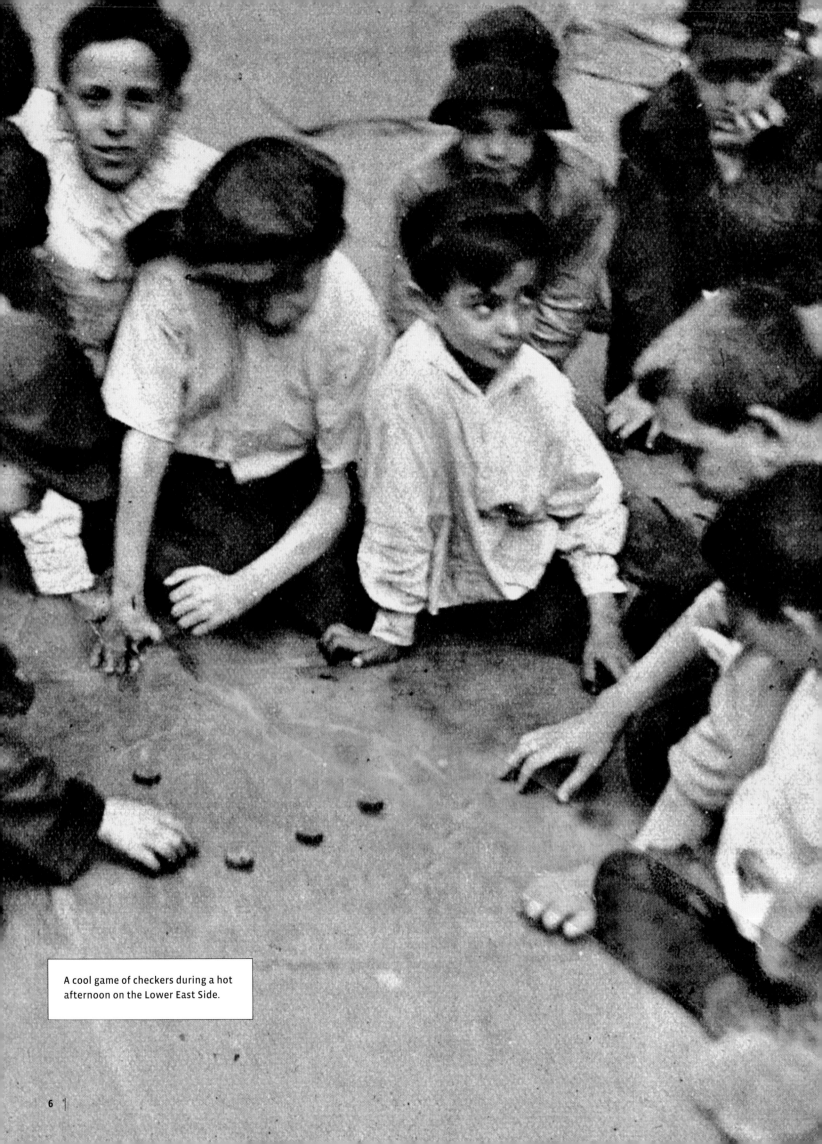

A cool game of checkers during a hot afternoon on the Lower East Side.

INTRODUCTION

Pete Hamill

ALMOST EVERY AFTERNOON in New York, I take a longish walk through the streets of my native city. Even in familiar places, I'm often surprised, but one New York walk always stirs my imagination: I begin at Chatham Square and walk northeast on East Broadway toward another New York, a sacred place where past, present, and future come together. The many languages of the new expanding Chinatown keep me company for blocks. Above me rise ancient tenements adorned with the iron calligraphy of fire escapes, upon which Jews and Irish and Italians once dozed on torrid August nights. My blood quickens. I'm heading to the conjunction of streets that I think of as the Place of the Three Shrines.

One shrine is the Seward Park Public Library, near the corner of Jefferson Street, erected in 1909 through the bounty of Andrew Carnegie. For almost a century poor kids have come here and learned how to think, to know the world beyond the Lower East Side, and to imagine their future lives. Here, where many young Jews first found Walt Whitman, Chinese and Latino kids are now discovering the glories that have followed, many of them made by men and women who once used this library. Here, as it was decades ago, a voice says to the young poor: Shakespeare belongs to you too.

Across the street, at 197 East Broadway, is my second great New York shrine. It's called the Educational Alliance. For generations kids have come here to learn the language of the metropolis, to be excited by music and dance and art and often inspired to make art themselves. They learned from splendid teachers, and they learned from one another. Through its doors passed such artists as Louise Nevelson and Ben Shahn, Mark Rothko and Adolph Gottlieb, Leonard Baskin and the Soyer brothers. Poverty did not defeat them.

To the right, at 173–175 East Broadway, is my third great shrine, its name proudly etched into the stone of its facade: the Forward Building. It rises twelve stories above the sidewalk, and once (from its construction in 1911–1912 to 1974) it housed one of the greatest newspapers in the city's history. The formal name in English was the *Jewish Daily Forward*. The readers, writers, editors, and typesetters called it simply the *Forverts*.

The newspaper was founded in 1897, when the great flow of Yiddish-speaking immigrants was arriving in the harbor. From 1881 to 1921 more than two million of them rose from the obscurity of steerage to blink in the morning sun, seeing for the first time the Statue of Liberty, filing into Ellis Island to be processed, occasionally humiliated, or even rejected, but caging their fear and trembling with hope.

They were the people you can see in some of the extraordinary photographs in this selection from the files of the *Jewish Daily Forward*. In these images they are still young. The men look serious, the women wary. But they walked into this immense city filled with people who were not like them, and they set about enriching that city, altering it, giving it much more than they ever took. One of the means of doing what they later did was the newspaper, written in the language of the old country, called the *Forverts*.

It was not the only newspaper published in Yiddish (at one point there were at least four other major dailies) nor was it the first. But by the 1920s it was the most successful, selling about 250,000 copies a day. The man behind its many splendors was a tough, intelligent, sophisticated immigrant from Vilna, Lithuania, named Abraham Cahan. I stare at the Forward Building now and try to imagine Cahan in 1882, freshly arrived in New York, burning with the socialist creed, more exile than immigrant, here in flight from the secret police of the czar. In the photographs we see a man with a fiercely concentrated face, absolutely focused eyes, a defiant mustache. He must have been something at twenty-two.

Cahan soon learned English, went to work on newspapers, learned lessons from the papers of Hearst and Pulitzer. He was one of the founders of the *Forverts* in 1897, the year after he published his short novel *Yekl: A Tale of the New York Ghetto*. He became the editor in 1903, when he was forty-three; he left after six months. But he soon returned for good, remaining in charge of the paper until his death in 1951.

The newspaper he shaped resembled the photographs in this book. It reflected the world that the immigrants knew, a Lower East Side where the certainties of the shtetl were often discarded, where the talk in coffee shops and appetizing stores and delis was often vehement with debate. All orthodoxies were challenged. There were Zionists and anti-Zionists among the readership. There were European-style anarchists. There were political firebrands who burned brightly for a few seasons, then sputtered and vanished. There were intellectuals and pushcart vendors. There were men and women who ferociously defended their American children and feared for what would happen to them in this teeming, secular city. And yes, there were people who failed, who were defeated by the indifferent, sometimes brutal city.

Cahan seemed to speak for all of them. He remained a democratic socialist, a defender of working people. And, gazing at the old Forward Building, I can imagine his rage at the horrors of the 1911 Triangle Shirtwaist fire, from which so many beautiful young women plunged to their deaths. I

can imagine his passion as he emerged from the offices on East Broadway and walked a few blocks to see a picket line where honest working people were protesting the venality of the bosses. I can imagine his fury when owners hired goons to break strikes. Cahan was no street corner revolutionist. His socialism (like that of many others) was channeled into the trade union movement, to the unions that were defending the people you see in these photographs. His paper spoke to those people and for them. The message was simple: You can live in pride and dignity, and your American children will live even better.

From Hearst, Cahan learned that a popular newspaper could also be a source of entertainment. In the years before radio and television changed America, Hearst published weekly short stories by O. Henry and others. The *Forverts* did the same, with its own writers and with the help of its readers. The language was Yiddish, but the newspaper could both inform and entertain. Cahan started a feature called the "Bintel Brief," which carried letters from readers on everything from socialism to marriage, in often innocent and effective language, and which always required answers. The column was not a means of artistic expression; it was a means of solving many mysteries of New York.

Cahan also welcomed professional writers, including a fine one named Israel Joshua Singer from Warsaw, who was followed in 1935 by his younger brother, Isaac Bashevis Singer. I stand on East Broadway and see Cahan emerging with one Singer brother or the other, and sometimes both, heading for the Garden Cafeteria, arguing about literature and art and what makes people weep or laugh. In 1978, only a few months before he was awarded the Nobel Prize in Literature, I interviewed Isaac Singer in his apartment on the Upper West Side. We spoke of many things that day, but his eyes sparkled when I asked about his newspaper. "I love the *Forverts*," he said. "It gave me my American life."

It did the same for many people in these photographs. Cahan did not sentimentalize his readers. He knew that the downtown Jews were not all noble and hardworking. There were gangsters among them, starting with the legendary Monk Eastman. There were Jews who exploited their more vulnerable brethren. There were "cadets" who took young immigrant Jewish women into desperate lives in brothels, in New York and out west.

But he also proclaimed the triumphs: the scholarships won by the children of immigrants; the rising graduation rates from American schools; the strikes that ended in victory; the emergence of Jewish politicians. And other matters too. Who among the readers did not exult at the victories of the great lightweight boxing champion Benny Leonard? Who among them did not celebrate the triumphs of the Yiddish theater up on Second Avenue? Yes, there were occasional theatrical absurdities (like the Yiddish production of *King Lear* that tacked on a happy ending). But Cahan could also point with pride to the seriousness of the Yiddish stage, at a time when much of the English-speaking theater was given over to silliness. In that same period the Lower East Side Jews were giving the city another immense gift, a sense of irony. The humor

and the literature often underlined the differences between what America promised and what America delivered. In American comedy and literature that special kind of irony, at once a weapon and a form of armor, remains alive to this day.

This archive also reflects the gathering darkness in Europe. How many readers of the *Forverts* went off to fight for the Spanish Republic after 1936? More than a few, including my friend Curly Mende out of Brownsville. He didn't enlist with Murder Inc. at Midnight Rose's luncheonette on Livonia Avenue; he joined the Lincoln Brigade. He was terribly wounded in the battle of the Jarama and, after he recovered, went out to serve on American merchant ships. Years later in the Lion's Head in Greenwich Village he brought me his copy of *The Rise of David Levinsky*, that fine 1917 novel by Abraham Cahan. "You better read this," he said. "If you don't, you don't know nothin' about New York."

He was right. Cahan also taught New Yorkers who could not read a word of Yiddish. People like me. My first editor, Paul Sann of Dorothy Schiff's *New York Post,* once told me of Cahan: "That was one tough Jew, baby. And one of the best goddamned newspapermen that ever worked in this town."

In the 1930s everything began to change. The Yiddish newspapers needed a continuous flow of Yiddish-speaking immigrants in order to flourish. One reason: As a means of assimilation, they worked too well. The American children of the immigrants could speak Yiddish, but most could not read it; even when they did, they preferred reading other papers. They were on the path out of the Lower East Side, many through the City College of New York. Two factors slowed the arrival of new immigrants: tighter (often racist) restrictions on immigration, along with the slaughters of the Great War (1914–1918). The flow was much reduced in the years of peace, then completely halted again when the United States (and much of the world) was impoverished by the Great Depression. Nobody immigrates to a poor country.

Hitler rose to power in 1933. A trickle of Jews made their way to New York, but the doors were closed to the poorest of the Jewish poor under pressure from the American right wing. Millions of them were murdered by the Nazis in what was later called the Holocaust. The language they spoke largely vanished with them, along with the vivid culture that gave so much to America.

After the war, in my neighborhood in Brooklyn, mainly Irish and Italian with a dwindling number of Jews, I would still see the *Forverts* on the newsstands. But there were fewer and fewer copies, until finally there were none at all.

And yet . . . and yet look at these photographs. They all are still there: street kids and beauty queens, scholars and union guys, athletes and Holocaust survivors, singers and wise guys and greenhorns. Great photographs freeze time. The photographer looks, sees, snaps the shutter, and captures a fragment of time that, at its best, can stand for the whole. Look at them, let their subjects enter you, cherish them, and then walk along East

Broadway to the Place of the Three Shrines. That man with the fierce mustache, hurrying out of the Forward Building: that's Abraham Cahan. Don't bother thanking him. He's in a hurry. Five blocks away the cops are shoving around pickets. There's a reporter on the scene, and a photographer, but Cahan wants to look for himself. After all, he wasn't called one of the best goddamned newspapermen in New York for nothing.

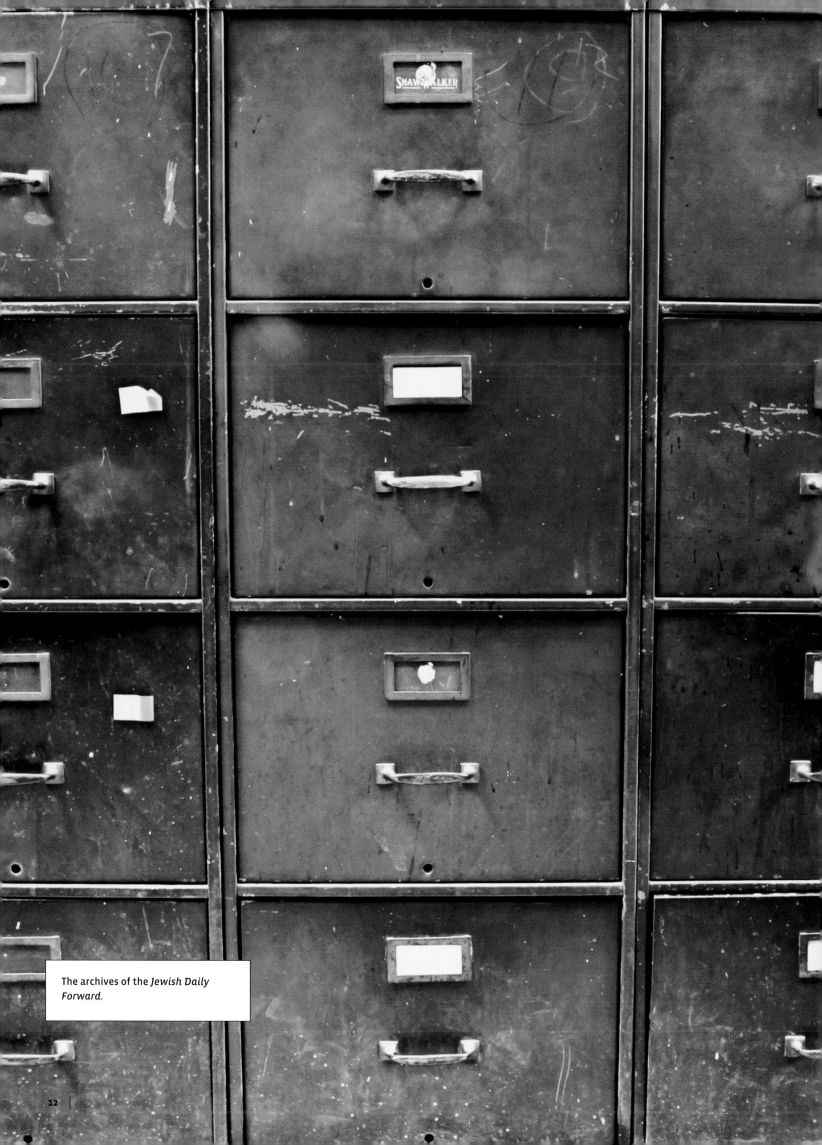

The archives of the *Jewish Daily Forward.*

ABOUT THE COLLECTION

Alana Newhouse

IN FEBRUARY 1945, Vice President Harry Truman sent a note to an old friend named Edward Jacobson. The two men, who first met in army training at Fort Sill, Oklahoma, had been partners in a short-lived haberdashery store in Kansas City in the 1920s. A little more than two decades later, Jacobson was trying his hand again at selling men's clothing, and his friend Truman, on the cusp of becoming the president of the United States of America, was writing to wish him luck.

Sixty years later I found a copy of the letter in a folder at the back of a metal filing cabinet drawer. The note, written by one of the most powerful men of the last century, had been filed under "Jacobson."

Although Jacobson is well known among historians—he has even been partly credited for his friend's 1948 decision to grant diplomatic recognition to the new state of Israel—one might fairly assume "Truman" would trump "Jacobson" in any filing system. But the metal cabinet in which I found that note is part of the archives of perhaps the most famous Jewish newspaper in the world. And to its staff and readers, the buck stopped at "Jacobson."

Welcome to the archives of the *Jewish Daily Forward*.

The newspaper, known as the *Forverts*, published its first issue on April 22, 1897. Almost immediately, the newsroom began accruing the materials of journalism—letters, documents, sundry keepsakes, and, of course, photographs—most of which were set aside in metal filing cabinets. When the *Forverts* moved in 1974 from its historic building on the Lower East Side, the filing cabinets were transferred to a storage room in the paper's new home on East Thirty-third Street.

Over two decades later, as the newspaper prepared for its 100th anniversary, staff members discovered this enormous treasure. The paper that had opened the door to America for generations of Jewish immigrants—the first American newspaper, in any language, to be published nationally; the paper that had boasted a larger daily circulation in the early 1920s than the *New York Times*; the paper that had been a daily presence in the lives of millions of Americans of three generations—had amassed a collection of over forty

thousand photographs that spanned the entire twentieth century. Although the paper's staff had regarded them for decades as no more than pictures of familiar people and events, younger people who came upon the collection for the first time recognized its unmatched value as a detailed record of an entire century. Archivists were hired to catalog, identify, and rehouse the collection, and what they uncovered surprised even them: a unique chronicle of broad historical reach and rare creative quality. Combined with contemporary photography from the English-language *Forward*, the collection tells the story not only of our newspaper but also of more than a century of Jewish life, a century that was at certain times incomprehensibly tragic, at others miraculously hopeful, but invariably transformative.

The archive owes much of its robustness to the *Forverts*'s famed arts section, a special Sunday supplement of graphics inaugurated by the editor in chief, Abraham Cahan, in 1923. (The section was also known as the rotogravure, a term used for a process in which the picture, designs, and words are engraved into metal plates before printing. The archive contains thousands of these metal plates.) On a trip back from the Palestine Mandate in 1926, Cahan asked Maurice Winograd, a published Yiddish poet, to work full time for the *Forverts* as editor of the arts section. Winograd proved an inspired choice. He utilized news agency photographs to depict current events, developed themes and contests ("Vote for your Favorite Beauty"), and offered readers windows into seemingly foreign worlds, with sections that ranged from classical Greek and Roman art and a history of the presidents of the United States of America to surveys of "Interesting Jewish Types from Africa and Palestine" and the development of the human embryo. Perhaps most significantly, Winograd asked readers to send in their own photographs for publication, a feature that contributed to the sense among many that the *Forverts*, no matter how influential, was still a member of the family.

As a result, the archive now includes a wide range of the classic photographs one has learned to associate with the *Forverts*—Lower East side push-carts, Yiddish theater, labor rallies—along with gems no one would expect. The photographs depict the major Jewish cities of the world, such as New York, Warsaw, Tel Aviv, and Cracow, as well as more exotic photo reportage from such rural areas as the Carpathian region in eastern Europe; they feature Jewish peddlers and merchants along with contestants in village beauty contests and matchmakers caught mid-deal.

The collection also includes sizable contributions from famed photojournalists, including Roman Vishniac, Menakhem Kipnis, and Alter Kacyzne, all of whom were enlisted full time by the newspaper. (In 1947 the *Forverts* published a book of their photographs entitled *The Vanished World: Jewish Cities, Jewish People*. That volume marked the newspaper's fiftieth anniversary and

memorialized the recently destroyed communities from which its readers had come.) Vishniac, later the best known of the three, traveled extensively through far-flung Jewish villages and hamlets of rural eastern Europe. Kipnis covered similar ground, though with his own distinctive style; his work includes a remarkable 1902 shot, included in this volume, of Tsar Nicholas II passing quickly through a small Polish shtetl, averting his gaze from the Jews standing at attention, their head coverings removed. Kacyzne, a Yiddish writer and dramatist as well as photographer, traveled through North Africa and Palestine, in addition to Poland.

Under the direction of archivist Chana Pollack, more than half of this massive, vital collection has been rehoused and cataloged to date. Both the cataloged and uncataloged files were plumbed for this volume, in an effort to present a rich, accurate representation of the archive as a whole. As a result, certain information is still left to be unearthed, including more precise provenance, fuller descriptions of subjects, and information about exactly when (and, in some cases, if) each photograph was published in the newspaper. Whenever possible, though, we have included information on dates of publication as well as translations of the original captions.

We hope you see in these photographs what we do: a remarkable visual history of Jewish life during one of its most dynamic centuries, as seen through the lens of the newspapers that have been there every step of the way.

Acknowledgments

MANY BOOKS ARE billed as collaborative affairs, projects that benefit from the work of many hands. Yet none fits the bill quite the way this one does. For more than a century, countless editors, writers, copy editors, typesetters, and, of course, photographers have contributed to our newspapers. The Forward Association, which publishes the Yiddish-language *Forverts* and the English-language *Forward*, has been supported by generations of employees whose work has often been as essential as it has been unheralded. We owe these men and women a debt of gratitude for bequeathing this legacy to us. In particular, we would like to thank the current Board of Directors of the Forward Association, as well as the president, Dr. Barnett Zumoff, and its executive director, Samuel Norich.

This volume, which is the first in a planned series of Forward Books, would not have come to fruition without the dedication and patience of our agent, Henry Dunow, and the unfailing support of Amy Cherry at W. W. Norton. And we could not have asked for a better list of contributors; one of the surest indications of this volume's worth has been the willingness of these people, among the most trenchant thinkers and gifted writers of our time, to be part of it.

The present staffs of both newspapers deserve our grateful acknowledgment. For 110 years and counting, the *Forverts* has been a magnet for the most impressive Yiddish writers and editors of their day, and today's team, led by Boris Sandler, is no exception. (If you don't read Yiddish, take a class. Being able to read their newspaper will make it worth your while.) Since its inception in 1990, the writers and editors of the *Forward* have emulated its older sibling by crafting a weekly report of the Jewish story that values culture as much as politics, and rewards the loyalty of its readers with its eloquence, clarity of thought, and unfailing independence.

The *Forward* too has been blessed with a host of superior writers and editors, beginning with the founding editor Seth Lipsky all the way through to the current staff, led by the editor in chief J. J. Goldberg. A special thank-you to Kurt Hoffman, Boris Budiyansky, Jacob Suskewicz, and E. B. Solomont, who each devoted endless hours to this project.

Outside of the staff, Carolyn Hessel deserves pages of gratitude. Thanks to her efforts at the National Jewish Book Council, there is always room for one more good book, and we hope this one fits the bill. Krysia Fisher and Jesse Aaron Cohen at the YIVO Institute for Jewish Research went above and beyond reasonable expectations in obtaining scans of the rotogravure art section; we hope they are as proud of the results as we are.

This project would not have even gotten off the ground without the inspired and unflagging service, over the last three decades, of Harold Ostroff, who died on March 2, 2006. Many contributed to the survival of the *Forverts* even after the immigrant generations ceased to be able to sustain it, and many deserve credit for bringing the *Forward* the respect and affection it enjoys today. No one deserves more credit for both of those singular achievements than he.

Contributors

Paul Berman is a writer in residence at New York University and the author, most recently, of *Power and the Idealists* (2005).

Alan M. Dershowitz is the Felix Frankfurter Professor of Law at Harvard Law School and the author of twenty works of fiction and nonfiction, including, most recently, *The Case for Peace: How the Arab-Israeli Conflict Can Be Resolved* (2005).

Nathan Glazer is the author of *American Judaism* (1967), *Beyond the Melting Pot* (1963), *Ethnic Dilemmas* (1983), *The Limits of Social Policy* (1988), *We Are All Multiculturalists Now* (1997), and other books on American society, ethnicity, and social problems. He was one of the founding editors of *Commentary*, a coeditor of the *Public Interest* from 1973 to 2003, and a professor of sociology at Harvard University from 1969 to 1993. He is now professor emeritus at Harvard.

J. J. Goldberg is the editor in chief of the *Forward*.

Pete Hamill is a journalist, novelist, and New Yorker. He has been a columnist for the *New York Post*, the *New York Daily News*, the *Village Voice*, *New York* magazine, and *Esquire*. He has served as editor in chief of both the *New York Post* and the *Daily News*. His many fiction and nonfiction books include *Snow in August* (1997), *A Drinking Life* (1994), and *Forever* (2003). His most recent book is *Downtown: My Manhattan* (2004).

J. Hoberman is the senior film critic for the *Village Voice* and an adjunct professor of cinema at Cooper Union. His books include *Bridge of Light: Yiddish Film between Two Worlds* (1991) and, with Jeffrey Shandler, *Entertaining America: Jews, Movies, and Broadcasting* (2003).

Jenna Weissman Joselit, a longtime columnist for the *Forward*, teaches American studies and modern Judaic studies at Princeton University. She is also the author of, among other things, *The Wonders of America: Reinventing*

Jewish Culture, 1880–1950 (1994), *A Perfect Fit: Clothes, Character, and the Promise of America* (2001), and an upcoming book on America's fascination with the Ten Commandments.

Roger Kahn is a newspaper reporter, magazine writer, columnist, and author. His books include *The Boys of Summer* (1972) and *Into My Own: The Remarkable People and Events That Shaped a Life* (2006).

Deborah E. Lipstadt teaches at Emory University and is the author of *Beyond Belief: The American Press and the Holocaust* (1986) and *History on Trial: My Day in Court with Holocaust Denier David Irving* (2005).

Allan Nadler is a professor of religious studies and the director of the program in Jewish studies at Drew University. He also serves as a special consultant for academic affairs at the YIVO Institute for Jewish Research. He is the author of *The Faith of the Mithnagdim* (1997) and *The Hasidim in America* (1998), as well as more than one hundred scholarly articles, essays, and reviews.

Caraid O'Brien is a performer, playwright, and producer. She directed Bloomsday on Broadway at Symphony Space from 2003 to 2005 and is a three-time recipient of a new play commission from the National Foundation for Jewish Culture for her translations of the plays of Sholem Asch and David Pinski.

Ilan Stavans is the Lewis-Sebring Professor in Latin American and Latino Culture at Amherst College. His books include *On Borrowed Words* (2001), *Spanglish* (2003), *Dictionary Days* (2005), and *The Disappearance* (2006). He is the editor of *The Oxford Book of Jewish Stories* (1998) and the three-volume *Isaac Bashevis Singer: Collected Stories* (2004).

Leon Wieseltier is the literary editor of the *New Republic*. He is the author of *Kaddish* (1998), among other books.

Ruth Wisse is the Martin Peretz Professor of Yiddish Literature and professor of comparative literature at Harvard University. Before that she taught at McGill University, where she helped found the Jewish Studies Department. She has written several books on literature, including *The Schlemiel as Modern Hero* (1971), *A Little Love in Big Manhattan: Two Yiddish Poets* (1988), and *The Modern Jewish Canon* (2000), and the political book *If I Am Not for Myself: The Liberal Betrayal of the Jews* (1992).

Paul Zakrzewski is the editor of *Lost Tribe: Jewish Fiction from the Edge* (2003). His writing has appeared in the *Washington Post*, *Boston Globe*, and elsewhere, and he is a recipient of a 2006 Emerging Writer Fellowship from the Writers Room of Boston.

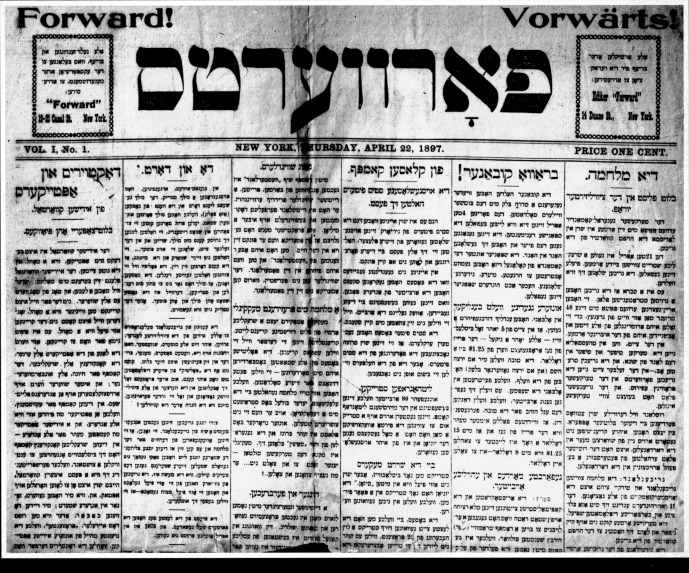

The first issue of the *Forverts*, published on April 22, 1897.

ONE

ℶ

1897–1925

THE *JEWISH DAILY FORWARD* first hit the streets of New York City on April 22, 1897. Its appearance marked a coming of age for America's Jewish community, giving voice to a new type of Jewish American. Jews had lived in America for centuries, but they had been few in number and tended to blend quickly into the larger society. Beginning in 1881, waves of antisemitic persecution in Russia touched off a mass exodus that eventually brought more than two million Yiddish-speaking Jews to this country, before Congress imposed immigration quotas that shut America's doors in 1921 and 1924.

Settling in urban ghettos like New York's Lower East Side, the immigrants re-created the culture of the old world they left behind and set out to learn the ways of their new home, while battling the loneliness, poverty, and injustice they found here. The *Forverts* became their voice and their champion. Its name was its battle cry: Forward toward a new social vision of equality and justice, and at the same time, forward into the American society that the immigrants were reaching out to embrace. Under the leadership of its founding editor, the crustily independent Abraham Cahan, the newspaper became known as one of America's most powerful advocates of social justice, a fearless defender of trade unionism and democratic socialism. No less important, it was the voice of the Jewish immigrants and of the new American Jewish community they were building.

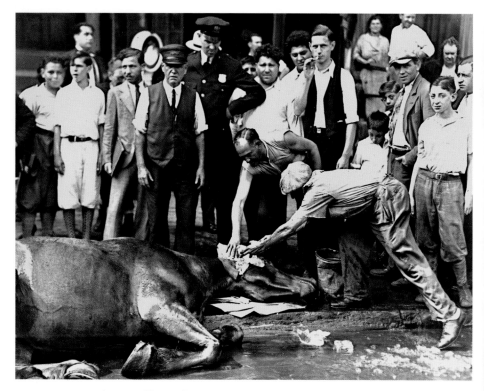

Two men try to revive a workhorse that collapsed on the street, drawing a crowd of onlookers.

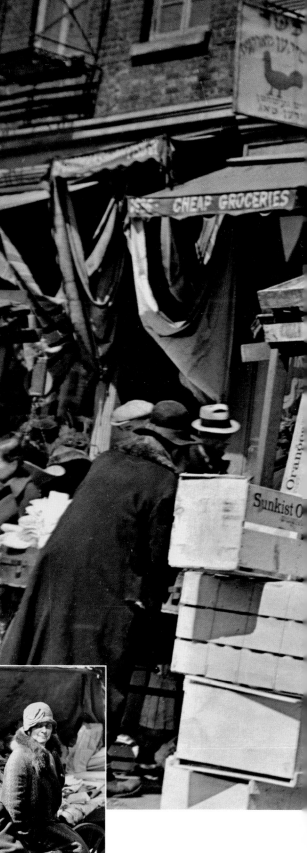

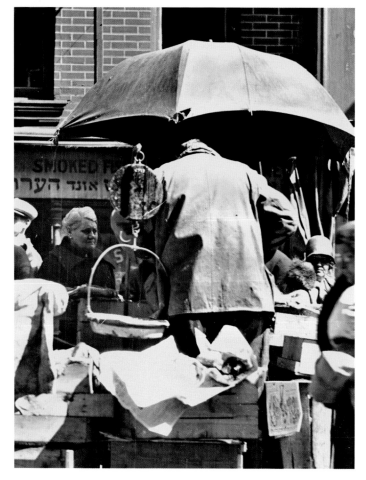

In the market.

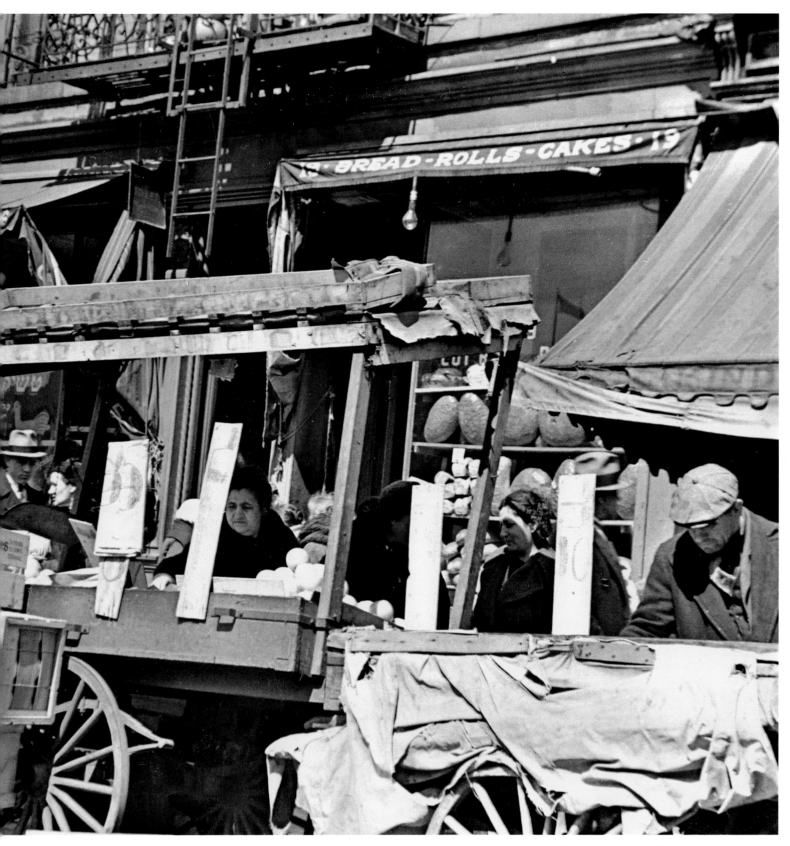

The narrow streets of the Lower East Side teemed with street vendors—so much so that the pushcart became the neighborhood's iconic image.

Leaving Europe

Ruth Wisse

IN THE LAST quarter of the nineteenth century the Jews of Europe launched the largest of their migrations, something they would not have done had their hosts learned to tolerate their presence. By then thoroughly European in citizenship and culture, the Children of Israel had "sojourned" on the Continent five or six times longer than they once had in Egypt. Their synagogues and graveyards dotted the landscape from Portugal to Ukraine. Yiddish, the European Jewish vernacular east of the Iberian Peninsula,

Had Europe fulfilled its promise of emancipation to turn genuinely democratic, hundreds of thousands of Jews would still be thriving today in Prague, Vienna, Salonika, Warsaw, Vilna, and Odessa. Instead, as new tyrannies replaced the old, the most desperate and perspicacious Jews set out to save themselves while they could. More than two million crossed the seas to America between 1881 and 1914. As the dark night of Europe closed over those who stayed, it confirmed the historical rule that the mass departure of Jews signals the moral decline of their host communities. The Bible attributes to God's agency the killing of the firstborn sons of Egypt, but European countries contrived to slaughter their own in successive world wars.

This is not to say that the Jews were simply the "wretched refuse" of Europe's teeming shore, as Emma Lazarus describes the newcomers in her sonnet that graces the Statue of Liberty. A Jewish renaissance had begun to generate a magnificent modern culture, and political parties

The cavalcade of Tsar Nicholas II through the town square of Biala, Poland, in 1902. Although the Jews stood at attention, with their head coverings removed, the tsar refused to acknowledge them.

Tsar Nicholas II arriving in Spain.

was spoken by the time of their departure by more Jews than had ever simultaneously shared any common Jewish language. By 1900 nine-tenths of the Jews in the world were European or of recent European descent.

charted new directions for every religious and worldly branch of Jewish society. Only a buoyant communal life in Europe could have sparked such an energetic large-scale resettlement. But by the end of the nineteenth century many Jews were no longer willing to accept the humiliations and restrictions that had been their lot, especially when they knew of a continent where they could attain equal rights.

The effects—on both properties and lives—of a pogrom in Mińsk Mazowiecki, Poland.

Freedom was the leitmotif of the Jewish exodus from Europe no less than of its biblical antecedent. Absent a Moses, Sholom Aleichem created the jolliest hero of Jewish fiction, Motl Peysi, the cantor's son, to show the way to the new land. Motl is known as the cantor's son because his sickly father dies in the opening chapter. The widow soaks the story in her tears. But Motl exults in the freedom from parental authority with a phrase that captivated Yiddish readers: "*Mir iz gut, ikh bin a yosem*—I am lucky, I'm an orphan!" Trailing no guilt, Motl embarks on the immigrant adventure with every confidence that his family's release from the European shtetl is unadulterated good fortune. While the author surrounds the young hero with plenty of fretful adults, nothing dulls the child's joy at having been unshackled from every constraint.

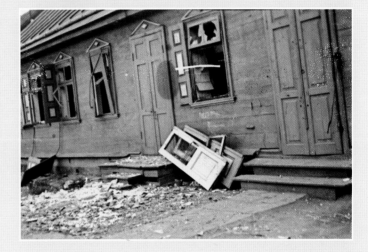

America's freedoms of course proved to be paradoxical: gains through loss and loss through gains. For one, many Jews elected freedom *from* religion, or at least freedom from their own. As opposed to Europe, where one could cease to be a Jew only by converting to Christianity, here one could cease to be a Jew by moving in among non-Jews in Oregon or Alabama. Despite flare-ups of anti-Jewish prejudice that sometimes slowed Jewish advancement and very occasionally threatened Jewish life, it was the extreme hospitality of the South that absorbed most Reform Jews, and Gentiles eager to intermarry that reduced their numbers in the North. In America the Jews themselves would have to set limits on their freedom if they intended to remain a distinctive part of the American fabric. If local Motls were not sent to some form of *heder*—traditional Jewish school—they stood no chance of remaining Jewish in America.

Oppression and poverty, and the hope of escaping both, had been the main spurs to mass Jewish emigration from Europe. "Your father is in America," croons the mother in a popular Yiddish lullaby, reassuring her child that once Father sends them money for the ocean crossing they will be feasting on challah and chicken broth in the middle of the week. What a shock the tenements and sweatshops of New York were for those who came dreaming of instant wealth! How much disappointment and misery they experienced seeing that nothing was as they had imagined! Yet the ultimate surprise for their descendants was how far America exceeded the expectations of those who reached its refuge. America would leave it up to the Jews to decide whether or not to preserve the legacies of the Exodus.

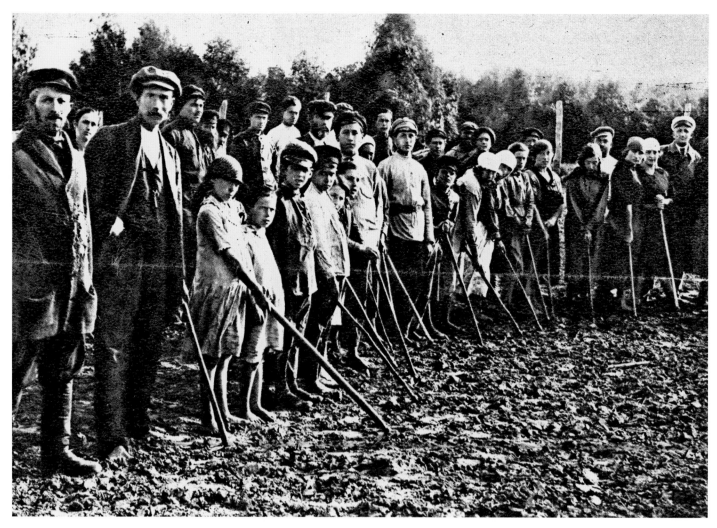

Jewish tobacco farmers of Bar, Podolia, holding their work tools in the tobacco fields.

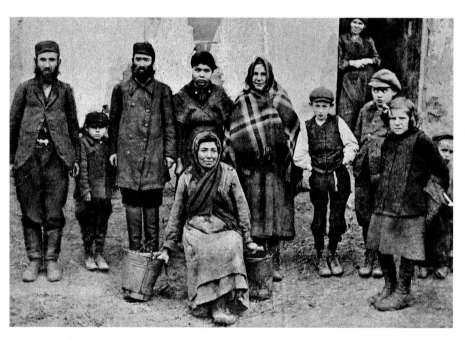

The *Forverts* kept its readership connected to the old country through regular photographic sections devoted to it. In one, "characters" of the shtetl, including town cripples, matchmakers, and water carriers (above), posed for their American brethren.

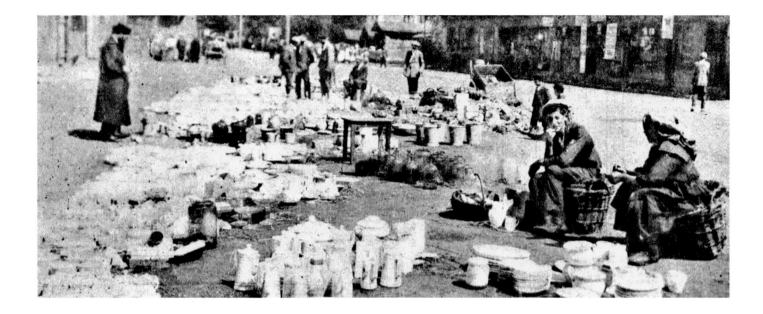

In the town squares of
Eastern European
villages—not unlike on
Orchard and Rivington
streets—outdoor markets
sold everything from food
and china to furniture.

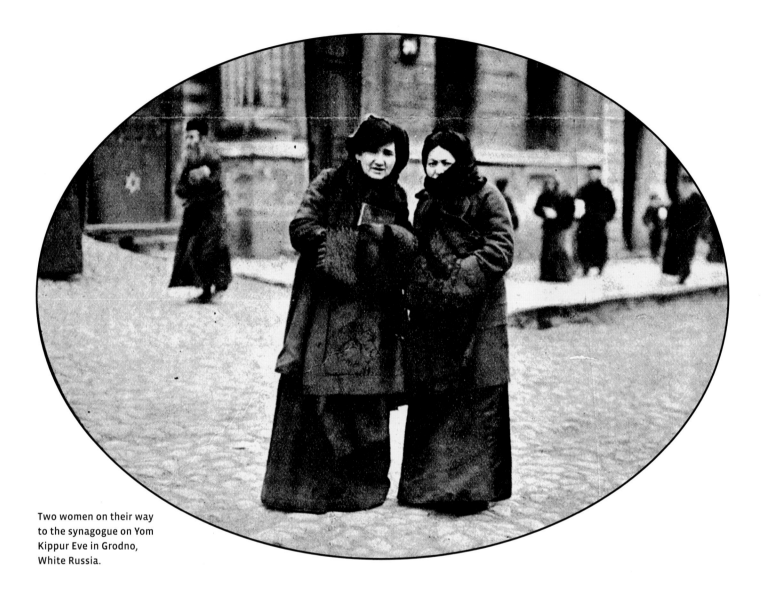

Two women on their way
to the synagogue on Yom
Kippur Eve in Grodno,
White Russia.

Welcome to the Lower East Side

Allan Nadler

"TEN MINUTES' walk brought me to the heart of the Jewish East Side," recounts David Levinsky, the eponymous protagonist of Abraham Cahan's monumental 1917 novel. "The streets swarmed with Yiddish-speaking immigrants. . . . The scurry and hustle of the people were not merely overwhelmingly greater, both in volume and intensity, than in my native town. It was of another sort . . . and a hundred and one things seemed to testify to far more self-confidence and energy, to larger ambitions and wider scopes, than did the appearance of the crowds in my birthplace." Indeed, by the turn of the twentieth century there was no freer or greater place on earth in which to indulge quintessentially Yiddish passions than New York's Lower East Side.

By the first decade of the twentieth century, New York's Tenth Ward, as the Lower East Side was then known, was home to more than a half million Jews, by far the world's most concentrated and populous urban Jewish population (Warsaw, which then boasted Europe's largest Jewish community, had a Jewish population of approximately three hundred thousand). The terribly crowded and impoverished conditions in which this massive immigrant community existed did not, however, diminish the unprecedented freedoms and opportunities of the Golden Land; quite the contrary, every imaginable expression of Jewishness—from the stringent Orthodoxy of the minority who remained faithful to tradition to the radically secular Jewish socialism that was fanned by the oppressive working conditions in the city's sweatshops—flourished. And each was represented by one of New York City's four thriving major Yiddish dailies, all of which enjoyed freedoms of expression unheard

of in the Russian Empire, from which the large majority of these Jews had fled.

While Cahan's young, wide-eyed Levinsky sensed a new energy and confidence on the Yiddish Lower East Side, most outside observers, as well as the Yiddish world's social and literary critics, were struck mainly by the neighborhood's grinding poverty, desperate materialism, cultural decadence, spiritual vacuity, and literary paucity. The rabbis were shocked by the East Side Jews' epidemic abandonment of Jewish observance and their widespread contempt for

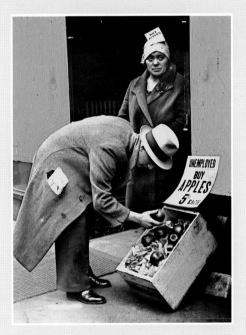

The Great Depression of 1929 struck the immigrant community particularly hard. Here a man buys an apple from the basket of an unemployed woman.

Talmudic learning. Where Cahan and like-minded populists saw endless opportunity, both highbrow Yiddishists and Orthodox traditionalists saw only the inevitable demise of what they viewed as authentic *yidishkayt*.

In fact, despite the neighborhood's deep poverty, the harrowing living conditions in overcrowded tenements and endemic crime; despite the widespread abandonment of traditional Jewish religious practice, the abysmally low level of Judaic knowledge, and common contempt for rabbis and scholars; despite the widely decried decadence of early American Yiddish literature and theater, both of which catered to the lowest impulses of the common folk by offer-

A group of men outside a store on the Bowery, waiting for jobs.

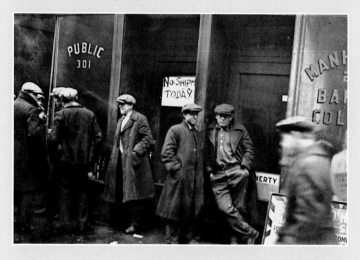

ing up trashy, sensational and often *shmutzig* fare; despite the abysmal state of the written and spoken Yiddish word on the Lower East Side (characterized by a paradoxical combination of free and unsystematic borrowing from street English with attempts to reach a higher linguistic plateau through the incorporation of heavy doses of German); despite all these things, Cahan celebrated the unprecedented promises of freedom and prosperity that the *goldeneh medina* held for the Jews.

Notwithstanding the East Side's squalor, first captured in the investigative journalist Jacob Riis's harrowing, graphic 1890 volume, *How the Other Half Lives*, and the terribly difficult lives of the Jewish immigrants who crowded its tenements and slaved in its sweatshops, there was indeed much that was essentially different, new, and exciting—and, by implication, superior to anything possible in the European

alte heym (old country)—about life on the Lower East Side. By the end of the nineteenth century there was a certain undefined energy reflecting "the larger ambitions and wider scopes" that for many Jews distinguished America from any of the previous lands of the long Jewish exile. Riis astutely observed that "in no other spot does life wear so intensely bald and materialistic an aspect as on Ludlow Street," the crowded artery that ran through the very heart of the section. Those East Side Jews who aspired so baldly to benefit from the *goldeneh medina*'s economic promises had only to observe the remarkable prosperity of so many of their German brethren, who had moved "uptown" and amassed fortunes after less than a half century in America, to recognize America's myriad opportunities for rapid financial success. At the same time, the socialist champions of the Jewish working classes were, for the first time in modern Jewish history, afforded full freedom to establish unions that frequently called strikes, to choose Socialist candidates in municipal elections, and to write anything they chose about the sadistic cruelty of "the bosses," all activities that would have led to imprisonment and worse in their European lands of origin. The first generation of Yiddish bards in America, most famously Morris Rosenfeld, appropriately became known as the sweatshop poets.

But those very promises cultivated the seeds of Yiddish culture's destruction, a notion that Cahan understood as well as anyone. He thus not only tolerated but almost championed the infestation of Yiddish with dozens of Anglicisms, maintaining—to the dismay of many of the *Forverts*'s finest

Although it kept one eye on the international world, the *Forverts* covered every aspect of the local community, including crime and Jewish criminals.

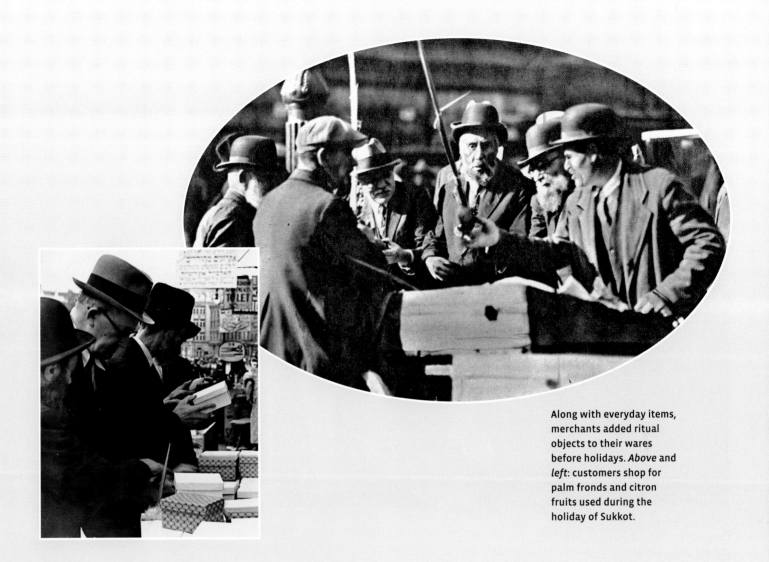

Along with everyday items, merchants added ritual objects to their wares before holidays. *Above* and *left*: customers shop for palm fronds and citron fruits used during the holiday of Sukkot.

contributors—that Yiddish was whatever his readers happened to be speaking. "Cahan began to regard himself as a guide, perhaps the guide, for the masses of immigrants," Irving Howe later wrote. "His task, as he saw it, was simultaneously to educate them in Yiddish culture and tear them away from it in behalf of American fulfillment. . . . It seemed at times as if, having been granted a dour vision of the final outcome of the whole Yiddish enterprise, Cahan took it as his special burden to carry through that vision to the end. Helping to lay the foundations for the immigrant Jewish culture, he worked mightily to undermine them; as if creation and disintegration were for him equally terms of fate." Indeed, despite a brief postwar resurgence of Yiddish in America, brought to these shores by survivors of the Holocaust, the circle suffocating Yiddish has been largely completed.

Yet more than mere ghosts of the once thoroughly Yiddish East Side linger in the shadows of defunct synagogues, shuttered yeshivas, closed dairy restaurants, and the Jewish landmark buildings that once lined East Broadway and Delancey Street. Not only are many young Orthodox families now reversing the trip taken by their grandparents over the Williamsburg Bridge and repurchasing the Grand Street co-ops, but a reinvented form of Yiddish music fills the morning air outside a former kosher wine factory that now hosts Sunday klezmer brunches, and once grand but long-abandoned synagogues have become magnets for experimental Jewish cultural programs. As the few remaining Jewish landmarks collapse or declare bankruptcy, new and light hybrid expressions of a postvernacular Yiddish life unexpectedly take root and mysteriously flourish, from the cracks of pavement along which millions of Yiddish peddlers, writers, philosophers, and madmen once so heavily shlepped.

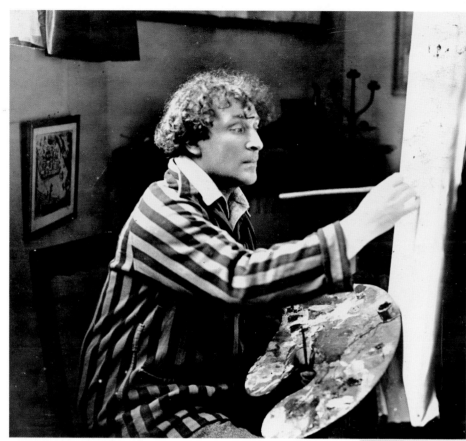

The famed painter Marc Chagall (1887–1985). Born Moishe Zakharovich Shagelov in Vitebsk, White Russia, Chagall, often closely associated with the surrealist movement, painted what became iconic portraits of Jewish folklore in the old world.

Some of the new worlds:
Cleveland, Ohio (right),
and Brownsville, Brooklyn
(below).

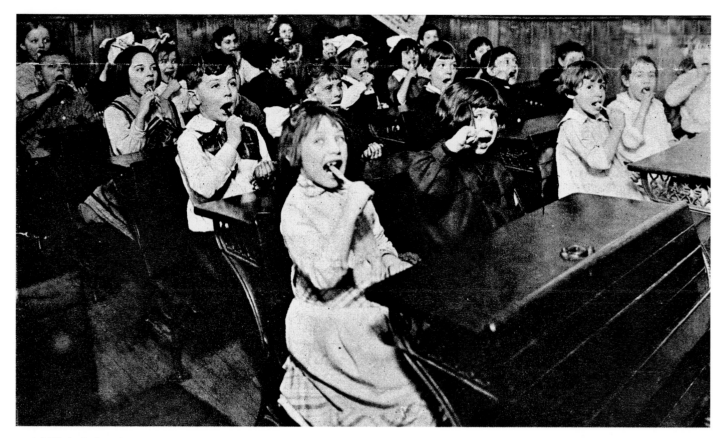

Jewish life, including the role of girls and women at home and in the community, changed dramatically on these shores. *Above*: Schoolchildren practice the "Toothbrush Drill" at a New York public school.

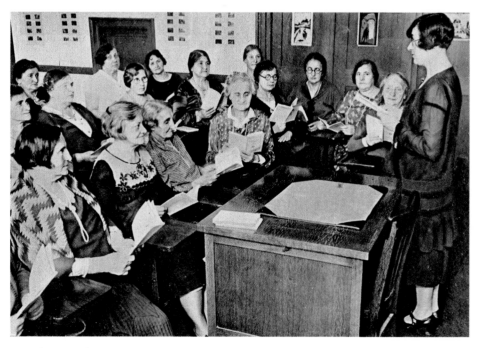

From the original caption: "Better Late than Never: Foreign-born women, many grandmothers and great-grandmothers, learning English at the National Council of Jewish Women."

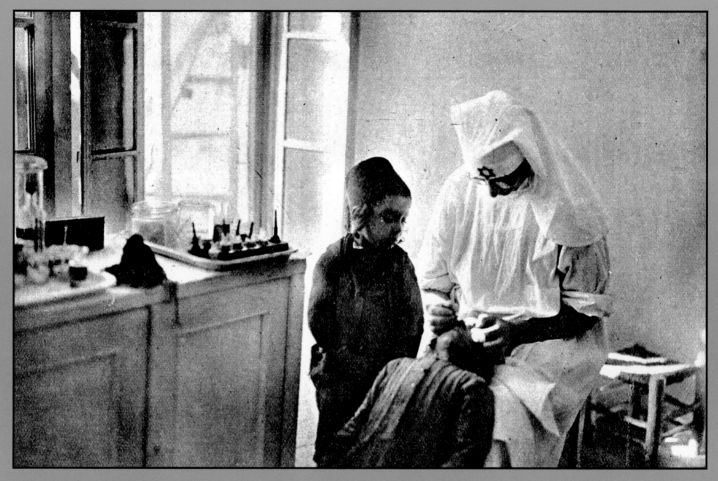

Beginning in the middle of the
nineteenth century, the Zionist
movement, which advanced the idea
of a national homeland and common
identity for Jews, had emerged.
Although most of the Jews leaving
Eastern Europe set sail for America,
a large number settled in Mandate
Palestine. The *Forverts*
commissioned a good deal of
photography from the region,
including work by the famed
photojournalists Alter Kacyzne and
H. Orushkes. *Above*: a Jewish nurse
at a Hadassah hospital treating the
eyes of a Yemenite boy.

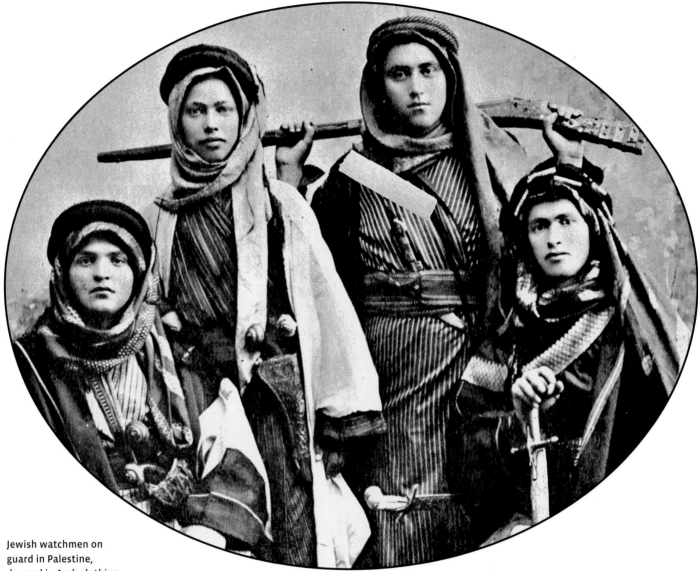

Jewish watchmen on
guard in Palestine,
dressed in Arab clothing.

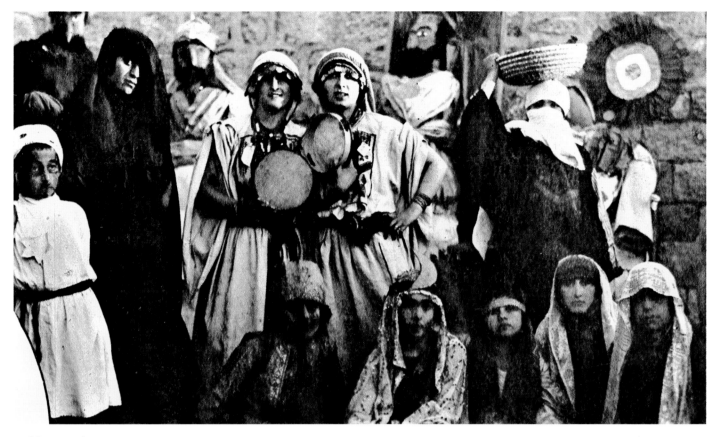

Jewish women in costume
at a carnival in Jerusalem.

An Arab woman at the
Jaffa Gate in Jerusalem.

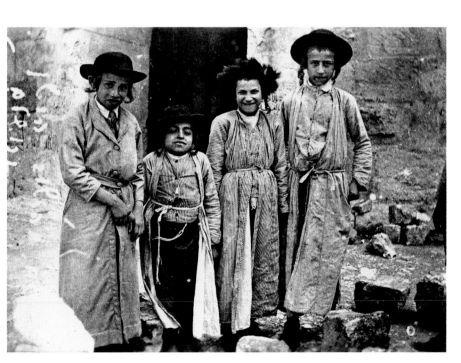

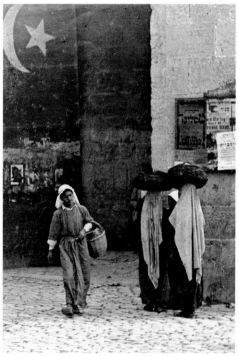

Yeshiva students from the
Old Yishuv community of
Jerusalem, dressed for
Passover.

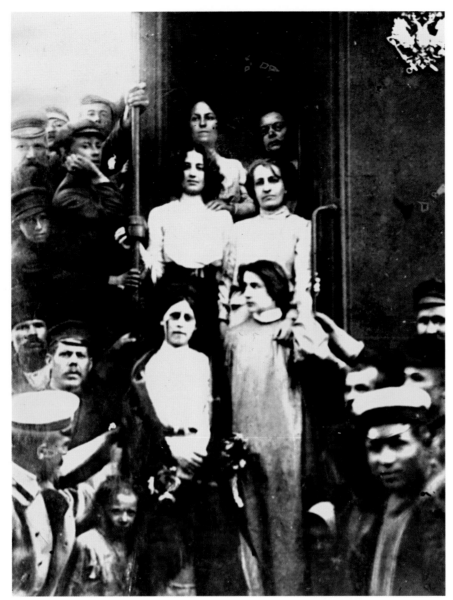

A group of young female revolutionaries in Russia, being transported to a forced labor camp in Omsk, Siberia. Peasants at the sides hold up the train and prevent it from taking the women there.

The Russian revolutionary Aleksandra Izmailovich, who was imprisoned in 1919 by the Bolsheviks and became known as a martyr of bolshevism.

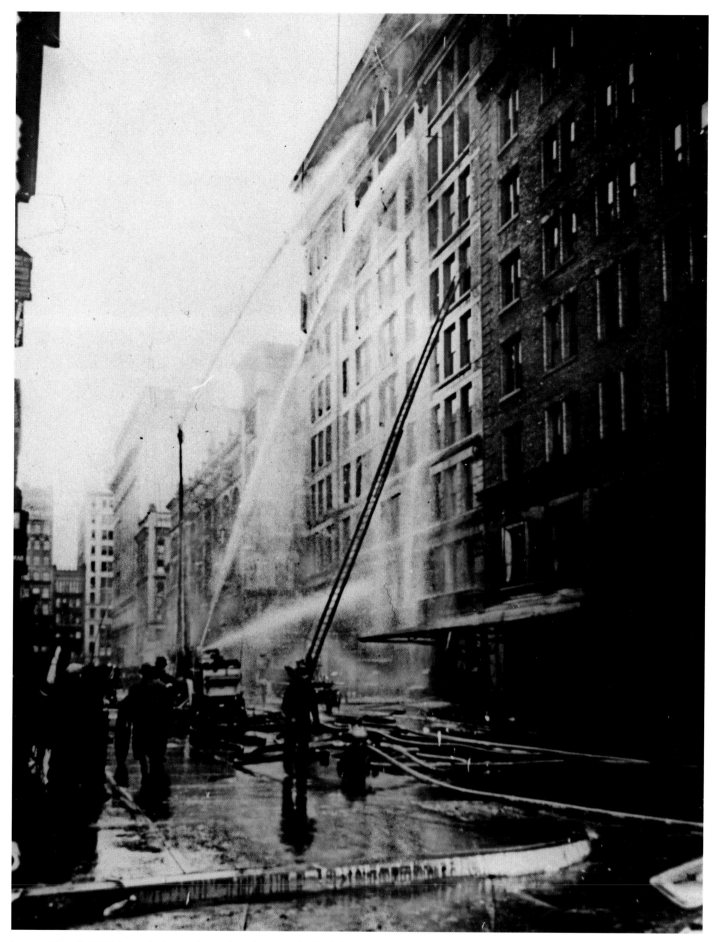

In one of New York City's greatest tragedies, 146 workers, nearly all of them young women, were killed after a fire broke out in the Triangle Shirtwaist Factory. The event became a galvanizing force for the emerging labor movement, eventually inspiring labor laws aiding factory workers in the areas of health, disability, and fire protection.

One of the archive's greatest treasures is its collection of international film and theater photography. *Above:* The Russian cinema star Varvara Kostrova.

Sholom Secunda, who
earned fame in the 1930s
as composer and arranger
for the Yiddish stage (his
songs include "Dona
Dona" and "Bei Mir Bist
Du Sheyn"), started off as
a child cantor.

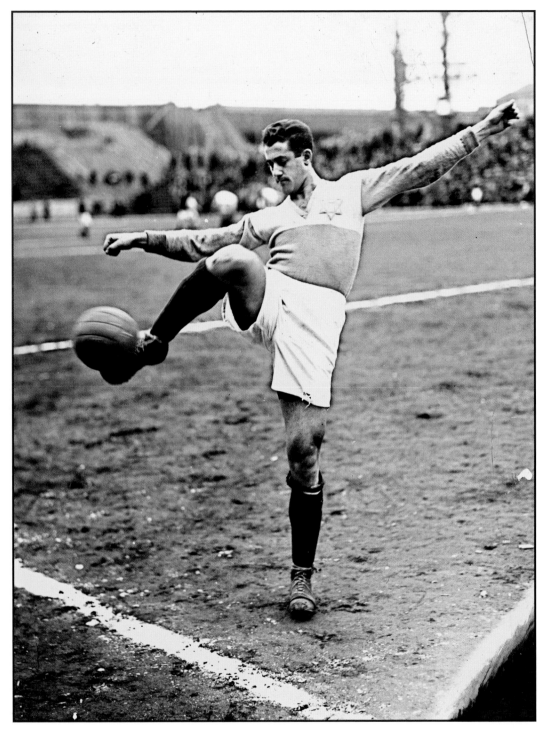

The soccer star Erno Schwarcz, a member of the Hakoah athletic club. Hakoah was founded in response to Austria's Aryan Paragraph, which forbade most Austrian sports clubs from accepting Jewish members. It eventually grew into one of Europe's biggest athletic organizations.

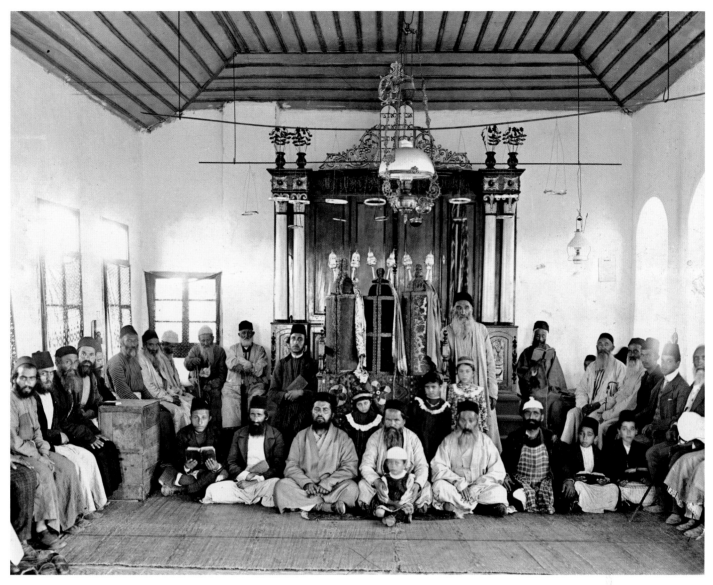

A group of men and boys inside a Jerusalem synagogue of Bukharan Jews, who hail from Uzbekistan and other parts of Central Asia.

In 1919, Locals 22 and 25 of the Dress and Waistmakers' Union of the International Ladies' Garment Workers' Union built Unity House, a country haven in Pennsylvania's Pocono Mountains. The project offered the relaxation and outdoor activities of a resort, along with consciousness raising and lectures (1924).

The famed labor leader
and longtime president of
the International Ladies'
Garment Workers' Union,
David Dubinsky.

The *Forverts* regularly covered local businesses. One feature highlighted the work of a local clockmaker.

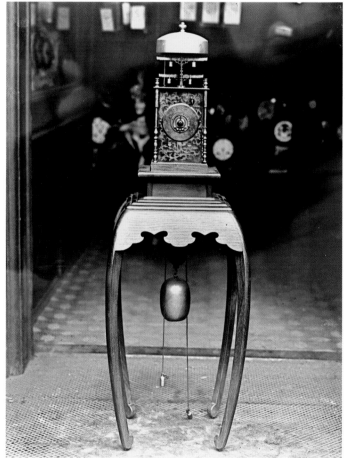

The actress Margaret
Livingston in a publicity
shot.

A young David Ben-Gurion, later to be the first prime minister of Israel, with his bride, Paula Munweis, in 1918.

The Zionist essayist Ahad Ha'am (seated), with the poet H. N. Bialik to his left (beardless with cane), during Ahad Ha'am's visit to the Hasidic colony of Nachlat Yakov in Israel.

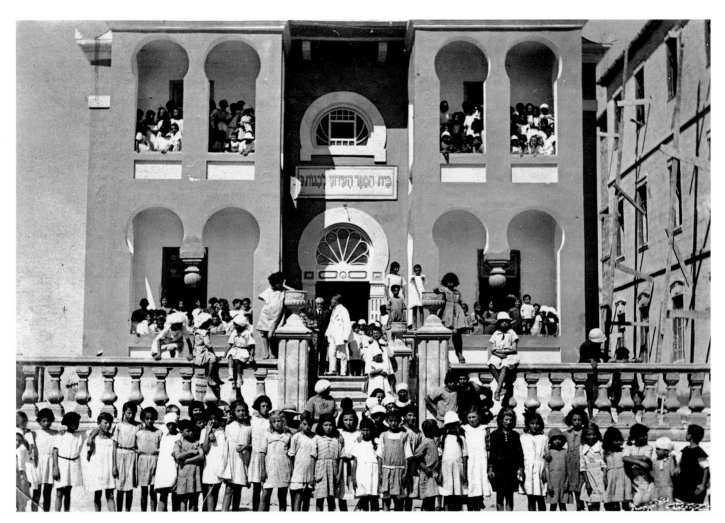

A class picture from a Tel
Aviv girls' school.

Before World War I, the newspaper instituted "The Gallery of the Missing Husbands," a bulletin board to help track down men who had deserted their families—a phenomenon that reached crisis proportions and sparked some of the earliest American Jewish communal organizations.

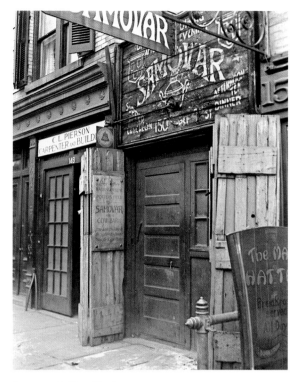

Samovar Café on West Fourth Street, the self-proclaimed "oldest restaurant in Greenwich Village."

A LITTLE TO THE WEST BUT A WORLD AWAY: A FEATURE ON GREENWICH VILLAGE.

Nut Club on Seventh Avenue.

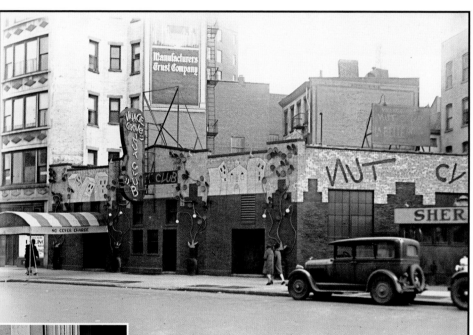

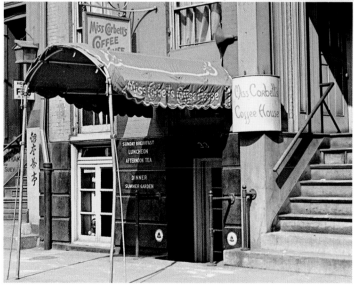

Miss Corbett's Coffee House, at West Eighth Street and Macdougal Street.

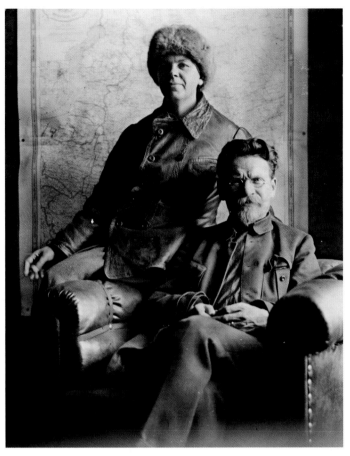

The Bolshevik
revolutionary and Soviet
politician Mikhail Kalinin,
seated, with his wife.

A demonstration for
workers' rights in Mexico
City.

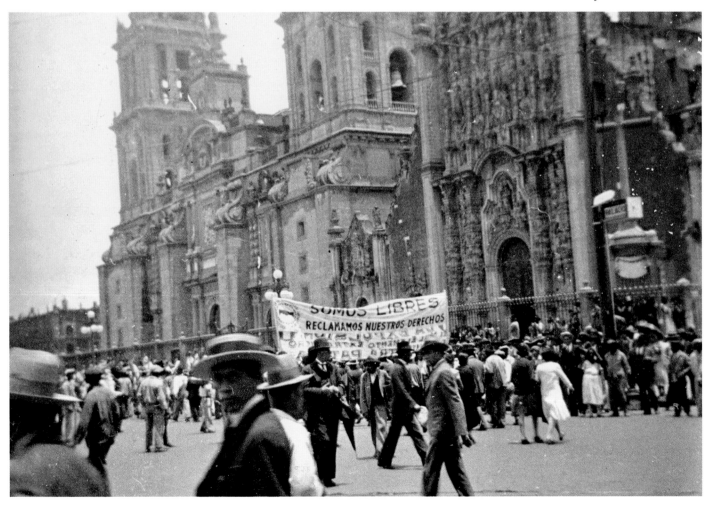

The Socialist Party leader
and five-time presidential
candidate Eugene V. Debs,
in glasses, in the
foreground.

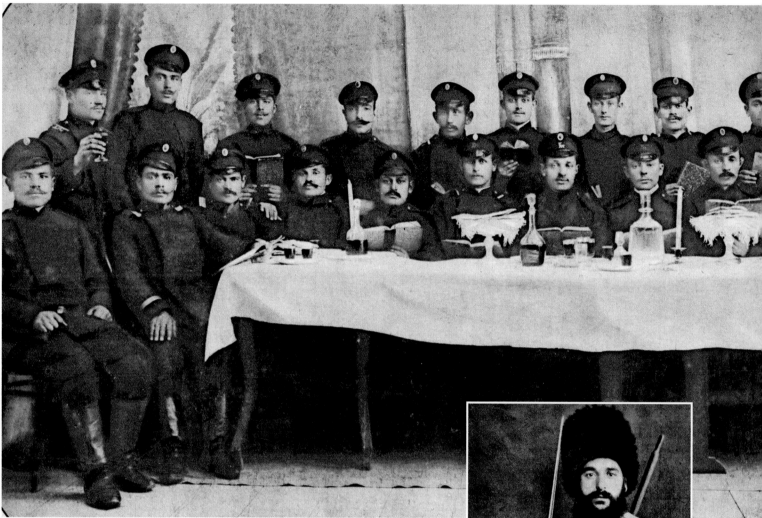

From the original caption:
"A Yeshiva student who left his rabbinic study to become a soldier of the World War."

A soldiers' seder in Russia, during the time of the tsar.

Johanna Jabotinsky, the wife of Ze'ev (Vladimir) Jabotinsky, the founder of Revisionist Zionism.

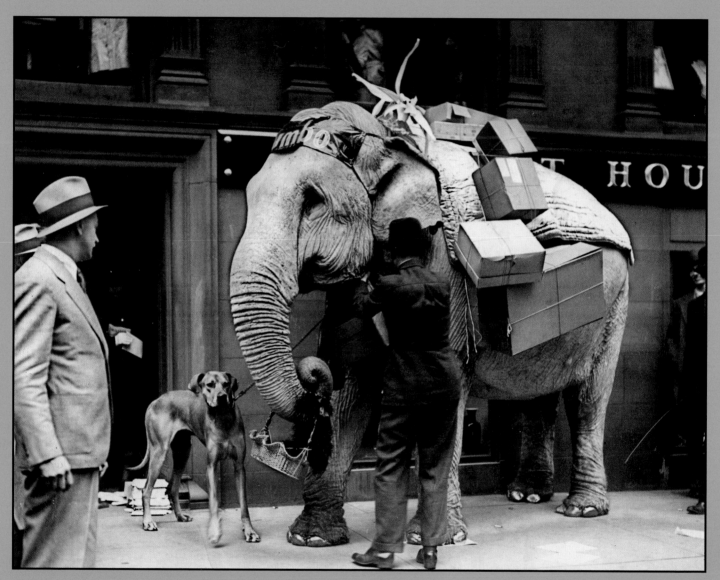

A man ties packages to an
elephant as people watch.

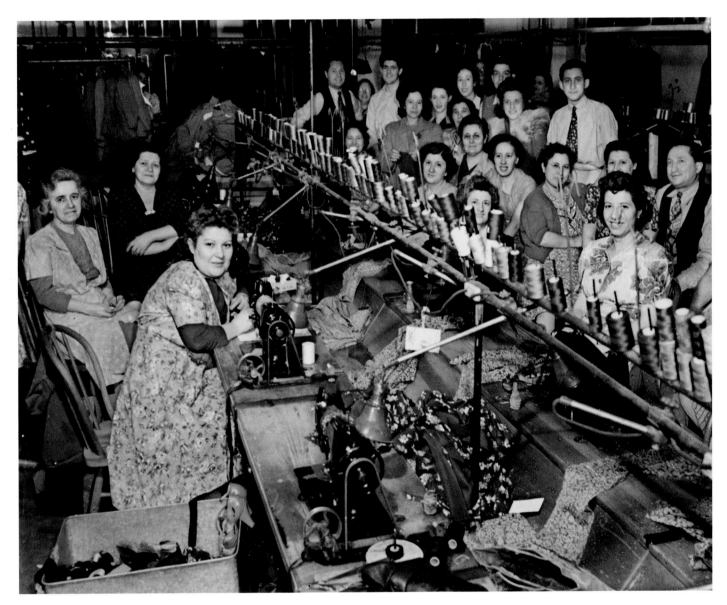

The primarily female staff
of the Gracette Dress
Company.

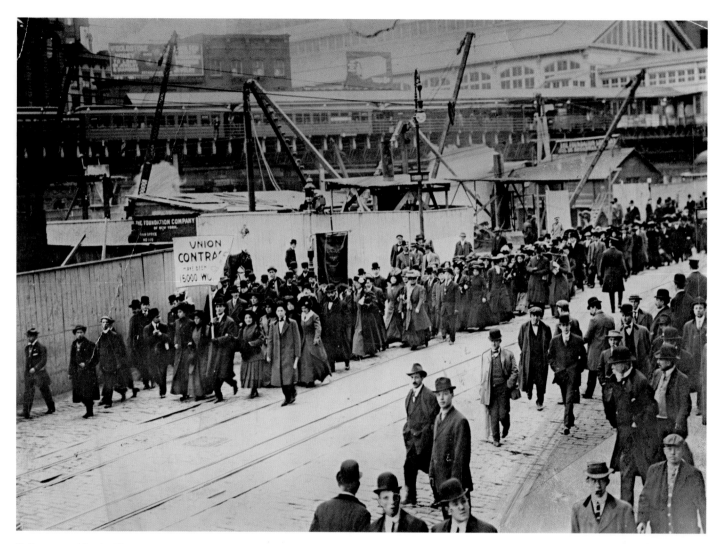

Strikers marching to City
Hall, New York (1910).

LABOR

Paul Berman

THE MOST ACCOMPLISHED and admirable Jew in American history, to judge by his contributions to democracy and social justice, was surely Samuel Gompers, though it may seem odd to say so, given that hardly anyone remembers him nowadays. He does look dreadfully stuffy in his photographs, smug and Teddy Roosevelt–like with

Executive members of the Cloakmakers' Union ratifying their agreement at a meeting at the Center Hotel.

bowler hat and matching belly. There is also the lamentable fact that V. I. Lenin, in his pamphlet *Imperialism: The Highest Stage of Capitalism*, singled out Gompers as the worst sort of imperialist toady, America's version of traitorous social democracy in action. But then Lenin was wrong about most things, doubly wrong about social democracy, and wrong

about Gompers, if we judge the man's career as a whole.

Gompers created the modern American labor movement. America always had workers' movements of one stripe or another, dating back to the eighteenth century. But Gompers, toiling in the New York cigar factories of the 1870s, studied Karl Marx's brand-new book *Das Kapital* and comprehended that henceforth trade unions ought to enroll employees and exclude employers. This was a subtle distinction that had eluded the trade unionists of the past. Then again, having taken a leaf from Marx, Gompers concluded that unions nonetheless ought to keep away from Marx's political organization, which in those days was the Socialist Labor Party. Gompers figured that unions ought to stay away from the other political parties too. The whole purpose of unions, in his judgment, was to represent the workers and no one but the workers.

It is true that Gompers regarded his Jewishness as merely a fact of private life, without any bearing on his new organization, the American Federation of Labor. Yet just as he was getting his AF of L properly launched, the Jewish immigrant proletariat began to grow in several cities across the United States, and unions of Yiddish-speaking work-

Samuel Gompers, the founder and longtime head of the American Federation of Labor.

ers sprang to life, mostly in the needle trades. The new unions, from the gigantic International Ladies' Garment Workers' Union and Amalgamated Clothing Workers down to the capmakers and hatmakers, fought a series of battles: the shirtwaist makers' "uprising" of 1909, the cloakmakers' "revolt" of 1910, and so forth, during a five-year streak of strikes. The unions took an ever more prominent place in Gompers's federation, and they grew strong and sometimes, in their treasuries, even wealthy.

Abraham Cahan's *Jewish Daily Forward*, with its stirring front-page Marxist motto, "The emancipation of the workers will be the task of the workers themselves" (so much grander than the miserable jingle "All the news that's fit to print"), lent a hand to the Jewish unions. The results? It was the Jewish labor movement that pioneered the modern American Jewish hyphenated identity, the sentiment and attitude that allowed the unions to thump on a Jewish tub and, at the same time, to champion the working class as a whole, to speak Yiddish, and, without the slightest apology, to affirm themselves as properly and fully American.

The Jewish unions leaned further into socialism than Gompers thought advisable, but that was partly because their political organization, the new Socialist Party of America, showed a little more flexibility than the rigid old Socialist Laborites of yore. Anyway, the Socialist Party faded away after a while, except in a few neighborhoods, leaving the unions free to make their own decisions. Some of the labor leaders emerged from the anarchist movement as well

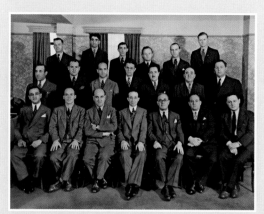

Leaders of the Furriers' Union.

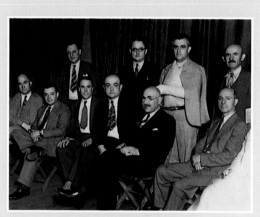

General Executive Board of the International Ladies' Handbag, Pocketbook & Novelty Workers' Union.

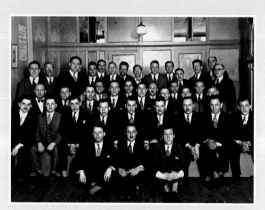

Leaders of the Millinery Workers' Union, Local 24.

and, in the anarchist style, proposed all kinds of imaginative ideas for workers' self-improvement. It was the anarchists who pioneered workers' education in the Jewish labor movement.

The anarchists organized cooperative colonies in the suburbs of New York and New Jersey and elsewhere, and they put up a fight against bureaucracy in the trade unions, a doomed campaign, but good to do anyway. Animated by these sundry inspirations, the Jewish labor movement set about spreading its spirit of solidarity far beyond the factories and sweatshops, a solidarity that led the unions to construct housing for their members, and vacation resorts, and schools, and generally a world of their own. Cahan's newspaper poured money into the AF of L during the reactionary 1920s, when the labor movement was hurting. And partly because of the strength of David Dubinsky's garment workers, Sidney Hillman's clothing workers, and an infinity of smaller Jewish labor organizations, the American labor movement in the 1930s achieved its grandest successes and pushed forward the New Deal of Franklin D. Roosevelt. And America became a better place.

The Jewish labor movement accomplished something else as well, and this was to mount a permanent campaign of international solidarity —against the tsar of Russia in the old days, later against the European fascists, and in time against the Communists too, after communism had shown itself to be one more force for oppression. Fighting against the Communists was a daunting task, given that for a while quite a few militants in the American Jewish unions

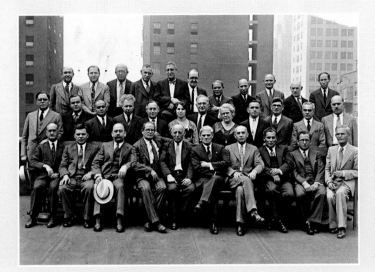

Leaders of the Cloakmakers' Union (1910).

the mainstream Jewish version, was a force for democracy at home, and likewise abroad, and even if the unions stumbled in their campaigns from time to time, their record, as a whole, demonstrated that the emancipation of the working class can be in fact the task of the workers themselves.

Did the Jewish unions in their half century of glory sometimes sink into mobster corruption or into the hands of sleazy opportunists? Did the unions sometimes hesitate

thought of communism as an improvement over the traditional left-wing ideas instead of as a dreadful perversion. But the mainstream unionists got the upper hand, and they put up a lively fight in unions elsewhere in America too and, for that matter, around the world. For trade unionism, in

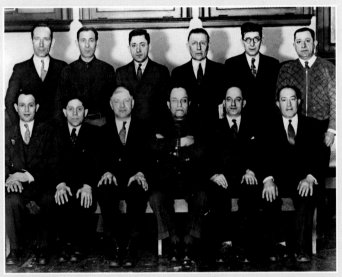

General Strike Committee of the Seltzer Workers' Union, Local 311.

ILGWU photo of female garment workers in a warehouse.

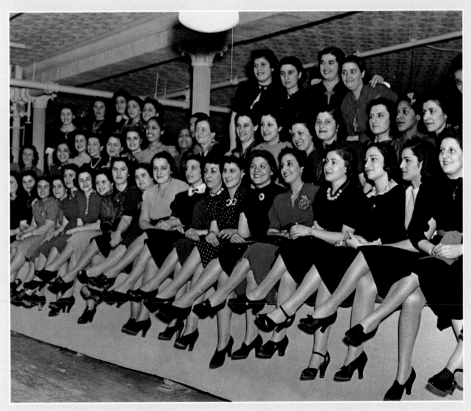

in their noble commitment to civil rights for blacks? All too true. The story has its shadows. Even so, a backward glance at those labor struggles of long ago is bound to make us wonder how our ancestors, the militant immigrant toilers, would judge us today. Would those people, the rank and file of the Jewish labor movement, think that we, their descendants, have remained the reliable friends of social justice? An uncomfortable question.

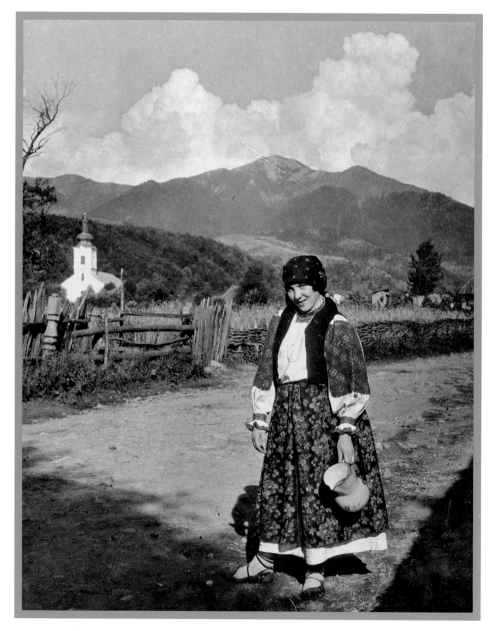

A Jewish woman in a
Carpathian mountain town
posing on a country road,
her water pitcher in hand.

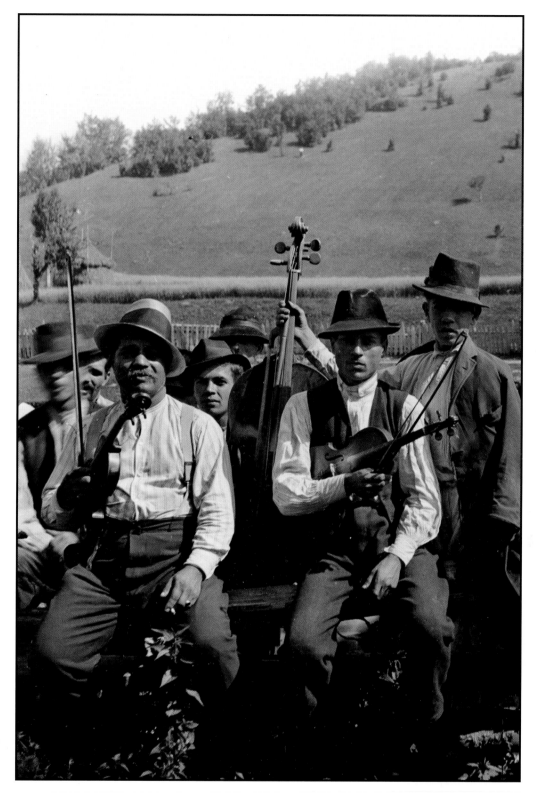

Romani (Gypsy) musicians,
the Zigeuner Fiddlers, in a
mountain town in the
Carpathians.

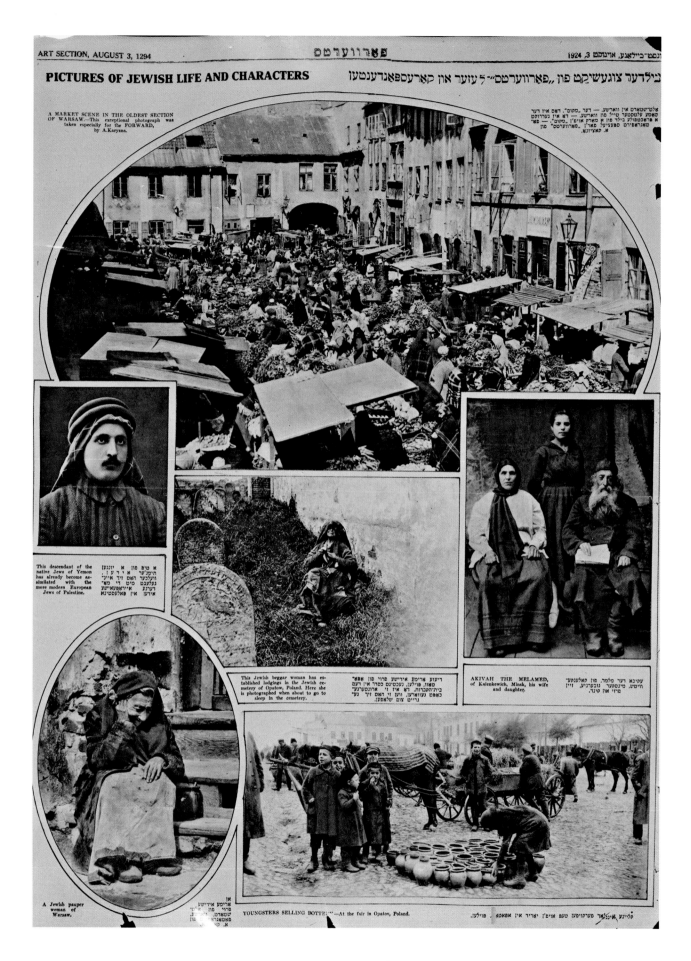

פֿאָרװערטס

PICTURES OF JEWISH LIFE AND CHARACTERS

בילדער צוגעשיקט פֿון „פֿאָרװערטס"– ל׳ עזער און קאָרעספּאָנדענטען

אלט־שטאָרט אין װארשע. — דער „מוקס". דאָס אין דער
באַסע עלטסטער טייל פֿון װארשע. — דאָ איז נערוטען
א פֿאָטאָגראַפֿיע בילד פֿון א מאַרק ראס אין נערוטען
מאַנצאָפֿערס ספּעציעל פֿאַר "פֿאָרװערטס" פֿון
א. קאַצידנע.

A MARKET SCENE IN THE OLDEST SECTION
OF WARSAW.—This exceptional photograph was
taken especially for the FORWARD,
by A.Kacyzna.

This descendant of the
native Jews of Yemon
has already become as-
similated with the
more modern European
Jews of Palestine.

א קים פֿון א יונגען
תימני"ער א י ר ע ן.
וועלכער האָט זיך אײנ־
געלעבט מיט די מאָ־
דערנע אײראָפּאַאישע
אירען אין פֿאַלעסטינא

This Jewish beggar woman has es-
tablished lodgings in the Jewish ce-
metery of Opatov, Poland. Here she
is photographed when about to go to
sleep in the cemetery.

דיעזע אָרימע אירישע פֿרוי פֿון אפּאַ־
טאוו, פּױלען, נעכטיגט כסדר אין דעם
בית־הקברות. דאָ איז זי אויטגענו־
מען געװאָרען, ווען זי האָט זיך נעך
נרייט צום שלאפֿען.

AKIVAH THE MELAMED,
of Kalenkewich, Minsk, his wife
and daughter.

עקיבֿא דער מלמד, פֿון קאַלענקע־
וויטש, מינסקער גובערניע, זיין
פֿרוי און קינד.

A Jewish pauper
woman of
Warsaw.

אן
אָרימע אירישע
פֿרוי פֿון
שטאָטער,
פּאָשמאַ־

YOUNGSTERS SELLING BOTTE——At the fair in Opatov, Poland.

קלײנע אינגלאָר פֿערקויפֿען טעפ אוים'ן יאריד אין אפּאָטאָס , פּױלען.

In 1923 the *Forverts* inaugurated a special Sunday supplement of
photographs. Known as the rotogravure (named after the printing
process used to publish these pages), the section became a
nurturing ground for photojournalists as well as the basis for what
became the paper's extensive archive.

Forward
Art Section
AUGUST 3, 1294
SECTION 3

פֿאָרװערטס

קונסט ביילאַגע
אינוסט, 3, 1924
SECTION 3

Forward

די פּראָגרעסיװע פּעזידענט אין וויים ־ פּרעזידענט פּאַנדידאַטען, סען. נאַטאָר לאָפֿאָלעטטע (רעכטס) און סענאַטאָר והילער.

Senator La FOLLETTE, Progressive Presidential candidate, is shown here with his running mate, the vice-presidential candidate, Senator Burton K. Wheeler. (International).

ראָוא זילבערט, די יונגע אידישע אַקטרי ריסע, װאָס איז אומ־ געקומען אויף דער שיף "באָסטאָן".

ROSE SILBERT, the Jewish actress, who was killed while on her honeymoon on the steamship "Boston". (Rappoport studio)

ב. C. VLADECK, manager of the Forward and Commissioner of the HAIAS, who spent the past two months in Europe in an intensive study of immigration problems.

בי. סי. װלאַדעק, מענעדזשער פֿון פֿאָר־ װערטס און דער־אַזער פֿון אידי" קאָמישאָנער דיש" שאָנעלט, װעלכער האָט פֿאַרבראַכט די לעצטע צװיי מאָנאַטען אין איראָפּא אין אַ װעט אין אימיגראַציאָנס־פּראָבלעמען.

(לינקס): די גרעפֿין האָ־ לוב, פֿון עסטעריר, א גע־ װעזענע ניו יאָרקער קאַ־ באַרעט סענגערין, האָט מען אַנגעקלאַגם איהר מאַן פֿאַר א שיידונג און מאַכם 600 טויזענר דאָל. דעם גראַף'ס ליעבע מים דיטער זינגערין אין נאַטיעל א גע־ װאָרינע סענזאַציע אויף בראָדװעי.

Baroness Holub, (left) of Austria, former New York cabaret singer, is suing her millionaire husband for a separation and a settlement of $600,000. The baron's wooing of the singer, — presenting her with diamonds, rubles and furs,— was the sensation of Broadway. (International).

פּיעטראָ מאַסקאַני, דער בעוואוס־ סטער איטאַליענישער מוזיק־ פֿערפֿאַסער, קומם אהער פֿאַר א קורצען מור.

PIETRO MASCAGNI, foremost Italian composer, will visit United States shortly after an absence of 22 years. (Keystone).

די מערדער פֿון'ם פֿראַנקס באַבישעם, ריטשאַרד לעב (רעכטס) און נ פֿאַן לעאָפּאָלד, פֿאַ־ טאָגראַפֿירם אין שיקאַנע.

The Franks boy killers, Richard Loeb (left) and Nathan Leopold, photographed at the trial in Chicago. (International).

ריקאָף (לינקס), דער רוסי־ שער פּרעמיער, איז דאַ פֿאָ־ טאָגראַפֿירם װי ער גים א ברידערלעכען שלאָג־האַנד דעם זינאָװיעװסקי", דער געוועזענער הויפֿם פֿון "טשעקא", די סאָוועטען גיטסטים פּאָליציע. װאָס האָם אוטשערעבאַכט מולװערדער סענשעט.

RYKOFF (left), Lenin's successor, is shown here in a handshaking pose with Dzherzinsky, former head of the dread "Cheka", the Russian spy system.

גלאָריא סוואַנסאָן, די בעוואוס־ טע מואױ אַקטריסס, איז גע־ װאָרען א כלה פֿאַר דעם איטרי" שען פֿידעל־קינסטלער יאַשא בראָדװעי. קלאַנג אויף בראָדװעי.

GLORIA SWANSON, the moving picture actress, has been reported engaged to the violin virtuoso Jascha Heifetz. (Keystone).

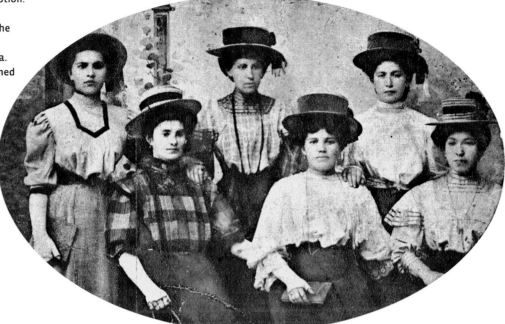

From the original caption: "Six Chums of Biala, Poland, all lived on the same street, and all emigrated to America. Also, they are all named 'Ida.'"

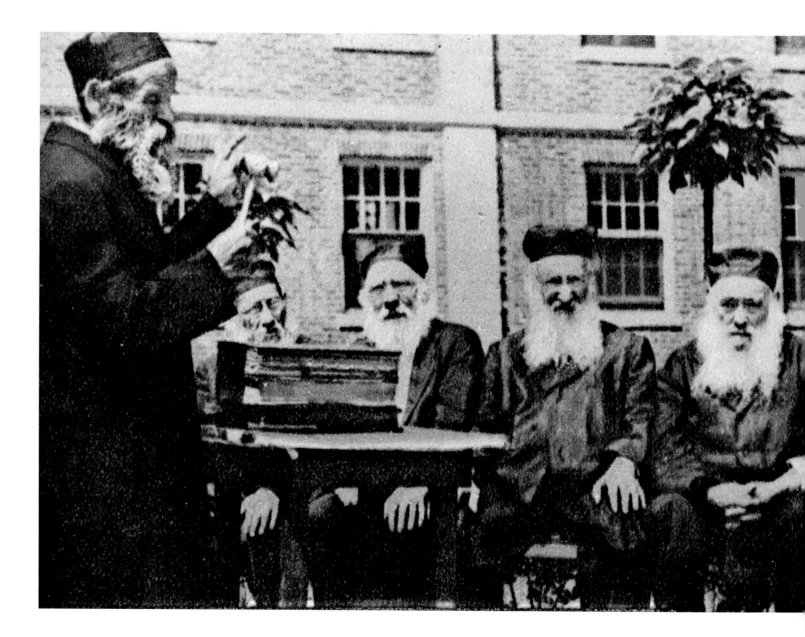

From the original caption: " 'Members under 100 Years of Age Not Admitted'—A meeting of the century club of the Hebrew Home for the Aged at Dorchester, Mass. From left to right: Louis Starr, the president, 108; Louis Croll, 100; Jacob Krock, 101; Rabbi Moses Berlin, 100; Shmeri Rozmarin, 101; Morris Rotkowitz, 104; Aria Libman, 103; Louis Zabara, 101; Joseph Jacobson 100; Louis Lerman, 100."

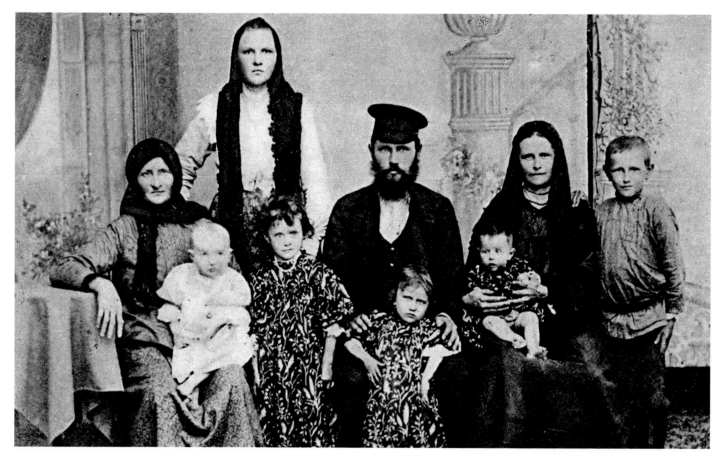

Members of a Christian
family from Eastern
Europe who converted to
Judaism and settled in
Palestine.

Dina Goldstein, the
talented young actress of
the Lenox Theater, 1924.

Jewish children in an
exercise class in Dvinsk,
Latvia.

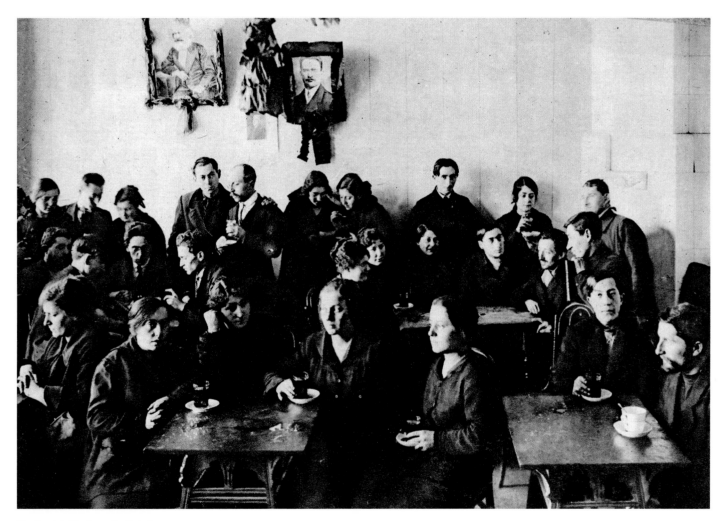

The Jewish Workmen's Club, in
Praga, a suburb of Warsaw,
Poland, where workers spent
their free time, drinking coffee
and tea at small café tables.
Watching over them, in the photo
on the wall, was Karl Marx.

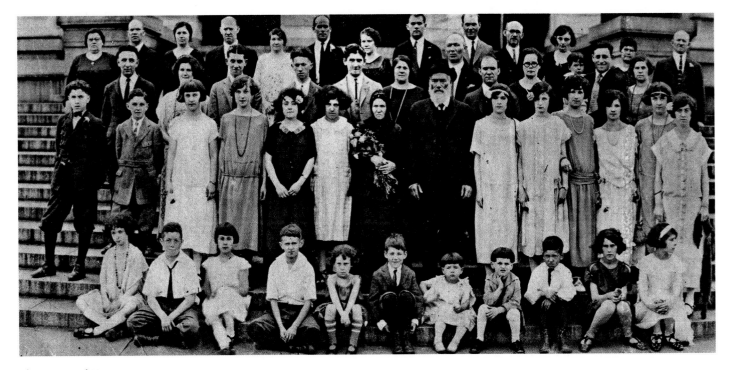

Above: Mr. and Mrs. Milunchick, of St. Paul, Minnesota, surrounded by their children, grandchildren, and great-grandchildren, on their fiftieth wedding anniversary.

Mr. and Mrs. L. Chuck, of Chicago, Illinois, seen with their children, at their twenty-fifth wedding anniversary celebration.

Mr. and Mrs. Aranowitz, of Brooklyn, New York (center), with their family, celebrating the couple's golden wedding anniversary.

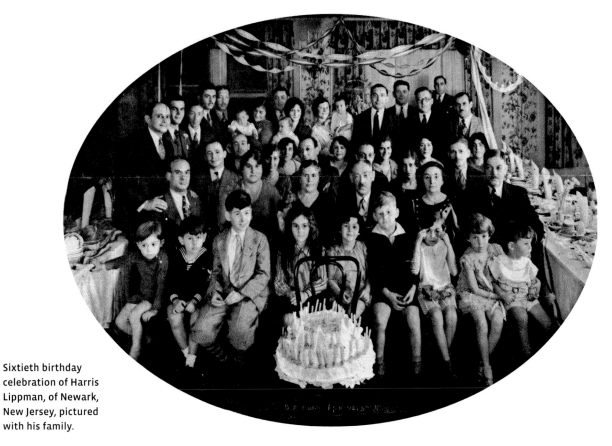

Sixtieth birthday celebration of Harris Lippman, of Newark, New Jersey, pictured with his family.

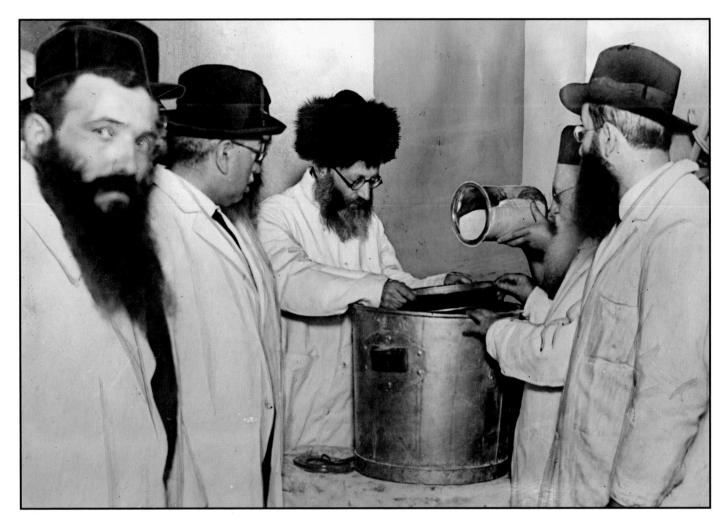

Rabbi Abraham Isaac
Hacohen Kook, the
spiritual leader of
religious Zionism and the
first chief rabbi of
prestate Israel, seen
mixing flour for a batch of
matzos in Jerusalem, 1925.

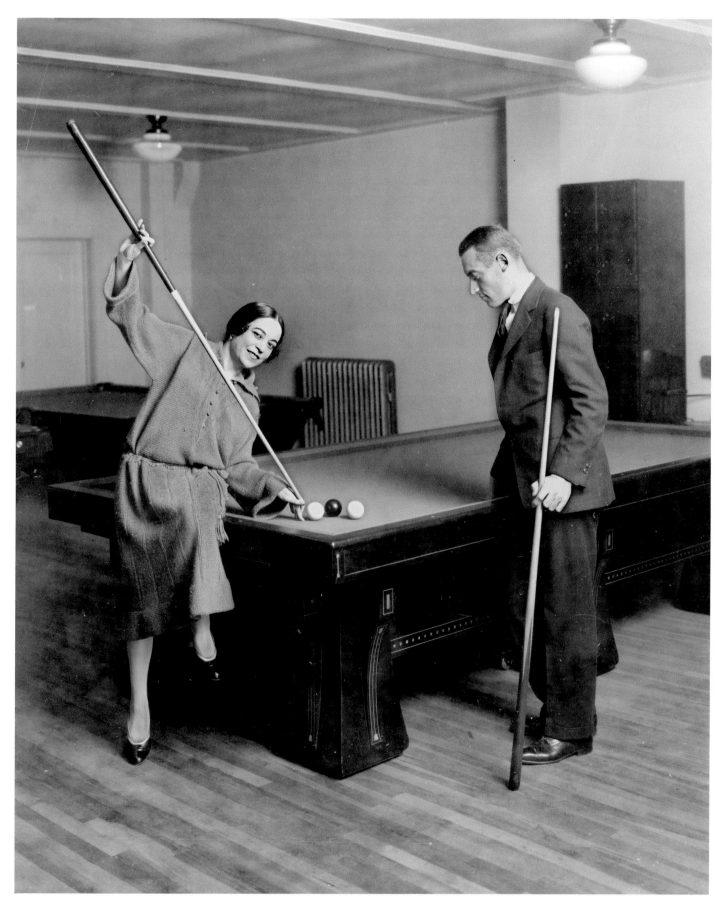

The Jewish folksinger Isa Kremer
positioning her pool cue, while
Jack Schaefer, the reigning world
champion of billiards, looks on.

Mr. and Mrs. Sutin of
Albany, New York, a
traditional Orthodox
couple, upon celebrating
their golden anniversary.

The actor and producer
Ludwig Satz and his
traveling troupe of actors,
in front of their train in
Bessarabia.

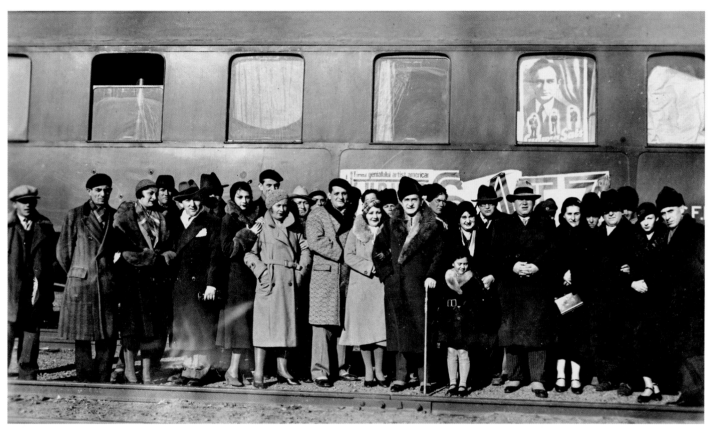

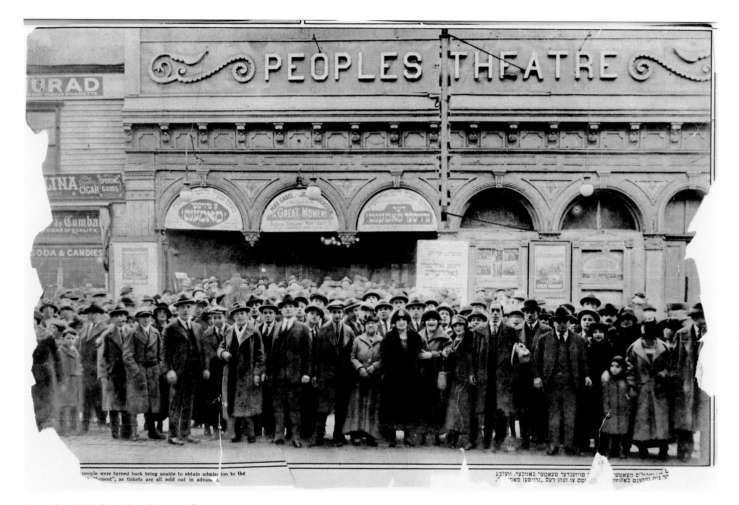

From the original caption: "A mass of theatregoers outside the Peoples Theatre, waiting for tickets to the Yiddish play *The Great Moment*. Many were turned away, the tickets having sold out well in advance."

FILM

J. Hoberman

WHEN IN DOUBT, print the legend. As in the novels *What Makes Sammy Run?* and *Ragtime*, as well as in Neal Gabler's popular history *An Empire of Their Own*, the American movie industry and the history of immigrant Jews are inextricably combined; they arrived together at the dawn of the twentieth century in the slums of New York.

The development of motion-picture exhibition—which is to say, the proliferation of five-cent storefront movie theaters—coincided with the great immigration out of Russia and Eastern Europe. Home to half a million Jews, the Lower East Side was the most densely populated and most nickelodeonized area on earth. Among other things, it was a neighborhood of fans. During the economic downturn of 1908 the *Jewish Daily Forward* reported that although "most music halls have shut down, Yiddish theaters are badly hurt, and candy stores have lost customers," people were still lining up for the nickelodeons. "There are now about a hundred movie houses in New York, many of them in the Jewish quarter." In fact nearly a fourth of Manhattan's 123 nickel movie theaters were located amid Lower East Side tenements with another 13 squeezed among the Bowery's Yiddish theaters and musical halls, and 7 more clustered in the somewhat tonier entertainment zone at Union Square.

The nickelodeons could be extremely profitable. In December 1907, *Variety* calculated that one typical Lower East Side nickelodeon, the Golden Rule Hall, on Rivington Street, had weekly grosses of eighteen hundred dollars against expenses of five hundred dollars. It's been estimated that 60 percent of exhibitors were Jewish, including such garment merchants turned exhibitors as Marcus Loew, William Fox, and Adolph Zukor. In the years just before and after World War I, Fox and Zukor, as well as such other first-

generation Jewish immigrant exhibitors as Carl Laemmle, Louis B. Mayer, and the Warner brothers, became Hollywood moguls. (The first American Jew to run a film studio, however, was Sigmund Lubin of Philadelphia.)

There were also Jewish stars. The vamp Theda Bara (born Theodosia Goodman) and the cowboy Broncho Billy (né Max Aronson) were not widely known as Jews. Irene Wallace, on the other hand, was a non-Jewish actress who specialized in Jewish roles, and Charlie Chaplin was a Gentile who seemed so "Jewish" he was simply assumed to be so—not least by Jews.

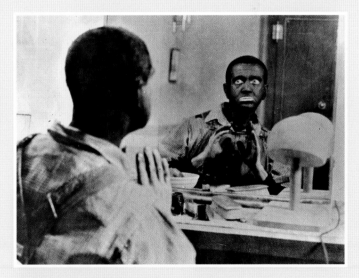

Al Jolson, one of the most popular entertainers of the twentieth century, seen here applying the blackface minstrel makeup of his signature act. Born Asa Yoelson and the son of a cantor, Jolson earned wide fame for his appearance in *The Jazz Singer,* the first feature film with sound to enjoy commercial success.

A sequence of exposures featuring the Yiddish actor Zygmunt Turkow in various character roles.

Early movies were not infrequently set in immigrant ghettos. Even after movie production had shifted almost completely to Southern California in the 1920s, nostalgic moguls continued to make a few Lower East Side set "melting pot" movies: *Humoresque* (1920), the 1922 Anzia Yezierska adaptation *Hungry Hearts*, and, most famously, the first partial talking picture, *The Jazz Singer* (1927). The last starred the foremost American Jewish entertainer, Al Jolson, in the quasi-autobiographical story of a cantor's son who becomes a Broadway star. (The ads that ran in the *Forverts* gave Cantor Yosele Rosenblatt, featured in one scene, nearly as much prominence as Jolson.)

The Jazz Singer's tale of successful assimilation reflected powerful trends in American show business. Muni Weisenfreund, a star as well as a serious actor on the Yiddish stage, became the movies' Paul Muni. Edward G. Robinson—né Emanuel Goldenberg—was another distinguished Yiddish stage actor who went Hollywood. Both men achieved stardom playing ethnics—not Jewish but Italian gangsters. At the same time, the development of sound cin-

The film and stage actor Edward G. Robinson (1929).

The popular entertainer Eddie Cantor, with his wife and five daughters (1929).

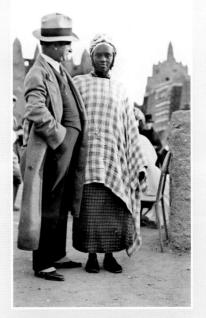

Ludwig Satz (above) at the Colonial Exposition in Paris. According to Satz's note on the back of the photograph, he paid this "Algerian maiden" two francs to pose with him.

The actor Maurice Freeman enjoying the company of a young actress.

ema gave rise to Yiddish talkies, several of which remade *The Jazz Singer* from a more Jewish perspective.

For the Yiddish-speaking audience, these movies were hardly inconsequential. When the Ludwig Satz vehicle *Zayn Vaybs Lubovnik* (*His Wife's Lover*) had its world premiere at the Clinton Theater on the Lower East Side, the *Forverts* ran its review above that for *Palmy Days*, a musical starring the East Side's own Eddie Cantor. Scores of Yiddish talkies were produced in and around New York over the next dozen years. There were also imports from the Soviet Union and Poland. When Joseph Green's *A Brivele der Mamen* (*Little Letter to Mother*) opened in New York in September 1939, the month war broke out in Europe, it was reviewed in the paper by no less an eminence than the editor in chief, Abraham Cahan.

Yiddish cinema declined during World War II and disappeared thereafter. In the ensuing decades only a few Hollywood movies featured explicitly Jewish protagonists. Not until the liberated sixties did the American screen showcase openly Jewish performers like Barbra Streisand and Woody Allen in specifically Jewish roles; not until the independent documentaries of the 1990s were movies again produced for a predominantly Jewish audience.

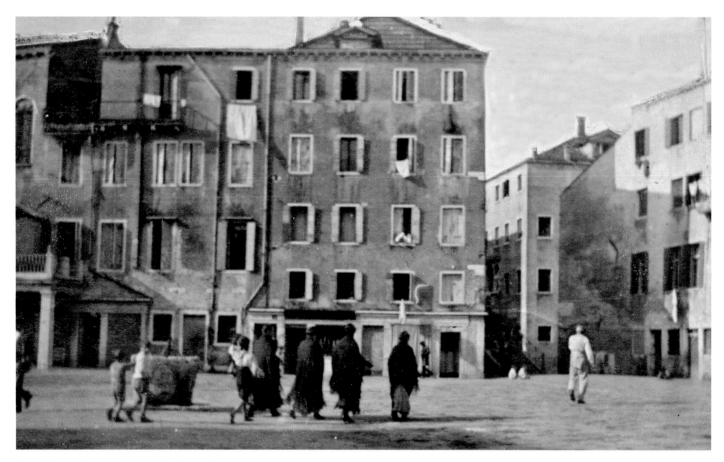

Our photographer wrote the following note on the back of this photograph, taken in the Jewish ghetto in Venice: "This was taken in the Ghetto Nuovo or New Ghetto. The Old Ghetto is close by. I couldn't get a picture of it because the high old buildings on all sides completely shut out the sun. Observe the well in the midst of the square. That is where the women do their washing. The lower floors of the buildings contain shops. On the right you can just see the little bridge which leads across a canal to the Old Ghetto. The square is paved with stone and so are all the streets of Venice. There is no dust in the city."

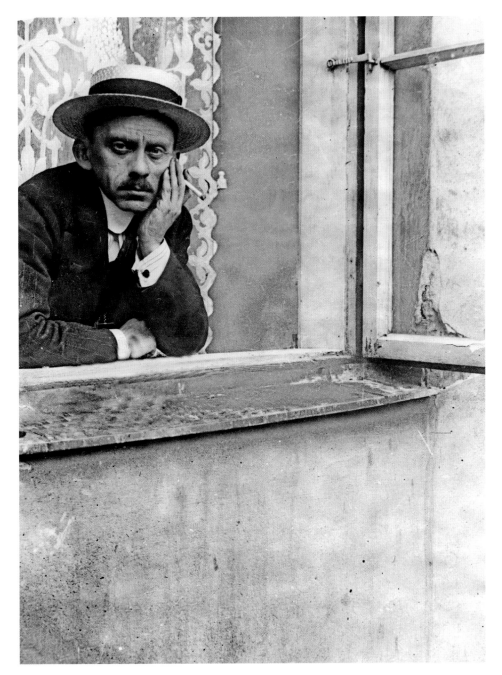

The Polish Yiddish author
and political activist
Hersh-David Nomberg in
1916.

A statue of the Buddha in a parade of world religions in Moscow (1922).

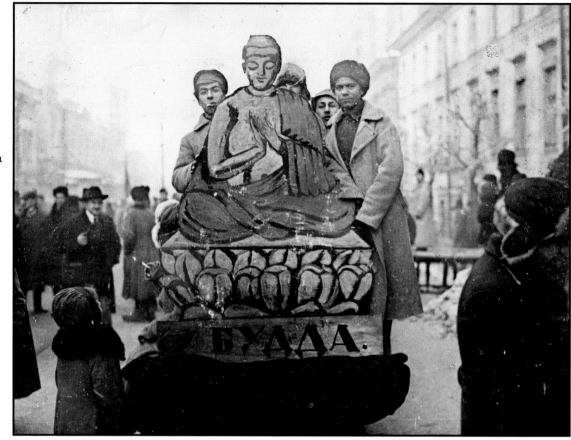

Representatives from Mongolia, in Russia, wearing ethnic costumes and headdresses (1923).

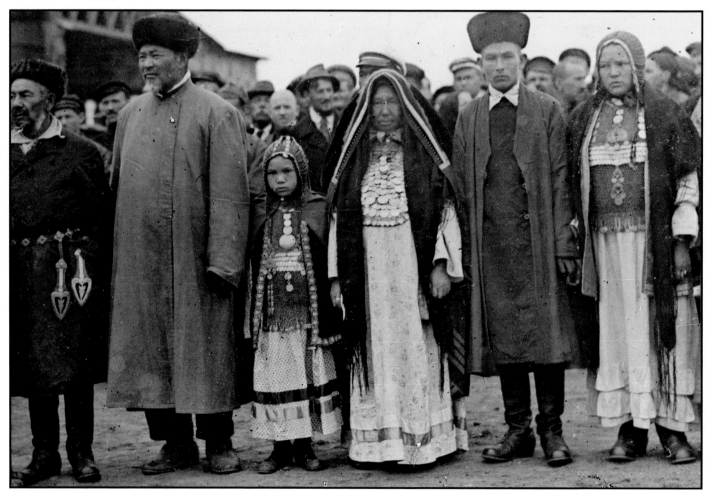

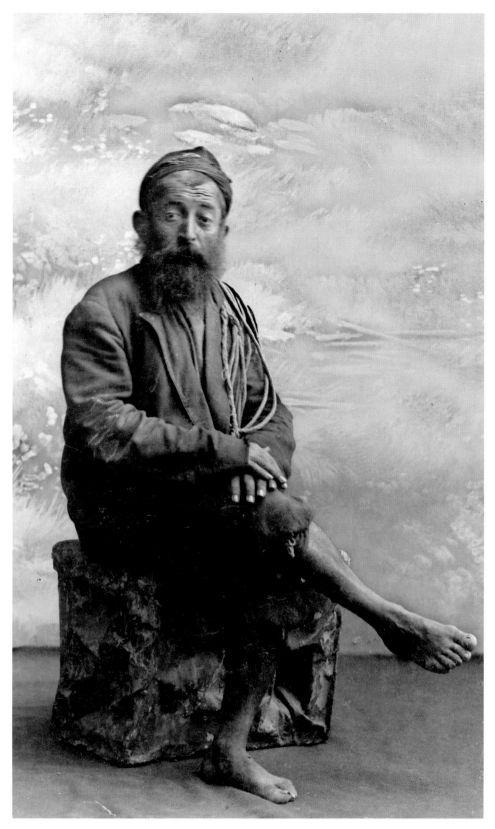

An impoverished Jewish
man from Yafo, Palestine.

A Social Democratic youth
performance in
Magdeburg, Germany.

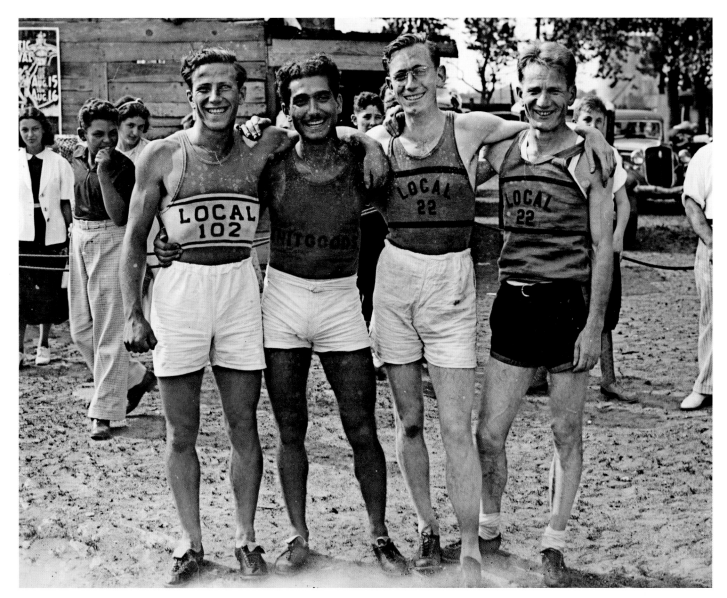

Members of the
International Ladies'
Garment Workers' Union,
representing Locals 102
and 22 and the Knitgoods
Workers, at a union
outing.

The opera singer Rosa Ponselle
(right) in Hollywood during the
1920s. According to the caption,
she posed here specifically for
the *Forverts* arts section.

Albert Rothschild, scion of
the famed banking and
wine family, as a toddler,
with his stuffed animal
(Vienna, 1924).

Infants at a nursery in Poland.

A singing lesson in the Jewish People's School in Otwock, Poland.

Lunchtime at the Dumont
Nursery School of P.S. 174
in Brooklyn.

From the original caption:
"They Who Knock at Our
Gates—A group of
immigrants arriving in
New York. Their one
worry, 'Is the Quota
Exhausted?'"

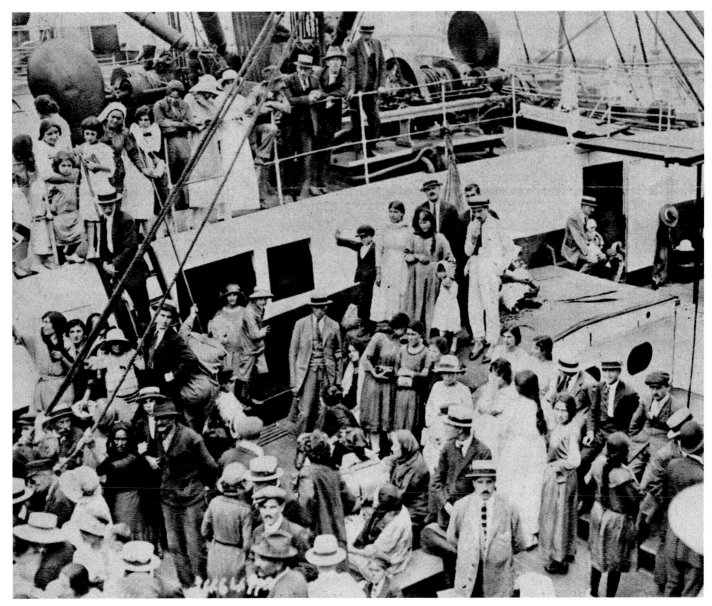

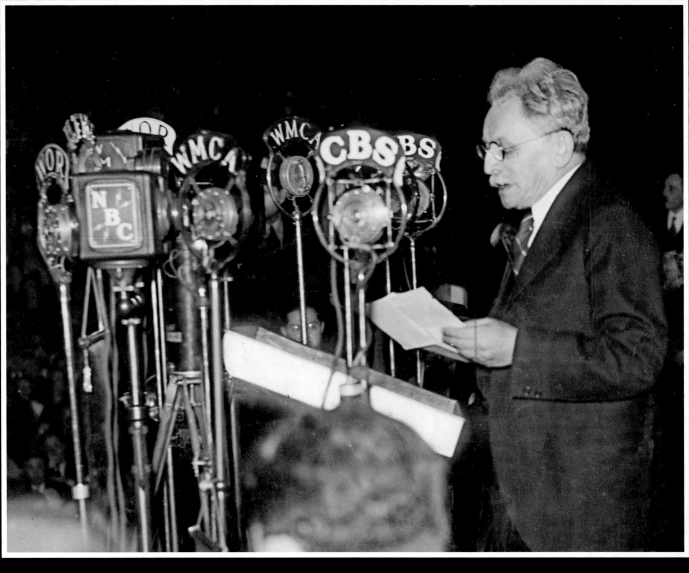
When Abraham Cahan spoke, as in this 1933 address, the nation listened.

1926–1945

I N T H E Y E A R S after World War I, as America entered the Jazz Age, the Jewish immigrants and their children were settling into America. The Lower East Side of pushcarts and sweatshops was giving way to a sophisticated world exploding with cultural, political, and entrepreneurial energy. Second Avenue was lined with Yiddish theaters and publishing houses that were admired around the world. The children of the immigrants were bursting out of the ghetto and putting their stamp on American music, film, business, and academia.

The *Forverts*, growing with its community, had become one of America's premier metropolitan dailies. From its headquarters on East Broadway, the tallest and most recognizable building on the Lower East Side, it built a nationwide circulation topping a quarter million and wielded influence that reached around the world.

In addition to reporting the news, the *Jewish Daily Forward* served as a public square for Jewish America. It published fiction and poetry by the leading figures of Yiddish literature, from Morris Rosenfeld, "the poet of the sweatshops," to Sholem Asch and, in later years, Isaac Bashevis Singer. It also gave voice to ordinary folks through the letters they wrote to the "Bintel Brief," Cahan's famed advice column, and the pictures they sent in from community events and family gatherings.

As America sank into the Depression in the 1930s, the *Jewish Daily Forward* threw its weight behind Franklin Roosevelt and his New Deal, and its influence reached a peak. At the same time, the newspaper kept a close eye on the dark clouds gathering over Europe. *Forverts* reporters and photographers, knowing they were their people's lifeline, documented the rise of Nazism, the struggles of Polish Jewry, and the outbreak of war with an intimacy and passion no other news organization could match.

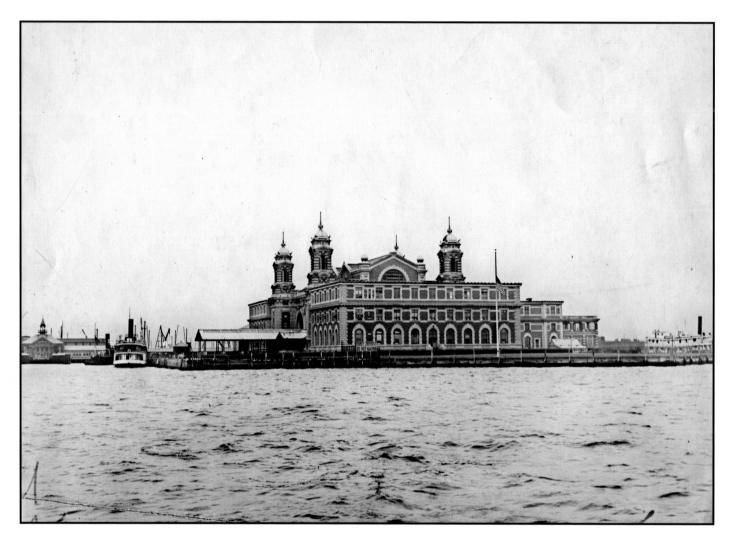

Ellis Island, quieter after
the 1921 and 1924
immigration quotas took
effect.

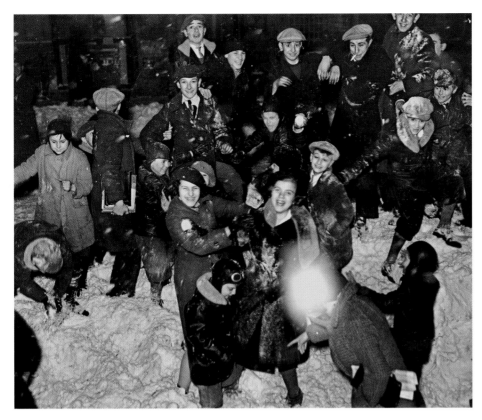

For those who managed to get in before the doors closed, a new world awaited. A nighttime snowball fight on Henry Street in the Lower East Side.

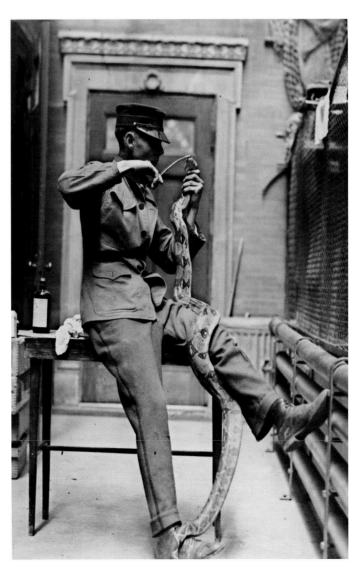

A guard at the Bronx Zoo tending to the mouth of a boa constrictor after the snake's rabbit lunch.

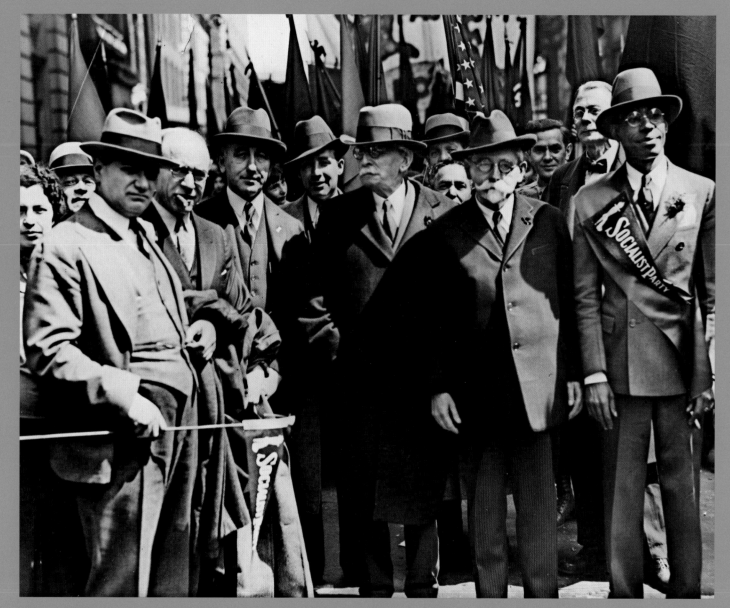

Abraham Cahan (center,
looking to his right)
flanked by fellow Socialist
Party leaders.

The Purity Cooperative
Association in Paterson,
New Jersey (1930).

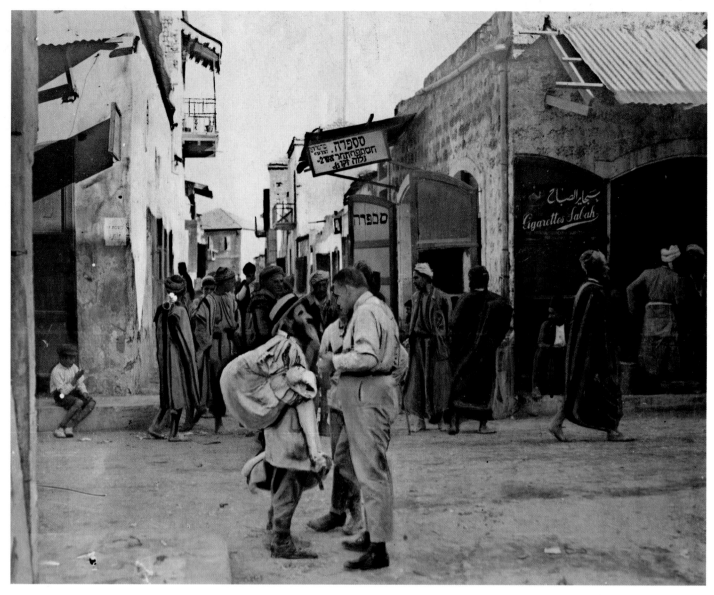

Jewish merchants
converse in front of a
Jewish barbershop, in the
Arab district in Jaffa (1929).

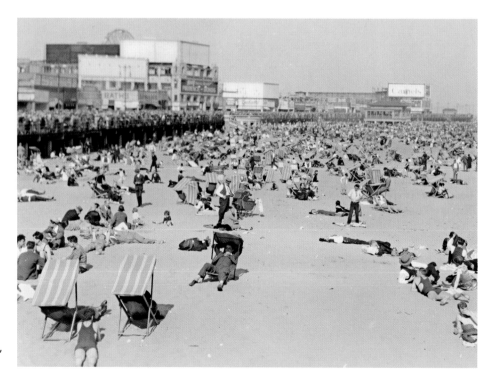

A crowded day at the
beach, at Coney Island,
Brooklyn (1930).

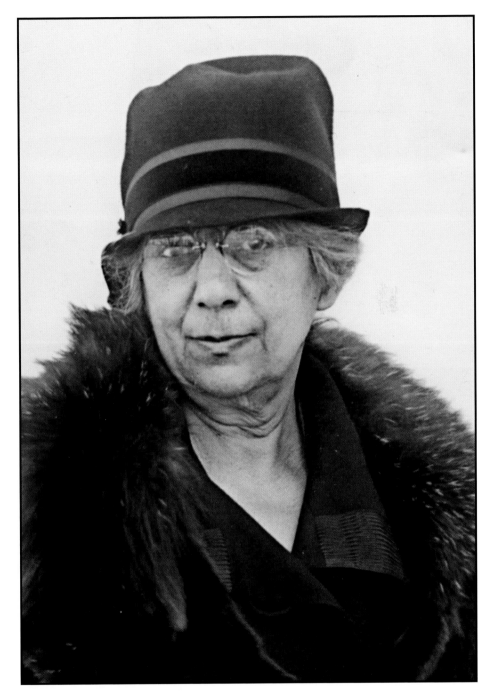

Henrietta Szold, the
famed activist and
president of Hadassah,
the Women's Zionist
Organization of America.

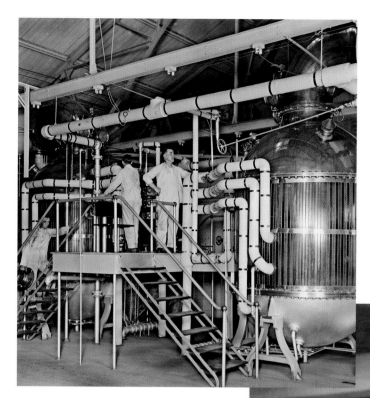

Glass-lined milk tanks and boilers for pasteurizing milk.

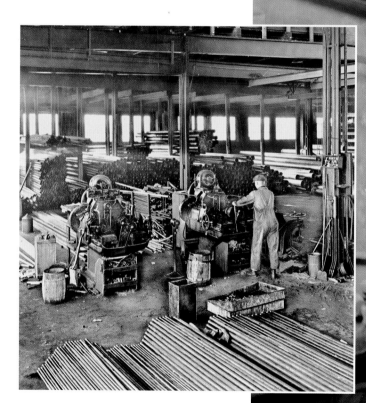

A man works the pipe-handling machinery in an industrial pipe factory.

Israel Rokeach, founder of the eponymous kosher food company.

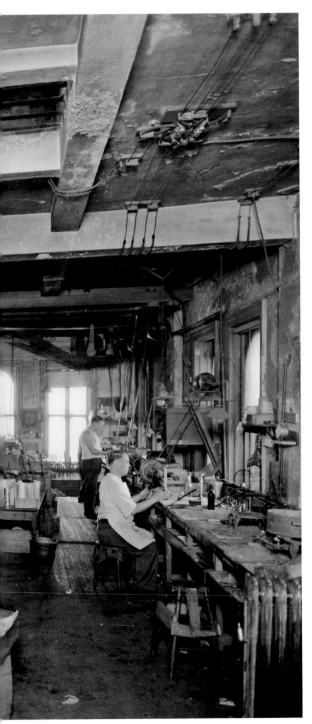

Candlestick makers working in the factory of the Royal Silver Company.

The entrance to Seagate, a
community of single-family
houses near Coney Island
in Brooklyn.

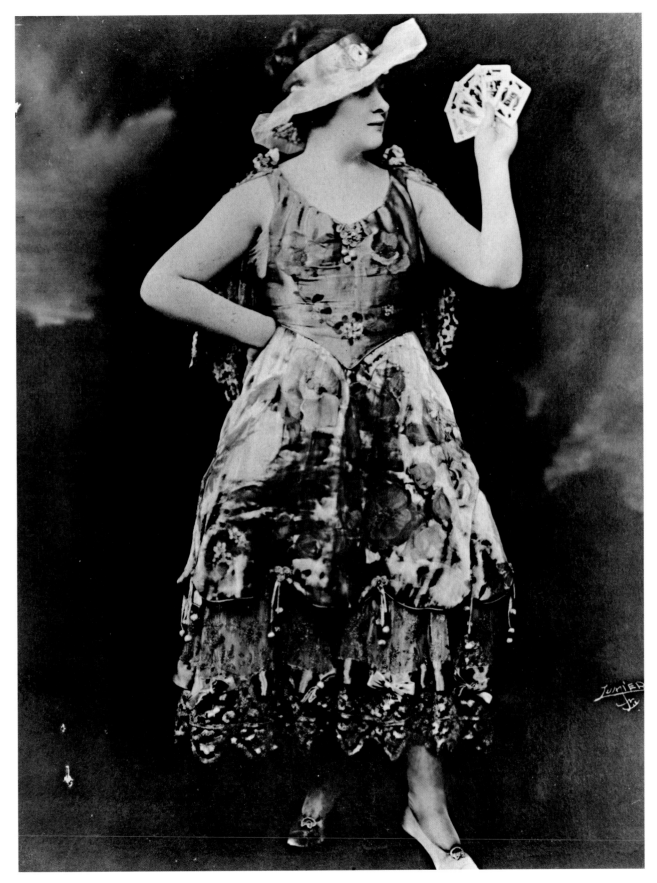

Sophie Tucker, the
legendary "Last of the Red
Hot Mamas," showing off
her hand of cards.

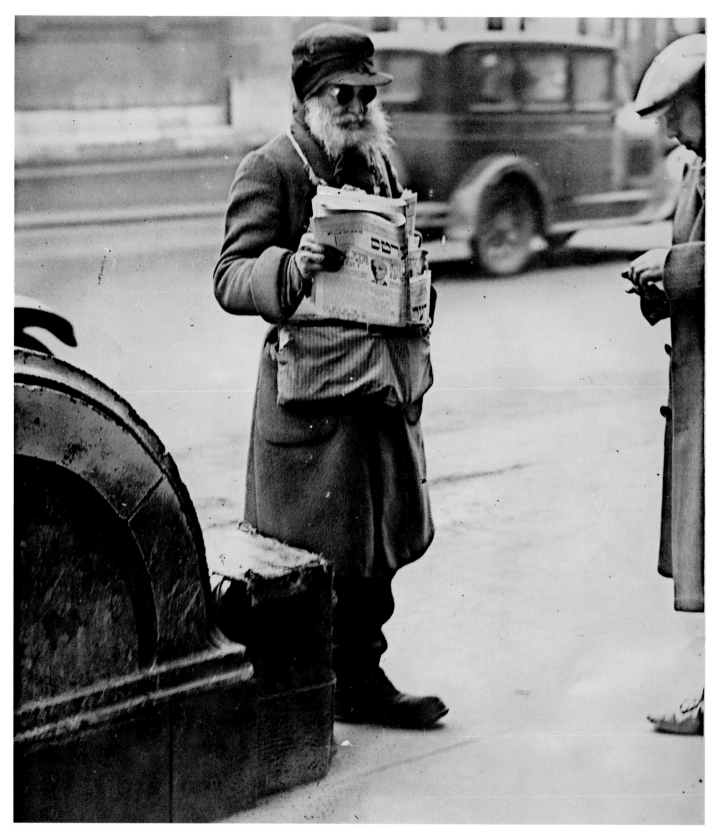

Selling the *Forverts*: not
just for newsboys.

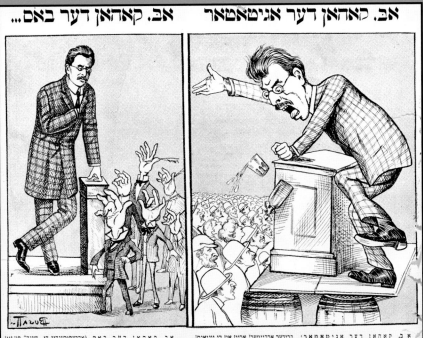

אב. קאהאן דער אגיטאטאר אב. קאהאן דער באס...

אב. קאהאן דער אגיטאטאר: ברודער ארבייטער! אריין אין די יוניאנס!
דורך דער יוניאן און מיט דער יוניאן קענט איהר פערבעספערען אייער טרוועריגע
צוניהר מיט סתעמאריי! וען די באסעם וועלען אייך פערדריינע די ציין מיט זיסע
שאטע קריגען די בעהאנדלונג, איך וועל זיין צו אייך גוט ווי אן אייגע
שפרעכונגען, אז זיי וועלען אייך גליקליך מאכען, אויב איהר וועם ניט אריין אין דער יוניאן
גער מאטע, נור למען השם, געהמ גים אריין אין דער שרייבער־יוניאן!...

By the 1920s the *Forverts* was not merely an observer of the growing labor movement; it was a prominent player. A cartoon in a rival newspaper portrays Abe Cahan in conflicting roles as "newspaper boss" (left) and "labor agitator" (right).

Group portrait of the judges and managers of the Jewish Court of Arbitration.

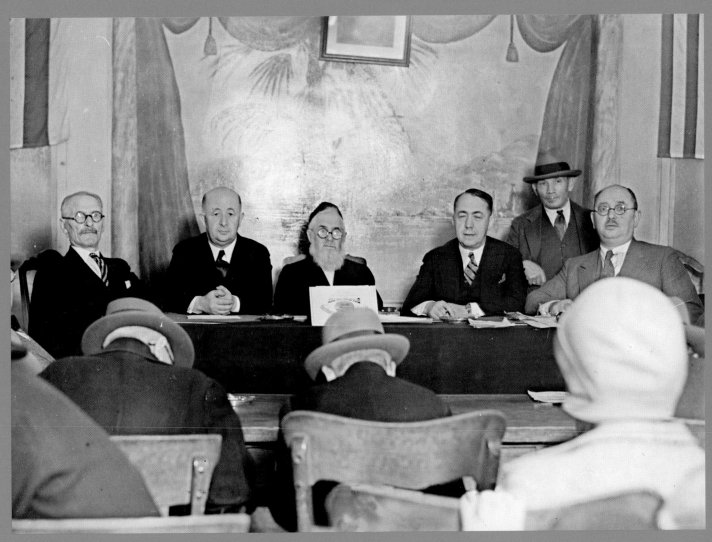

From a feature on young Talmudists.

The writer Israel Joshua
Singer, who brought his
brother Isaac Bashevis
Singer to join him on the
Forverts staff.

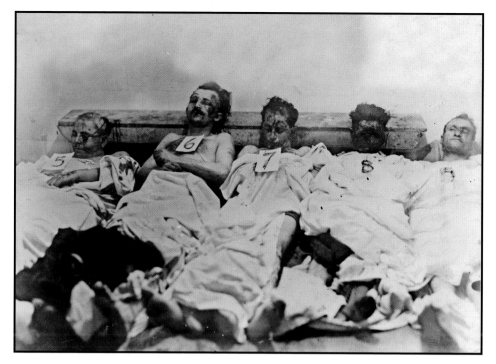

Riots in Palestine: five
dead bodies on stretchers,
their faces mutilated.

Violence in Armenia:
orphaned children
organized into a map of
Armenia, in an effort to
gain publicity for the Near
Eastern Relief Agency
after the 1915 genocide.

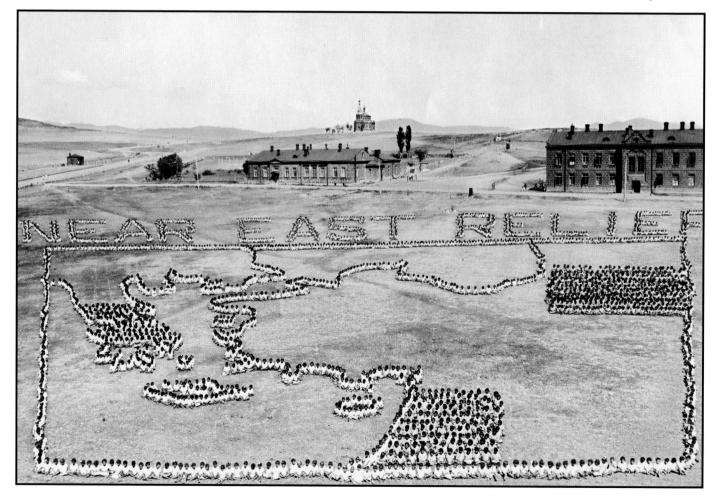

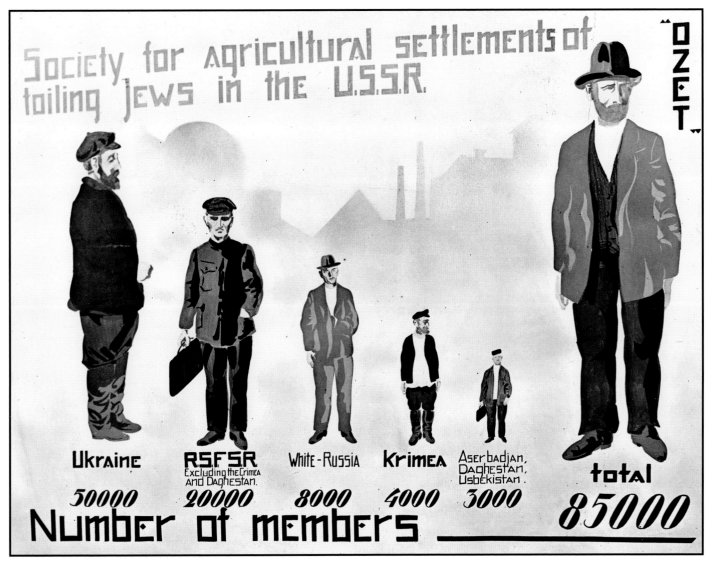

An early Soviet poster
depicting the agricultural
settlement of Soviet Jews
throughout the USSR.

A corner of Belmont
Avenue, Brownsville,
Brooklyn.

The writer Henry Roth,
whose immigrant novel
Call It Sleep was
published in 1934.

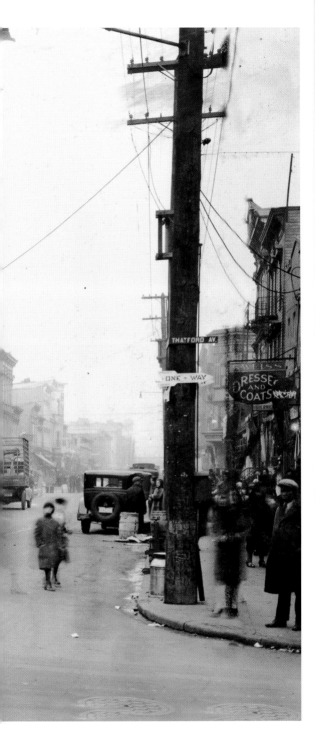

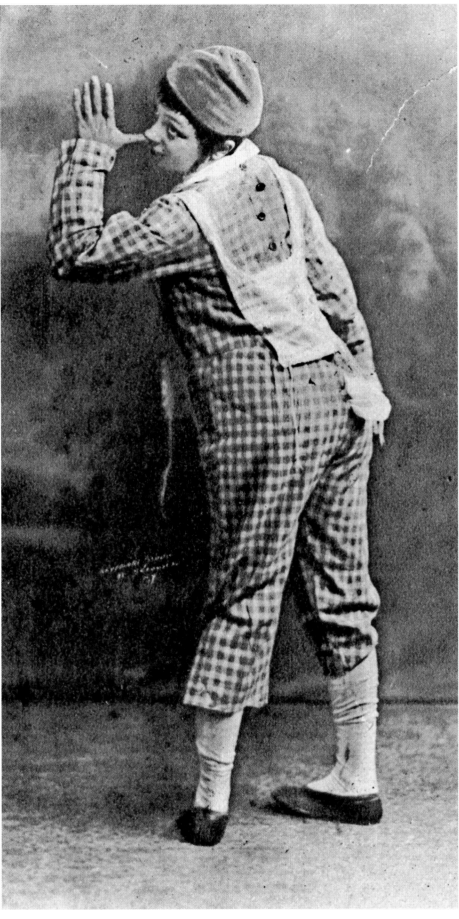

The darling of the Yiddish
stage, actress Molly Picon,
posing in drag for her play
Shmendrik.

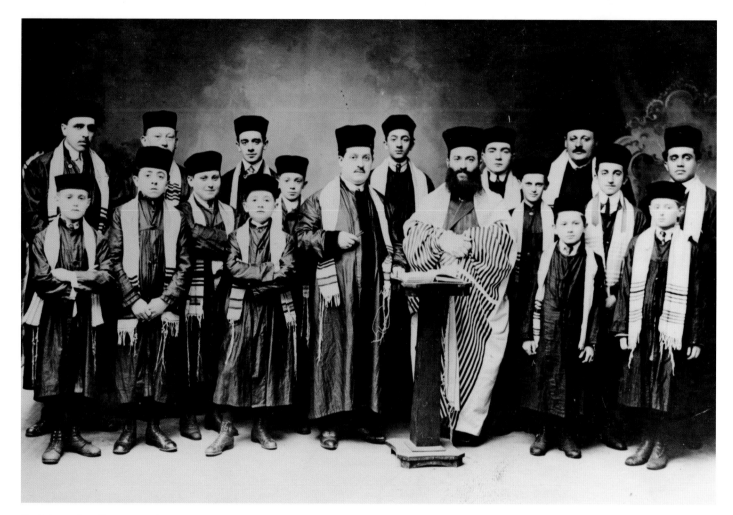

The internationally renowned cantor Yossele Rosenblatt (bearded). Enormously popular both in the pulpit and on the concert stage, he turned down Warner Brothers' offer of a hundred thousand dollars to play Al Jolson's father in *The Jazz Singer* because he believed it would demean his sacred calling. Nevertheless, he agreed to play a small part as himself, singing a Yiddish art song, for which he received star billing.

Movie moguls: Louis B. Mayer (below), the founder of Metro-Goldwyn-Mayer Studios, and Marcus Loew, the founder of Loews Theatres and Mayer's partner in MGM.

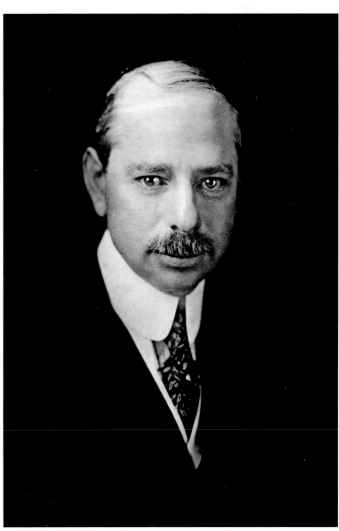

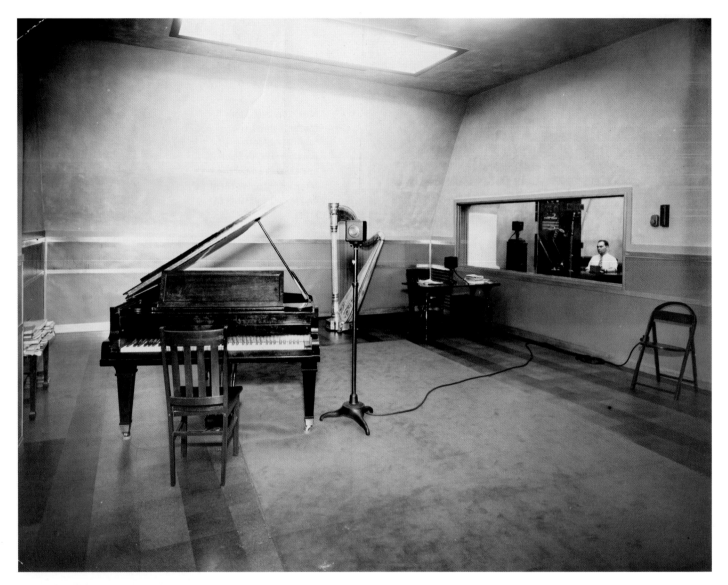

The studio of the *Forverts*'s radio station,
WEVD (its call letters stood for Eugene
V. Debs). The station, which featured
programming in Yiddish, quickly acquired
a wide audience and a famous slogan:
"The station that speaks your language."

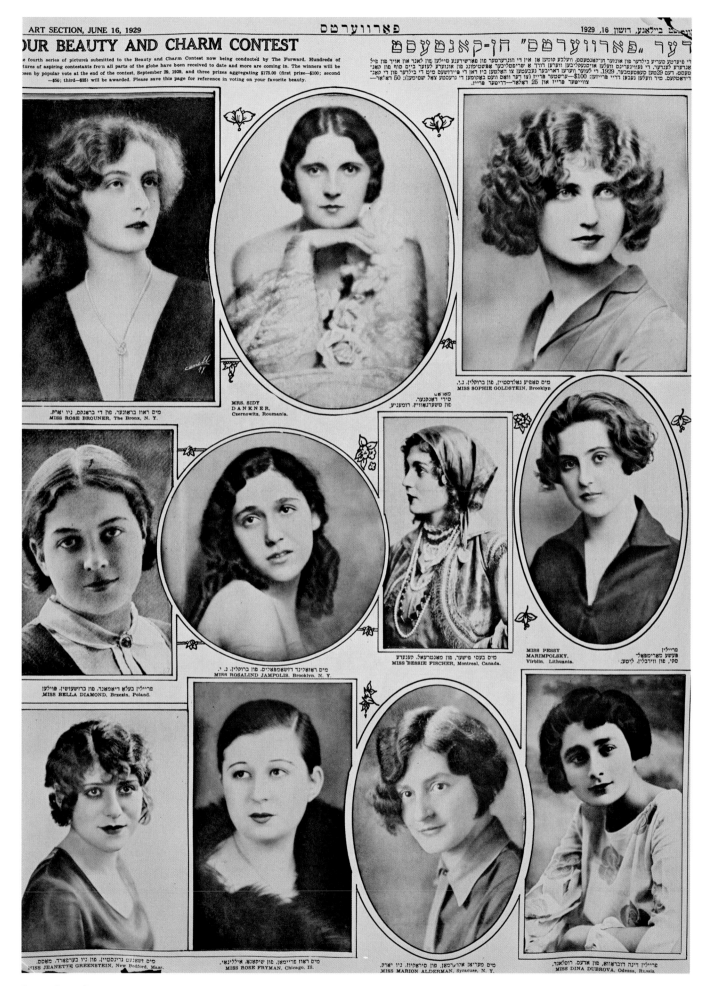

UR BEAUTY AND CHARM CONTEST

e fourth series of pictures submitted to the Beauty and Charm Contest now being conducted by The Forward. Hundreds of tures of aspiring contestants from all parts of the globe have been received to date and more are coming in. The winners will be een by popular vote at the end of the contest, September 29, 1929, and three prizes aggregating $175.00 (first prize—$100; second —$50; third—$25) will be awarded. Please save this page for reference in voting on your favorite beauty.

פֿאָרווערטס

דער "פֿאָרווערטס" חן-קאָנטעסט

1929 ,16 ,דזשון

מיס ראָח בראָונער, פֿון די בראָנקס, ניו יאָרק.
MISS ROSE BROUNER, The Bronx, N. Y.

MRS. SIDY DANKNER,
Czernowitz, Roumania.

מאָר.
סידי דאַנקנער,
פֿון טשערנאָוויץ, רומעניע.

מיס סאָפֿיע גאָלדסטיין, פֿון ברוקלין, נ. י.
MISS SOPHIE GOLDSTEIN, Brooklyn

פֿריילין בעלא דיאמאנד, פֿון בזשעזשין, פוילען.
MISS BELLA DIAMOND, Brzezin, Poland.

מיס ראָזאַלינד דזשאַמפּאָליס, פֿון ברוקלין, נ. י.
MISS ROSALIND JAMPOLIS, Brooklyn, N. Y.

מיס בעסי פֿישער, פֿון מאָנטרעאַל, קענעדע
MISS BESSIE FISCHER, Montreal, Canada.

פֿריילין
פּעסי מאַרימפּאָלסקי,
סקי, פֿון ווירבלין, ליטע.

MISS PESSY MARIMPOLSKY,
Virblin, Lithuania.

מיס זשאַנעט גרינסטיין, פֿון ניו בעדפֿאָרד, מאַס.
MISS JEANETTE GREENSTEIN, New Bedford, Mass.

מיס ראָוז פֿרײַמאַן, פֿון שיקאַגאָ, אילליני.
MISS ROSE FRYMAN, Chicago, Ill.

מיס מעריאָן אַלדערמאַן, פֿון סיראַקיוז, ניו יאָרק.
MISS MARION ALDERMAN, Syracuse, N. Y.

פֿריילין דינה דובראָוואַ, פֿון אדעס, רוסלאַנד.
MISS DINA DUBROVA, Odessa, Russia

A page from the rotogravure.

The actor Victor Chenkin
demonstrating types of
"Jewish gesticulation" for
use in the theater.

YIDDISH THEATER

Caraid O'Brien

MUCH LIKE THE Broadway theater district in Times Square today, New York's Lower East Side had an entertainment district of its own, all in Yiddish, that thrilled its audiences and captivated admirers around the world. Its glitter lit up lower Second Avenue and the surrounding streets for decades, from the late nineteenth century until World War II, when, to paraphrase the film director Joseph Green, six million of its best customers were murdered in the Holocaust. In its heyday in the teens, twenties, and thirties, there were six Broadway-size houses on Second Avenue and the Bowery, roof garden theaters, and vaudeville houses on Clinton Street as well as theaters in Brooklyn and the Bronx. And that was just New York. Philadelphia, Boston, Chicago, Detroit, and Montreal were major stops in North America, not to mention Europe, South America, and Africa.

As vast as it was in its international reach, the Yiddish theater was varied in the types of entertainment it encompassed. Thousands of plays and musicals were written in Yiddish, reflecting a wide diversity of theatrical styles, from German-style operettas with epic story lines pulled from the Bible to nonlinear experimental avant-garde. The Yiddish theatrical community in New York alone had three literary art theaters, two political workers' theaters, two acting schools, a marionette theater, many musical companies, and at least five theatrical journals and newspapers.

From its beginnings in the Jewish

Bessie Thomashefsky (above) and Boris Thomashefsky (right), one of Yiddish theater's royal couples.

A play in progress: *The Travel of Binyomen the Third.*

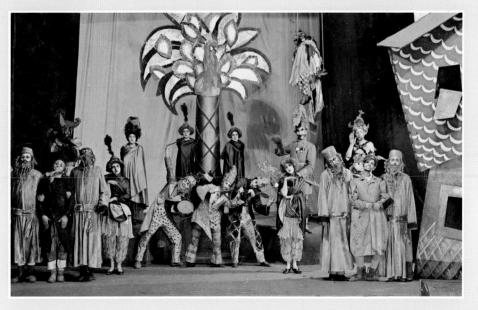

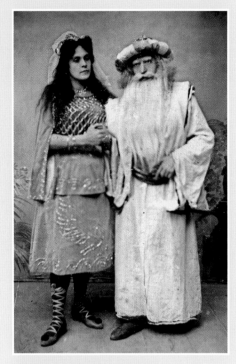

Esther Rachel Kaminska (left), onstage with Leyb Shtrasfogel, in a production of *Bar Kochba*.

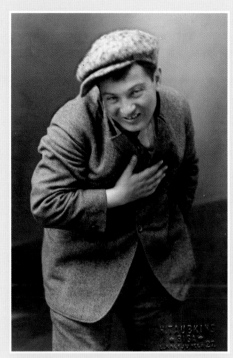

The actor David Vardi.

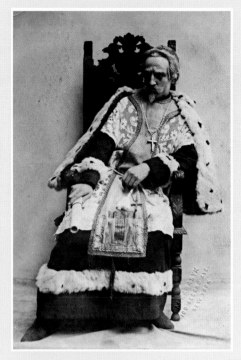

Maurice Schwartz as the Cardinal in *Zhidovka* at Glickman's Palace Theatre, Chicago.

Enlightenment, Yiddish theater was nearly inseparable from its messages of social progress. Its founding father, the Romanian-born playwright Abraham Goldfaden, wrote comedies mocking arranged marriages. Later generations of Yiddish musicals dealt unflinchingly with such social issues as drug abuse, abortion, and abandonment, issues not seriously explored by the escapist melodramas and romances, like *The Count of Monte Cristo*, that were popular on Broadway at the time. In the late 1800s the Russian socialist playwright Jacob Gordin teamed up with the actor-producer Jacob P. Adler to create a serious literary theater, moving away from melodrama, improvisation, and musicals. Their first collaboration, *Siberia*, exposed the horrors of imprisonment.

The competing theaters on Second Avenue were driven by a star system. Each had a leading actor who was not only a performer but usually the director and producer as well. The biggest stars performed in dozens of different productions a year, though they were

often identified by a particular role they reprised throughout their careers. Boris Thomashefsky, who produced Yiddish theater in America as early as 1882, was known for *The Yeshiva Boy*, also known as *The Yiddish Hamlet*. His wife, the comedienne Bessie Thomashefsky, often played an impish servant girl. Zelig Mogulesco created the comic archetype of the clumsy ne'er-do-well, reprised for later generations by Jerry Lewis. The elegant Bertha Kalich was admired as a great dramatic actress, as was Jacob P. Adler's wife, Sara Adler, who continued to perform while in a wheelchair. The irrepressible Molly Picon first burst on the scene as a cross-dressing yeshiva student. Doe-eyed Jennie Goldstein was the queen of melodrama. Herman Yablokoff, the clown; Pesach Burstyn, the whistler. Malvina Lobel was admired for her mysterious performance as Madame X; Keni Liptzin as the tough-minded businesswoman Mirele

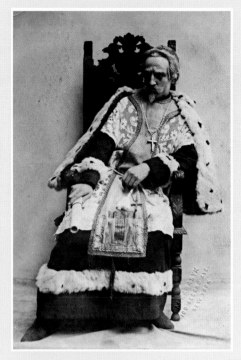

The actress Pepi Littmann, dressed in men's clothes for the play *Griner Bokher*.

The actor Abraham Morevsky.

The actress Leah Rosen in *The Chalk Circle*.

The actress Fanny Lubritsky, dressed as a Hasidic boy.

produced thirty-five different shows, including Yiddish translations of Wilde, Shaw, Ibsen, and Strindberg as well as original works by Peretz Hirschbein, Osip Dimov, and Sholom Aleichem. Among the original fourteen-member company were Celia Adler, Jacob Ben Ami, and Ludwig Satz. The next season Ben Ami left to start his own competing company and was replaced by Muni Weisenfreund (future Academy Award winner Paul Muni).

Constantly on the pulse of innovative world drama, Schwartz presented *The Dybbuk* in 1921, a year after its Vilna Troupe premiere in Warsaw. He brought two of its actors, Joseph Buloff and Luba Kadison, over from Europe after hearing about Buloff's dreamlike direction of the folktale *Yoskhe Musikant*. It wasn't until the 1930s that Schwartz had his greatest successes, however, with his adaptations of Yiddish novels. Most famous among them, his retelling of I. J. Singer's *Yoshe Kalb*, an epic drama set among the Hasidim in Poland, showcased a cast of sixty-two, ran for two years, toured Europe, and played Broadway in English. Schwartz also successfully adapted I. J. Singer's *The Brothers Ashkenazi* and several novels by Sholem Asch.

The last continuous season of the Yiddish Art Theater was in 1950, although Schwartz made several attempts to revive it in the decade that followed, including a performance in California of *It's Hard to Be a Jew*, starring Leonard Nimoy. Schwartz died in Israel in 1960, while struggling to produce Yiddish theater there. Although a handful of stars continued to produce shows on Second Avenue and later uptown, without Schwartz the landscape of the Yiddish theater was never the same.

Efros. As for the Romanian Yiddish skat singer Aaron Lebedev, it didn't matter what role he played as long as he sang—inspiring, among others, Danny Kaye.

One performer, however, is remembered not just for the roles he created but for the type of theater he championed. The actor Maurice Schwartz, after several years working with the great tragedian David Kessler, left to create a repertory company inspired by the critically acclaimed Moscow Art Theater. His inaugural season at the Irving Place Theater in 1918

Youth organization leader
Yacoub Effendi Ghussein.

**AN EARLY SERIES FEATURED
IMPORTANT REPRESENTATIVES
OF THE PALESTINIAN ARAB
COMMUNITY.**

Reform Party
representative Ishac
Effendi Budeiri.

National Defense Party
representative Ragheb Bey
Nashashibi.

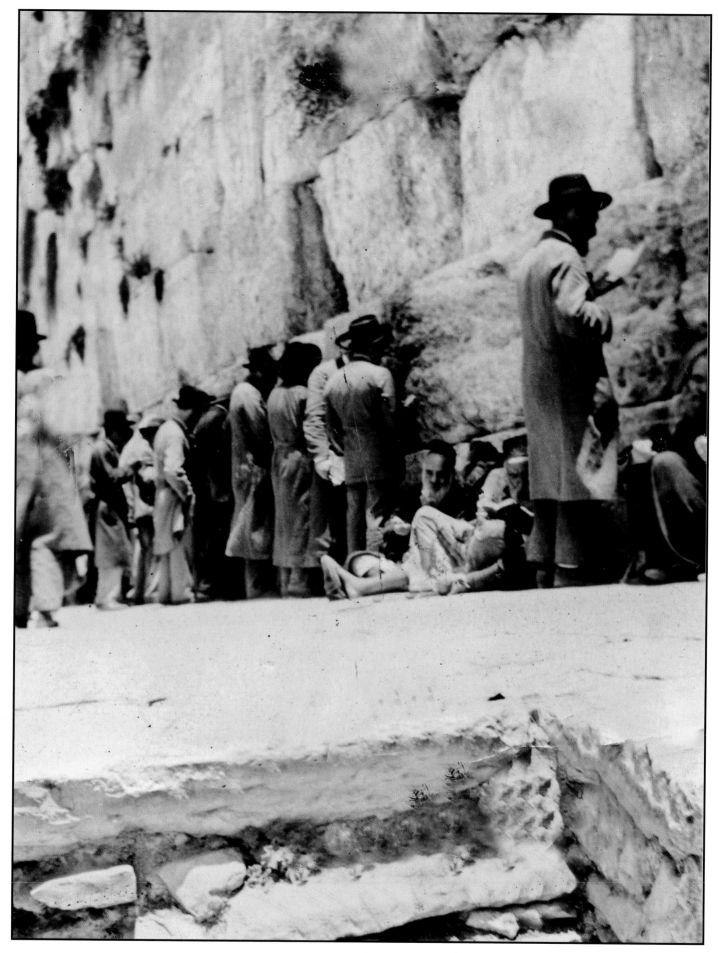

Prayer at the Western
Wall, Jerusalem.

The portrait artist Elias Grossman, who worked with the *Forverts*, sketching none other than Benito Mussolini. After his etching of Mussolini was published in the *New York Herald Tribune* to illustrate an articled titled "What Price Mussolini?" Grossman was forced to flee Italy.

The sculptor Carl J. Longuet
holding a bust he made of
his great-grandfather Karl
Marx, at an exhibition in
Paris in 1933.

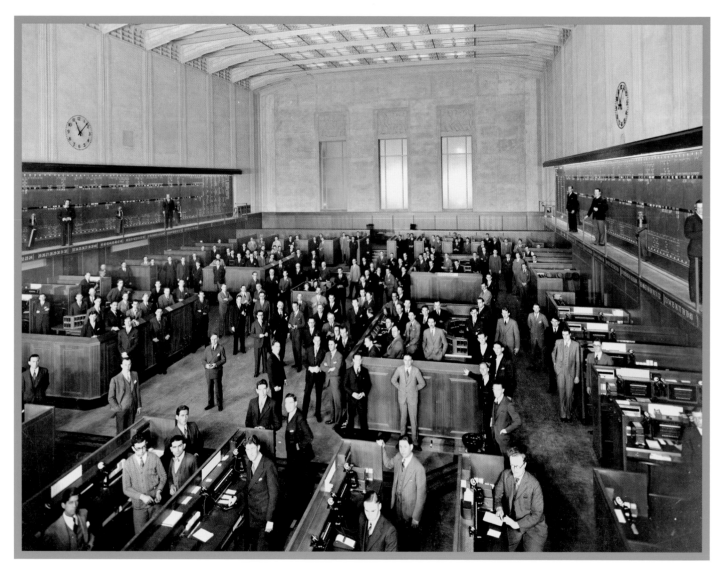

The San Francisco Stock
Exchange.

IN 1935, AS PART OF THE NEW DEAL, THE WORKS PROGRESS ADMINISTRATION WAS FOUNDED TO PROVIDE INCOME TO THOSE UNEMPLOYED DURING THE GREAT DEPRESSION, INCLUDING THROUGH JOBS IN THE ARTS.

A young woman crafting pieces of jewelry from metal (1938).

Art students working at their easels in a painting class (1938).

Stella Adler (above), who later became one of the country's most prominent acting teachers, training, among others, Marlon Brando. Adler came from a family of actors, including her father and sister Celia (right).

צילי אדלער פרוי
די אינפּאַקטע פרוי

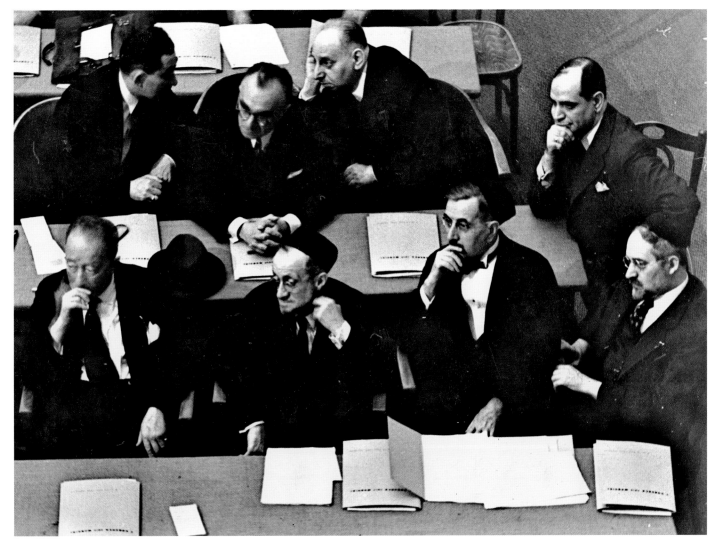

American delegates to the
World Jewish Congress, in
a photograph taken by
Erich Salomon.

It was said that the young grew up fast on the East Side.

The Warschauer Haym Salomon Home for Aged, St. Mark's Place, off Second Avenue (1938).

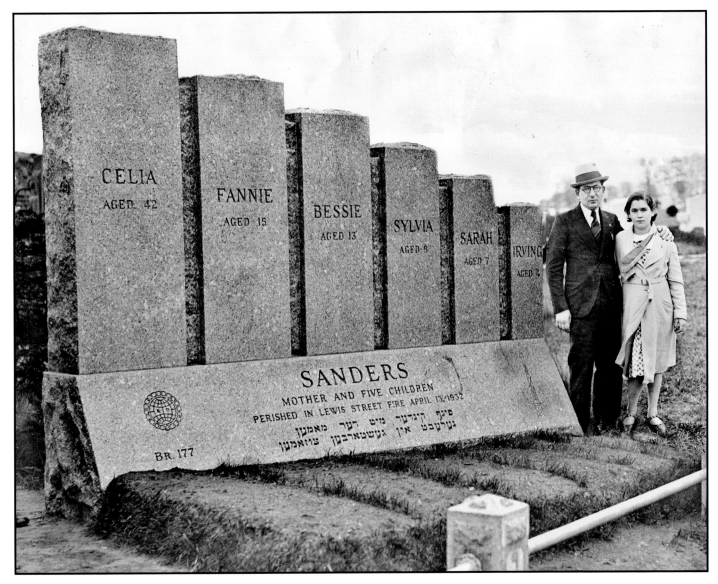

The gravestones are inscribed:

CELIA AGED 42

FANNIE AGED 15

BESSIE AGED 13

SYLVIA AGED 9

SARAH AGED 7

IRVING AGED 3

SANDERS
MOTHER AND FIVE CHILDREN
PERISHED IN LEWIS STREET FIRE APRIL 13, 1932

פינף קינדער מיט דער מאמען
געלעבט אין געטשבארבען צוזאמען

BR. 177

Abraham Sanders and his daughter Esther, sole survivors of a fire on Lewis Street, standing beside the memorial to their family in Mount Lebanon Cemetery.

Emma Goldman (right) and
a relative during a trip to
Canada (January 1934).

Socialist leaders visiting Native American reservations, with the hopes of teaching the tribes about socialism.

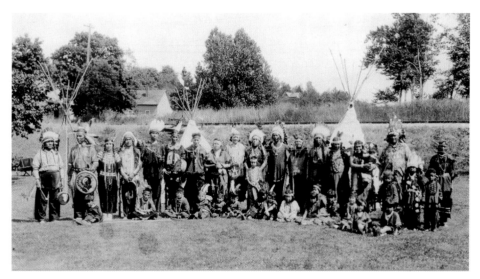

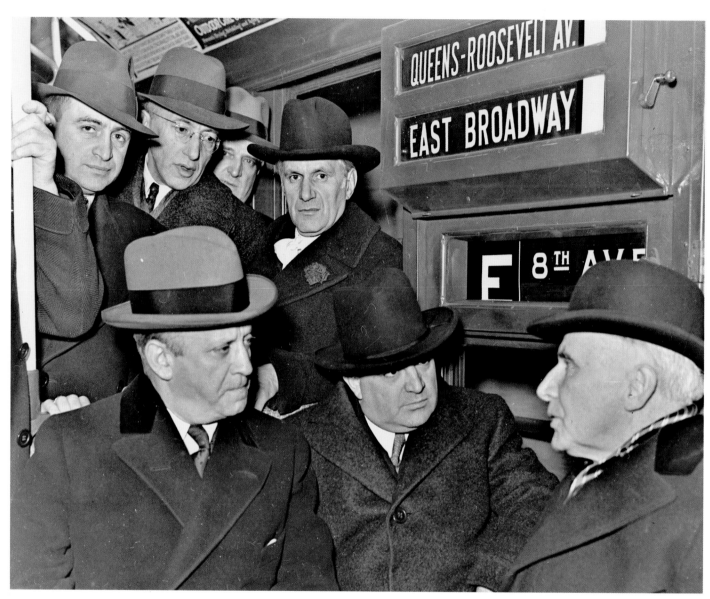

The *Forverts* general manager B. Charney Vladeck (standing, second from left) and others join Mayor Fiorello La Guardia (seated center) for a ride on the E train.

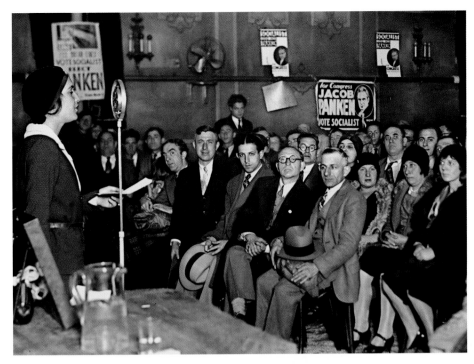

Hermione Panken, the eighteen-year-old daughter of Judge Jacob Panken, addresses a crowd at the "youth rally" meeting in the Stuyvesant Casino on a Sunday afternoon. Panken was a Socialist Party candidate for mayor in 1921.

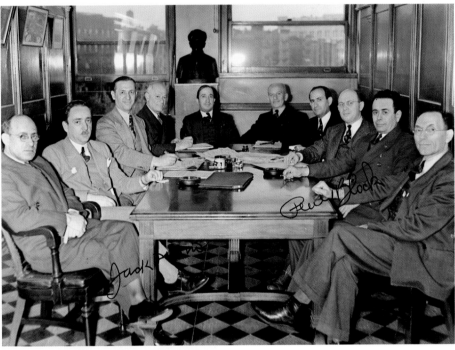

The board of directors of the *Forverts*.

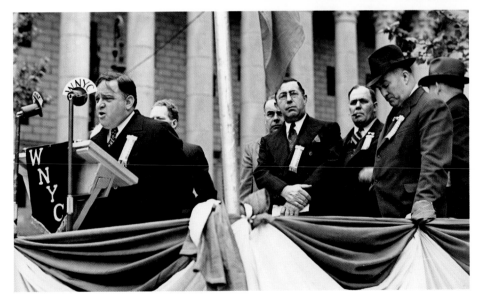

Mayor La Guardia addressing the Union Label Parade in Foley Square.

Norman Raeben, a well-known painter and the son of Yiddish writer Sholom Aleichem. Raeben was Bob Dylan's art teacher in the 1970s and was said to have inspired the song "Tangled Up in Blue."

Countess Alexandra Tolstoy, human rights advocate and the youngest daughter of the novelist Leo Tolstoy, on the upstate New York farm where she settled after fleeing the Soviet Union in 1929.

Standing guard on the steps of a church in war-torn Spain.

Headquarters of Sidney Hillman's Amalgamated Clothing Workers of America at Union Square.

The Coney Island boxer
Herbie Kronowitz.

A junior class at Yeshiva
College in New York City.

The 1931 Paterson, New Jersey, silk strike. Leading the strikers in their picket line, right to left: William Russell, Reverend Bradford Young, Mary McDowell of the teachers' union, Rob Lyttle of the *New Republic*, and Louis Budenz.

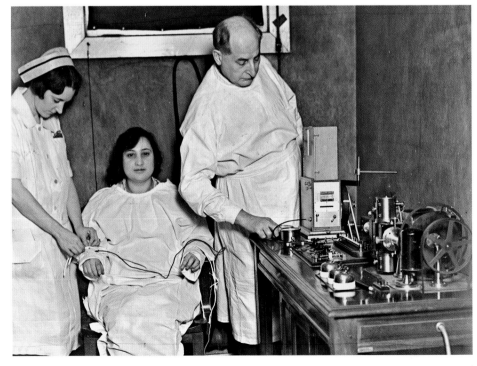

At the Union Health Center, nurse Alice P. Mahon, Lillian Beck, and Dr. I. Barstok, shown using the "cardiac" machine.

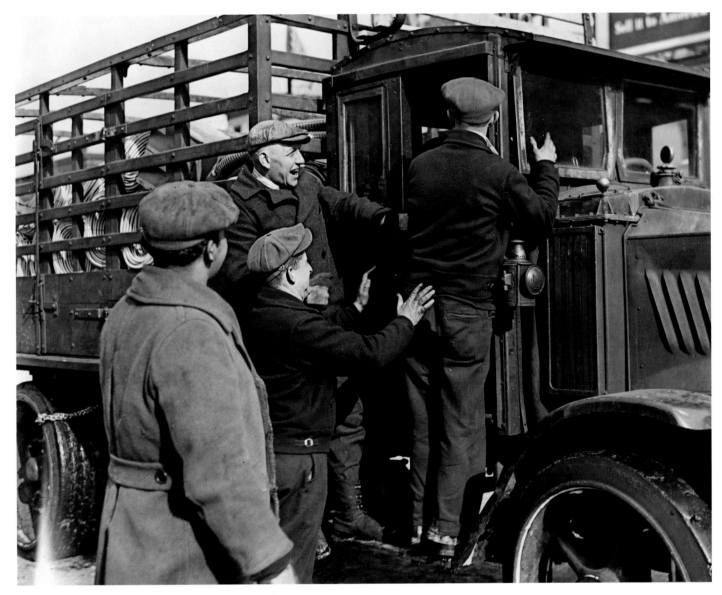

Members of the teamsters'
union stop a nonunion
truck in a one-day protest
(1935).

The fifty-ninth session of
the Council of the League
of Nations, in Geneva (May
1930).

An armed man on guard at a meeting of young pioneers in Palestine (1938).

Soldiers and civilians proudly displaying the Zionist flag while accompanying a truck from the beach into the port of Tel Aviv.

Young pioneers in Palestine (1938).

A group of children at a celebration of Tu b'Shvat in Palestine (1939).

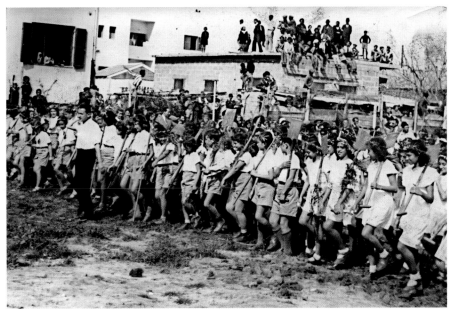

Yiddish sign for buses to Monticello from the Lower East Side.

Reveille at Camp Vakames, a *Forverts*-sponsored precursor to the Fresh Air Fund summer camps for children.

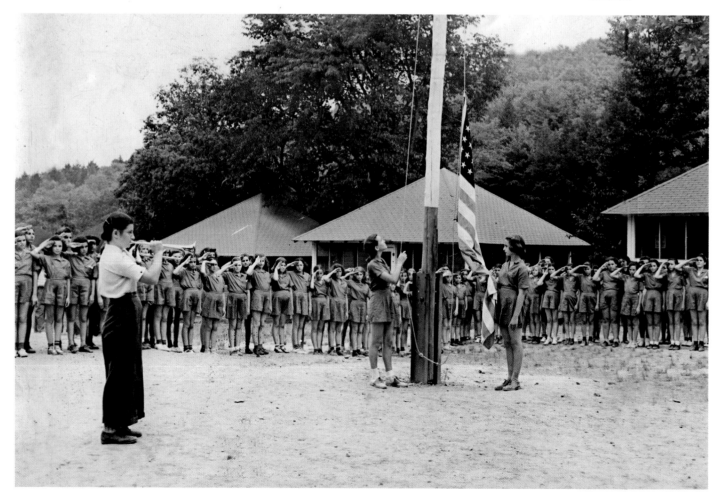

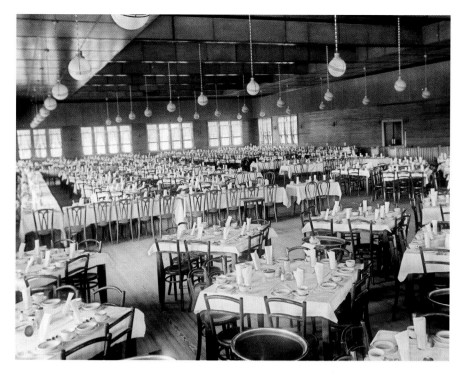

CAMP KINDER RING,
SPONSORED BY THE
WORKMEN'S CIRCLE
(1932).

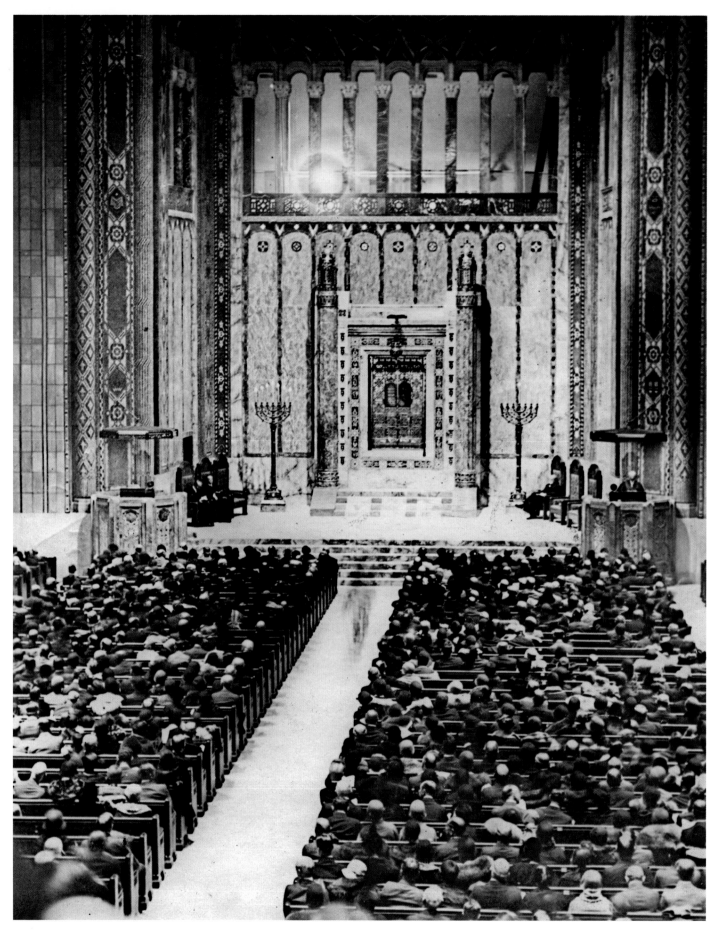

Rosh Hashanah services at
the new Temple Emanu-El,
on Fifth Avenue at Sixty-
fifth Street, New York City.

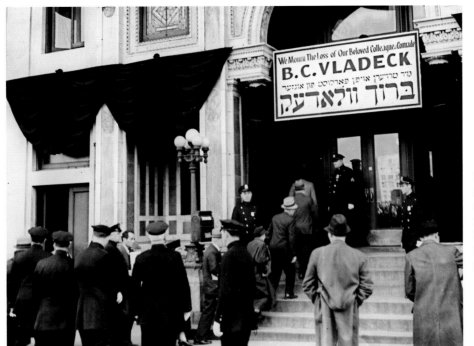

It was customary for the Forward Association to hold funerals for its members in the historic building on East Broadway.

Mourners entering the Forward Building on the Lower East Side for the 1938 funeral of Baruch Charney Vladeck, Socialist Party leader and *Forverts* general manager.

The funeral procession for B. C. Vladeck, along East Houston Street at First Avenue, en route to the Forward Building.

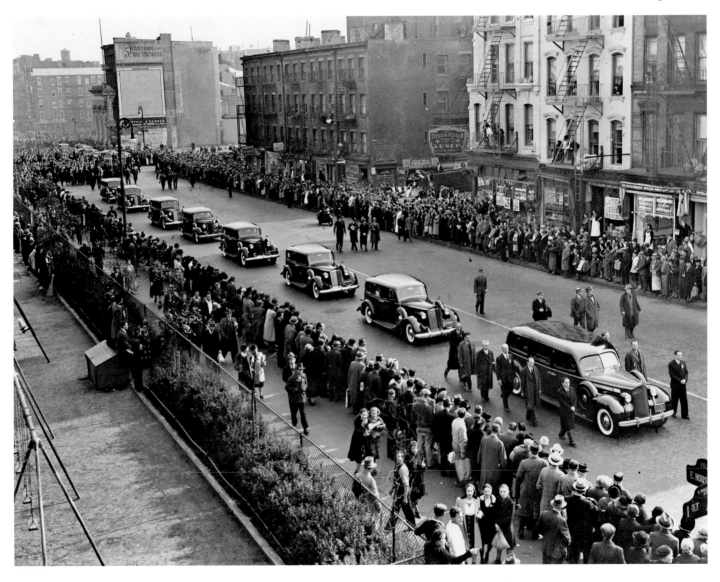

Soloman Levitan, the state treasurer of Wisconsin, with his granddaughter Shirley Gertrude Goldstine, Madison, Wisconsin (1932).

A weekday minyan at the Wall Street Synagogue.

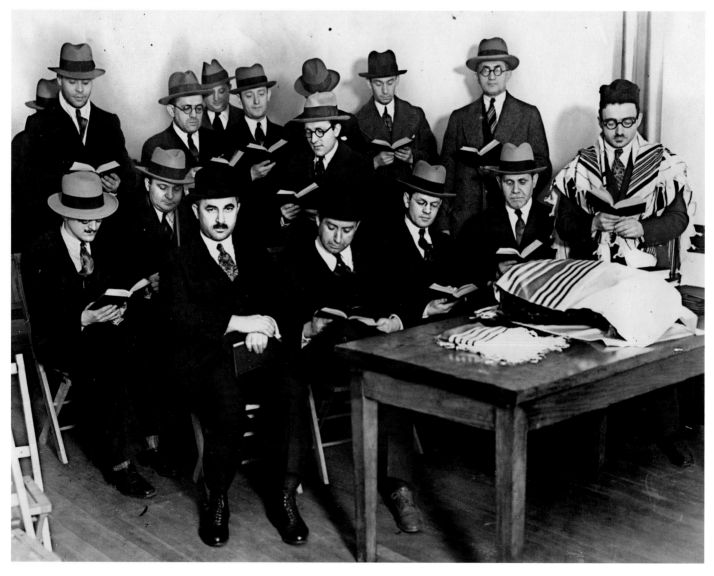

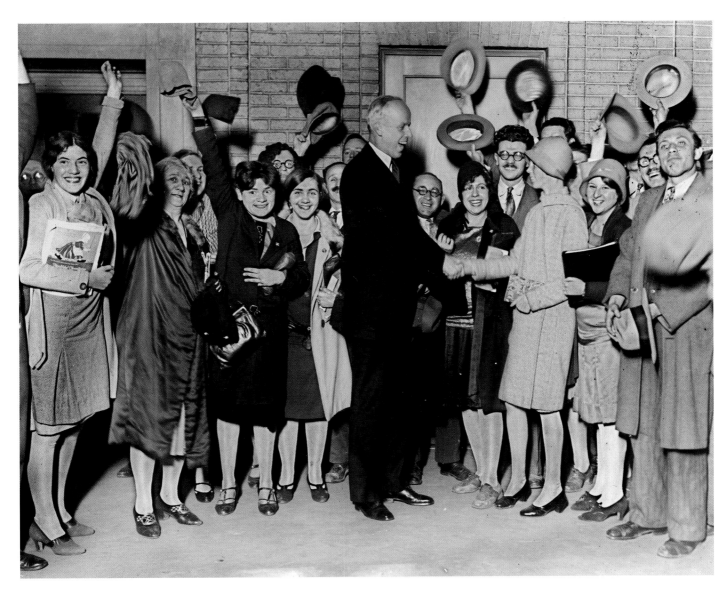

The Socialist Party leader
and six-time presidential
candidate Norman
Thomas shaking hands
with a jubilant crowd.

Samuel Baron, a resident of the Home of the Daughters of Jacob, in the Bronx, getting a birthday cake with 106 candles, from the president of the home, Max Weinstein.

People lining up in the main hall of the old Forward Building to get vaccinated for smallpox, a service offered by the Workmen's Circle.

Adrian, the famed fashion designer for Metro-Goldwyn-Mayer, sketching a design for a new production (1934).

The Viennese Jewish composer Oscar Straus, who worked in Hollywood after the Anschluss, with his wife and his dog.

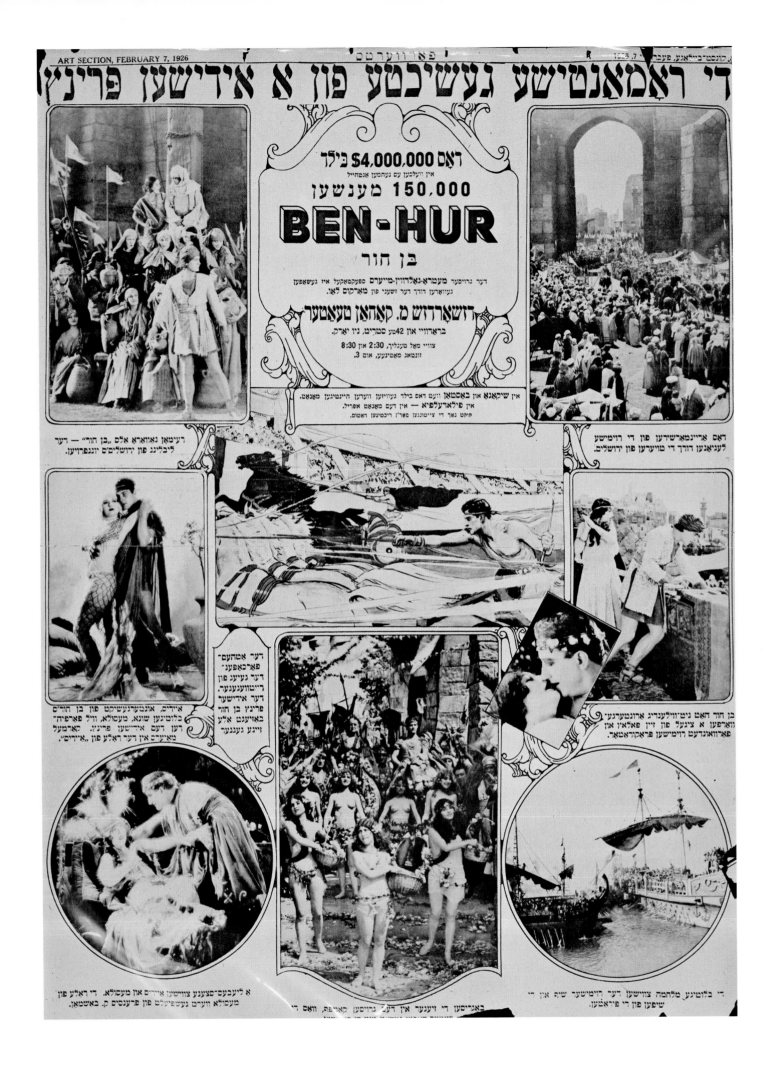

Forward

| Art Section |
| MARCH 28, 1926 |
| SECTION 3 |

פֿאָרווערטס

Forward

קונסט ביילאַגע

מאַרטש 28, 1926

SECTION 3

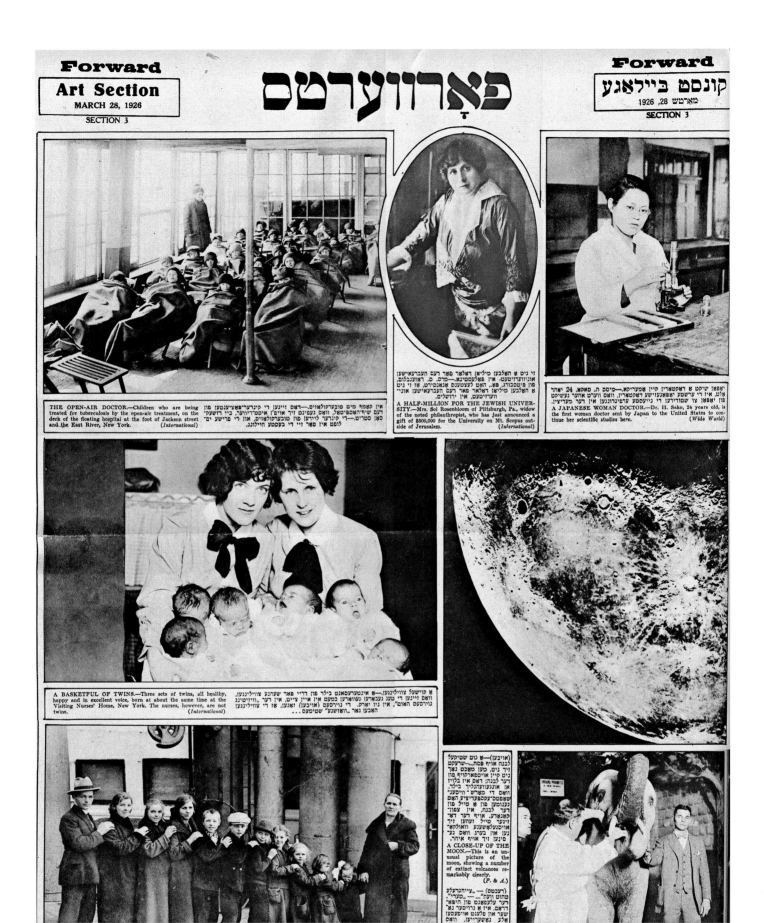

זי ניט אַ האַלבען מיליאָן דאָלאַר פֿאַר דער העברעאישער
אוניווערזיטעט אין פֿאַלעסטינע.—מרס. ס. ראָזענבלום,
פֿון פּיטסבורג, פּאַ., האָט לעצטענס אַנאַנסירט, אַז זי גיט
אַ האַלבען מיליאָן דאָלאַר פֿאַר דעם העברעאישען אוני־
ווערזיטעט, אויף צלום סקאָפּוס, אין ירושלים.

A HALF-MILLION FOR THE JEWISH UNIVERSITY.—Mrs. Sol Rosenbloom of Pittsburgh, Pa., widow of the noted philanthropist, who has just announced a gift of $500,000 for the University on Mt. Scopus outside of Jerusalem. (International)

יאַפּאַן שיקט אַ דאָקטאָרין קיין אַמעריקא.—מיסס ה. סאַקאָ, 24 יאָהר
אַלט, איז די ערשטע יאַפּאַנעזישע דאָקטאָרין, וואָס ווערט אַהער געשיקט
פֿון יאַפּאַן צו שטודירען די נויטיגסטע ערפֿאַרונגען אין דער מעדיצין.

A JAPANESE WOMAN DOCTOR.—Dr. H. Sako, 24 years old, is the first woman doctor sent by Japan to the United States to continue her scientific studies here. (Wide World)

אין קאַמף מיט טובערקולאָזיס.—דאָס זיינען די קינדער־פּאַציענטען פֿון
דעם שיף־האָספּיטאַל, וואָס נעמען זיך אויבן"ס איטסקררוואָר, ביי דישׁעף
אַ האַלבען מיליאָן דאָלאַר פֿאַר דעם העברעאישער אוני־

THE OPEN-AIR DOCTOR.—Children who are being treated for tuberculosis by the open-air treatment, on the deck of the floating hospital at the foot of Jackson street and the East River, New York. (International)

אַ קוישעל צווילינגען.—אַ אינטערעסאַנט בילד פֿון דריי פֿאַר שעהנע צווילינגען,
וואָס זיינען די טעג געבאָרען געוואָרען כמעט אין איין ציים, אין דער "וויזיטינג
נוירסעס האָם", אין ניו יאָרק. די נוירסעם (אויבען) זאַגען, אַז די צווילינגען
האָבען גאָר "וואָושנע" שטימעס...

A BASKETFUL OF TWINS.—Three sets of twins, all healthy, happy and in excellent voice, born at about the same time at the Visiting Nurses' Home, New York. The nurses, however, are not twins. (International)

(אויבען)—אַ גוט שטיקעל
לבנה אויף פֿאַך.—שיערעט
זיך ניט, מען מאַכט נאָך
ניט קיין אויטאָמאָביל פֿון
דער לבנה, דאָס איז בלויז
אַן אָנגעוועהנליך בילד
וואָס די מאַרש ווינטי
שאָטעס עקספּערימענטס האָט
גענומען פֿון אַ טייל פֿון
דער לבנה, אין צווישן
מאָמענט, אויף דער פֿאַר
קינער מיל נעהמען זיך
אוסגעקלשענע וואַלקאַ־
נען און בערג וואָס גע־
פֿינען זיך אויף איהר.

A CLOSE-UP OF THE MOON.—This is an unusual picture of the moon, showing a number of extinct volcanoes remarkably clearly. (P. & A.)

(רעכטס) — צייהנדעלע
טהוט וועה!... מיסט"
דער עלעפֿאַנט פֿון היפֿא־
ראם, איז אַ גרויסער אַ
שרי און פֿלעגט אויפֿמען
אַלע נאַשבורירעד, וואָס
קינדער פֿלעגעל איהם
ברענגען, נו, האָט ער
געבאַר אַנגעטויבען אַ אַזהו"
שטאַרק ליידען פֿון צאָהן־
וועהטאַק. אַז ער האָט ניט
געקענט עסען און גאָר נימ
געקענט שלאָפֿען, האָט מען
נעבראַכט אַ דענטיסט.

WITHOUT GAS.—Dr. Beretherton of New York is busily engaged in filling a cavity in the tooth of a circus elephant. (International)

ביריעגערטן אַמעריקא...—מרס. אָטאָ זאַהלער (ערשטע, רעכטס), וועלכע
איז די טעג אַנגעקומען אַהער, צו איהר מאַן, האָט בערייכערט אַמעריקא
באָפֿעלקערונג מים עלף מענשען, איהר קינדער.

ONE MORE JOB FOR THE CENSUS TAKER.—Mrs. Otto Zahler, a recent arrival from Berlin, with her 11 children. The names are, (West to East) John, Bertha, Martha, Clara, Herbert, Otto, Jr., Emma, Hans, 'a, Hanna, and Paula. (International)

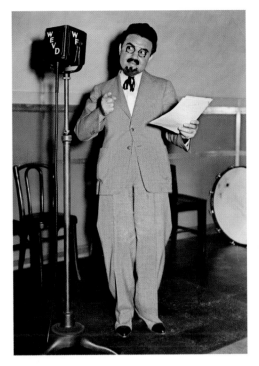

An actor portraying a
rabbi on *Vacation Follies*,
a *Forverts* radio show
(1936).

A performance of a show
based on the Depression,
titled *Before the Crash,
1929.*

ACCORDING TO THE NEW ETHOS, THE
LABOR MOVEMENT WAS A FEATURE NOT
ONLY OF ONE'S PROFESSIONAL LIFE BUT
OF ONE'S PERSONAL LIFE AS WELL, FROM
MAY DAY RALLIES TO UPSTATE RESORTS
AND EVERYDAY FORMS OF
ENTERTAINMENT.

A marching band at a
Union Label Parade in
New York.

A dance group performing at organized labor's May Day celebration, at Randall's Island (1937).

The cast of *Pins and Needles*, the 1937 prolabor musical produced by the ILGWU, outside the Morris Hillquit Memorial Hospital in Los Angeles, after a special performance for patients. (In 1962 the play was adapted for the cinema and starred a young actress named Barbra Streisand.)

DIASPORA LANDSCAPES

Ilan Stavans

WHEN I WAS AN adolescent in Mexico, a wise, impassive teacher at my *yidishe shule* used to tell our class that no matter how decisive we were in the planning of our future, randomness would always play a decisive role in it. "You're Mexican by accident," he would say. "If I had to take a guess, I would say that 85 percent of your grandparents didn't choose to settle in this country. And the country didn't choose them either."

This lesson came back to me as I admired this assemblage of photographs from the archives of the *Jewish Daily Forward*. The photojournalism was recorded during a time of intense instability for Jews. The Pale of Settlement, from Lithuania to Ukraine, was being undermined by sweeping changes: outbursts of xenophobia, rapid urbanization, and a fragile political atmosphere defined by conflicting ideologies. Similarly, the Ottoman Empire, around the Mediterranean Sea, was in bankruptcy and falling to pieces. As a result, Jews were in motion, traveling west to Argentina, the United States, Canada, and elsewhere in the Americas, south to Palestine and South Africa, and east to Australia.

Most people understand the word *diaspora*—from the Greek διασπορά, "a scattering of seeds"—as a curse. For Jews, it has been an incentive. To be in motion is to be allowed opportunities for renewal, to keep the mind in a permanent state of alertness, to see the world entire as a home. An itinerant life is a life worth living.

Our diaspora starts in Genesis 12:1, with Abraham receiving his

An adolescent girl at the Viennese Jewish Institute for the Blind.

The chief rabbi of Cairo, Haim Nahoum Effendi.

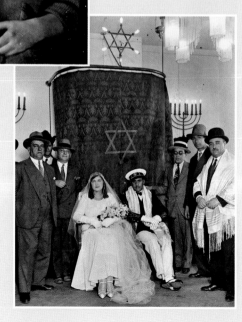

A wedding in a Madrid synagogue.

Leon Feldberg, the editor of the *S. African Jewish Times* (left) with Moshe Sharett, political secretary of the Jewish Agency and future prime minister of Israel (center), and Rabbi Joseph Gold.

command from the Almighty: "*Lech lecha me'artsecha umimolade-techa umibeyt avicha el-ha'arets asher ar'eka.*" In the King James translation: "Get thee out of thy country, and from thy kindred, and from thy father's house, unto a land that I will show thee." The next passage is a promise: "And I will make of thee a great nation, and I will bless thee, and make thy name great; and thou shalt be a blessing." The order to uproot is followed by a pledge for excellence.

I love the repetition of the word *and* in that biblical quote; it seems proof of continuity, above all else. Once Abraham's offspring became a nation, it went to the Babylonian captivity in the year 569 B.C.E., what is today the Levant. And in the year 70 C.E., after the destruction of the Second Temple, it went into exile: first to the heart of the Roman Empire and its colonies and thereafter to Spain, England, Germany, France, Italy . . .

Salon Tel-Aviv, in the Jewish ghetto in Tunisia.

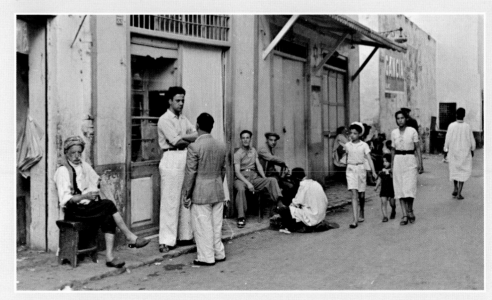

Exile is the state of being barred from one's own native country, typically for religious, political, or punitive reasons. It isn't the same as diaspora. In 1948, with the creation of the state of Israel, exile officially ended for the Jews, but the diaspora continues. In fact its possibilities are as plentiful as ever, and of course, so are its dangers. For being dispersed isn't approached benignly by more sedentary nations. Jews are constantly being portrayed as interlopers, a cabal about to conquer the globe. The historian Arnold Toynbee portrayed us as fossils.

A fossil is proof of death, though, not of survival. Ask around where a Jew comes from and you're likely to get a peripatetic answer: born in Istanbul, educated in Odessa, married in Cairo, active in the French resistance, made aliyah to Jerusalem, relocated to Lima, currently residing in Montreal. The sheer accumulation of references is never a deterrent. It is a source of pride.

Look at the pictures: a Yemenite "dancing" boy, a blind child at the Viennese Jewish Institute for the Blind, a wedding in Madrid, a shoe shiner in Tunisia . . . What do they have in common? The conviction that no matter how uprooted they have been, their commitment to tradition will make them endure. Whenever I think of that commitment, I am in awe. Is it really possible that after so excruciating a journey through history, lasting more than five millennia, Jews still find ways to be happy? These images show the extent to which Jews attend to their one and only business, the business of finding meaning in everything around. *Lech lecha,* indeed.

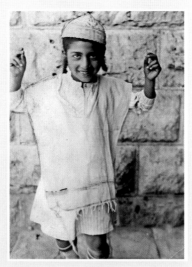

A Yemenite Jewish boy.

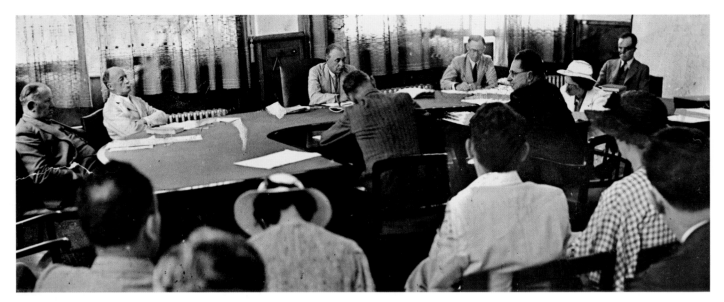

Meeting of the Royal
Commission on the Future
of Palestine, June 17, 1937.
The commission chairman,
Lord Earl Peel, is at the
center.

Chaim Weizmann and his
wife, Vera, visiting Tel Aviv
in 1938.

IF YOU WILL IT, IT IS NOT A DREAM אם תרצו אין זו אגדה

Theodor Herzl 1901

Hechalutz Zionist youth
dance troupe performing
at the opening of the
Palestine Pavilion at the
1939 New York World's Fair.

EDITORS OF THE SUNDAY
SUPPLEMENT OFTEN INCLUDED
FEATURES SIMPLY FOR THEIR
EDUCATIONAL VALUE.
PHOTOGRAPHS FROM "THE
HUMAN EMBRYO" DISPLAY AT
THE 1939 NEW YORK
WORLD'S FAIR.

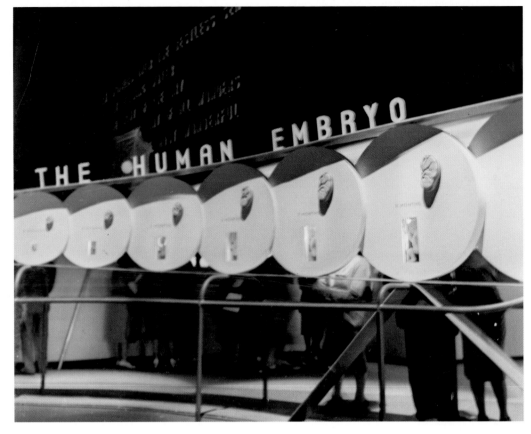

Month one.

Month two.

Month three.

Month four.

Month five.

Month six.

Month seven.

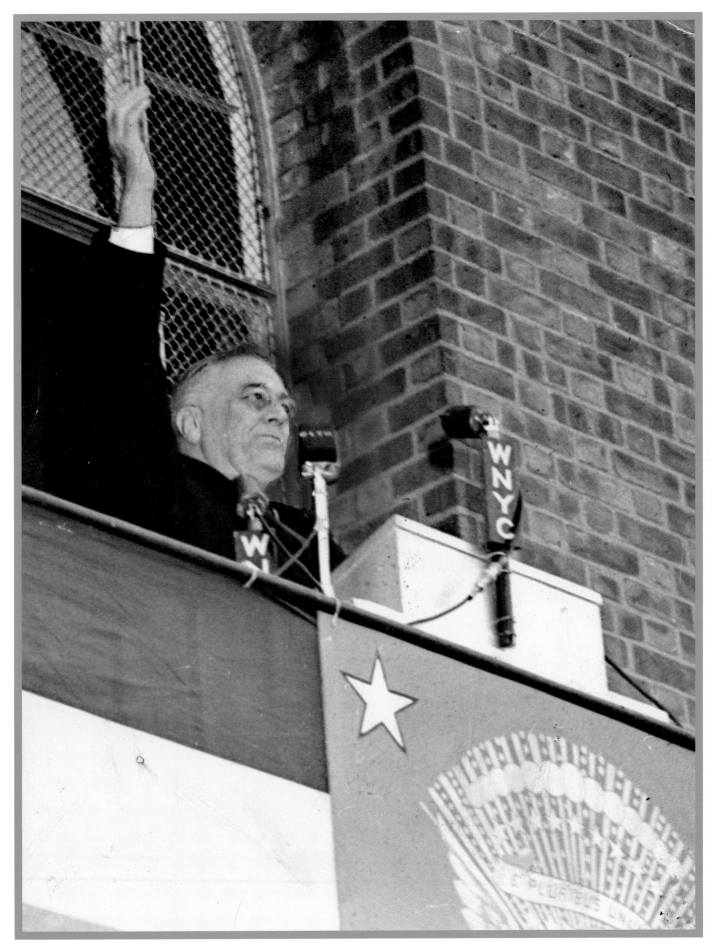

President Franklin D.
Roosevelt, addressing a
crowd in New York
(October 1940).

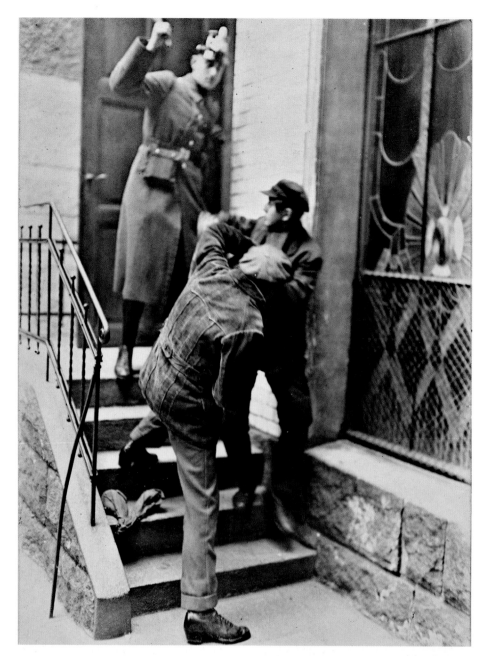

From the original caption:
"A policeman beating two
young men in Berlin."

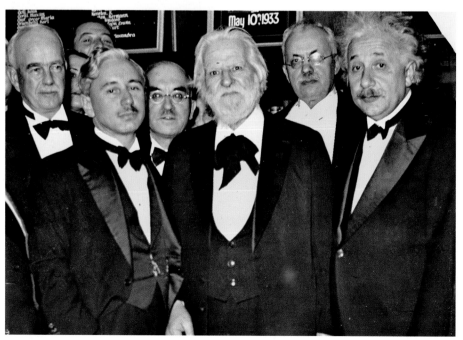

Intellectuals and writers,
including Albert Einstein
(far right) and Edwin
Markham (middle),
protesting the Nazi
burning of books (1934).

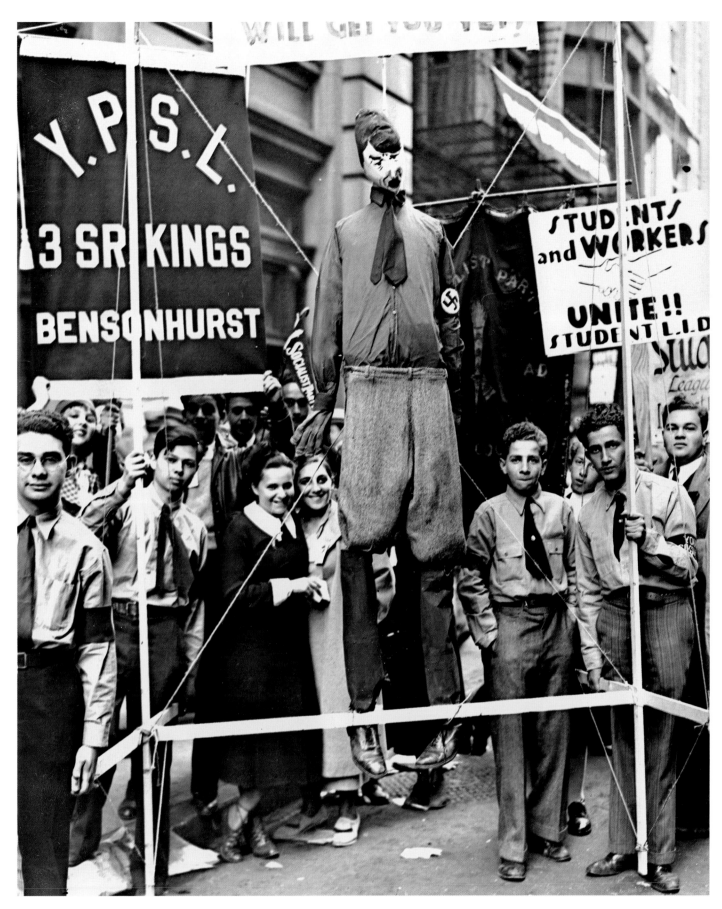

Members of the Young
People's Socialist League
and the Student League
for Industrial Democracy
standing by an effigy of
Hitler.

THE CELEBRATED INTERNATIONAL COMEDIENNE
NELLIE CASMAN

"The celebrated international comedienne" Nellie Casman.

The film star Paul Muni, who started on the Yiddish stage as Muni Weisenfreund, played in the movie *Scarface* and depicted many other roles, onstage and screen, including the three pictured here: *This One Man, Seven Faces,* and *The Good Earth*.

The leaders of the Soviet Jewish Anti-Fascist Committee, the Yiddish poet Itzik Fefer (left) and the director Solomon Mikhoels of the Moscow State Yiddish Theater, meeting with Albert Einstein at his New Jersey home during their 1943 visit to America. The committee was created by Stalin to drum up support for the war effort and boost the Kremlin's image in the West. It was shut down in 1948 after becoming a focus of pent-up Jewish identification, and its leaders were murdered on Stalin's orders—Mikhoels in 1948, Fefer in 1952.

The German Jewish writer Max Brod and his wife, arriving in Palestine (1939).

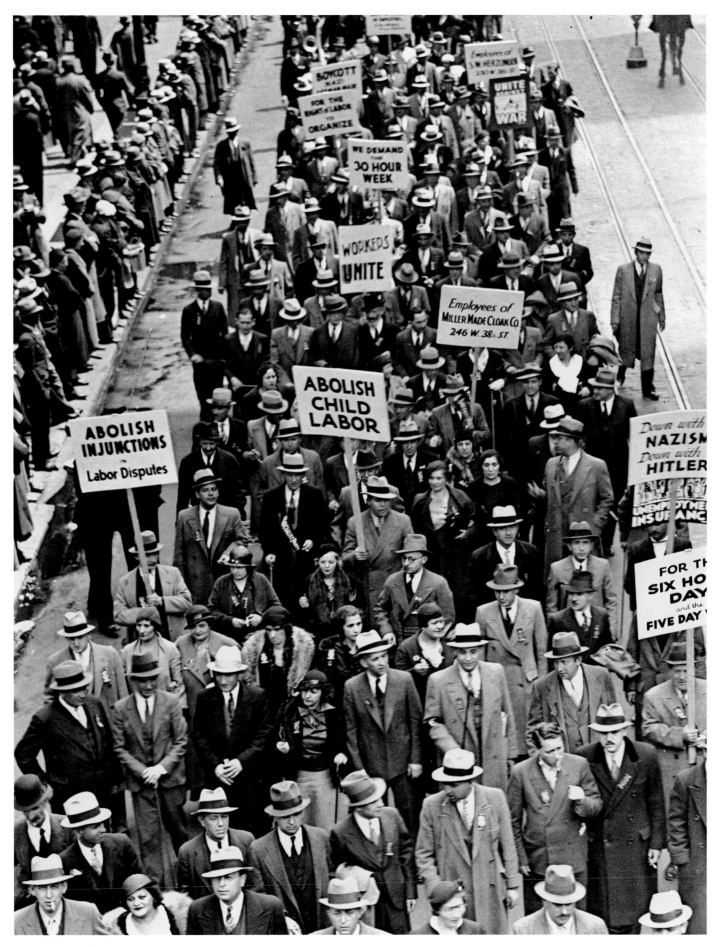

Overhead view of
marchers at a protest
rally.

Sholem Asch (third from
left) with Abraham Cahan
(second from left).

Central Park, New York.

From the original caption: "Osher Shapiro, a son of the Nouselitzer rabbi, was attacked by hoodlums who removed his sideburns, among other indecencies."

Mr. and Mrs. Lewis
Skolnick, pictured with
their four sons in uniform
(1943).

A U.S. Army chaplain,
Corporal Judah Metchik,
passing out literature
from the Jewish altar on
Armed Forces Day, at an
army base in Salzburg,
Austria.

The philanthropist and art
patron Edward Warburg at
boot camp near Plattsburgh,
New York, in 1940. The
youngest son of the banker
Felix Warburg and the
grandson of the Jewish
communal leader Jacob
Schiff, Warburg volunteered
as a private in the army, later
rose to captain, and was
decorated during the
Normandy invasion.

THE HOLOCAUST

Deborah E. Lipstadt

IT NEED HARDLY be said—yet it must be said, over and over—that the Holocaust was a catastrophe unparalleled in Jewish and human history. It was an event so enormous it is often hard to find words to express how deep and wide the gash of pain extended.

When Adolf Hitler became the chancellor of Germany in 1933, he already had a reputation as an extremist with a deep hatred of Jews. His election was alarming to the five hundred thousand Jews of Germany, a seemingly respected and well-integrated minority in one of the world's most advanced industrial nations. At first most assumed Hitler would strut on the stage, perhaps wreak some humiliation, and then pass into history, as other Jew-hating despots had done for centuries before.

Instead he instituted a reign of terror, beginning with restrictive laws and moving quickly to exclusion, dispossession, and outright terror. German Jews seeking to flee found doors shut in most of the world; in 1938 a thirty-two-nation conference was held in Évian, France, to consider the refugees' fate, but no nation was willing to welcome them. In November 1938 the Nazi regime unleashed a nationwide pogrom, a two-day orgy of anti-Jewish violence known as *Kristallnacht* (Night of Broken Glass), signaling the regime's intention to destroy the Jews physically.

In due time that intention was translated into deeds, some of the foulest in human history. Over the next seven years the Nazi war machine systematically conquered and enslaved most of the European continent. In each place they conquered, the Nazis rounded up the Jews and systematically murdered them. By the time the Nazi regime was toppled in 1945, six million Jews had been murdered—

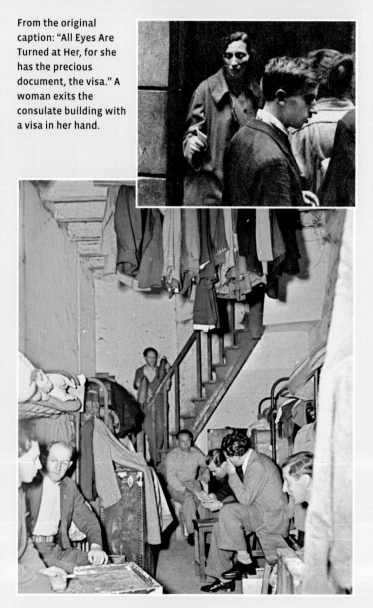

From the original caption: "All Eyes Are Turned at Her, for she has the precious document, the visa." A woman exits the consulate building with a visa in her hand.

During the war, nearly twenty thousand Jews sought refuge in Shanghai, where many lived twenty-to-thirty to a room in community houses.

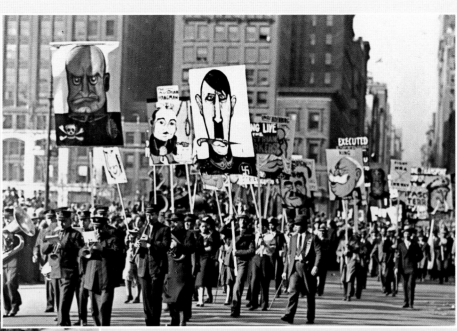

Members of the Communist Party Opposition, the anti-Stalinist breakaway group led by the expelled party leader Jay Lovestone, staging an antifascist rally in Madison Square (1934).

Refugees waiting at a train station, en route to a displaced persons' camp.

America at the time remained safely out of Hitler's reach throughout the years of terror, many experienced years of terrible fear and frustration, as news of loved ones they had left grew increasingly grim by the day. Most were immigrants or the children of immigrants, not fully certain of their place here. America, their new homeland, was beset by economic depression, political isolationism, and growing antisemitism of its own and was thus reluctant to become involved—especially since news of the escalating violence against Jews was consistently deemed too incredible or too marginal a story to be believed. Before

tortured, starved, and gassed to death in vast, demonic extermination camps or simply beaten, burned, and shot, one after another. At least one and one-half million of those murdered were children.

The destruction of the Jews was just part of Hitler's larger plan, which included nothing less than the conquest of Europe. As the world stood by, he annexed Austria, then Czechoslovakia. In September 1939, when German troops invaded Poland, Great Britain and France responded by declaring war. America remained neutral for more than two years, until the Japanese attack on Pearl Harbor in December 1941 propelled Americans into the war.

Although the five million Jews living in

Budapest-born kibbutznik-poet Hannah Senesh, one of thirty-two Jewish underground fighters recruited by the British Army to parachute into occupied Europe in 1944 and mobilize Jewish resistance. She was captured by the Gestapo in her native Hungary and executed by firing squad on November 8, 1944.

Leaders of the Jewish Labor Committee of New York standing before a truckload of clothing being sent to "the victims of Nazi aggression in Soviet Asia" (1942).

Inmates at a sanitorium in Otwock, Poland.

From the original caption: "A family torn apart in Warsaw. The children are leaving for England, yet their parents must remain in Poland."

A young boy in peaked cap and suit in a displaced persons' camp in postwar Europe (1945).

after the war. In fact a great deal of news about the persecution and annihilation of European Jewry was available to newspaper readers in America during the years of the Third Reich, but much of it may have been missed by readers of English-language papers, buried as it was on inside pages. Indeed, when newspaper readers did find articles describing the horrors being perpetrated on European Jews, they might well have dismissed them as unfounded rumors, as when the *Chicago Tribune*, one day in June 1942, published news of the murder of two million Jews—in a tiny article at the bottom of page six. No reader could be blamed for assuming that if this shocking news were actually true, the paper would have placed it in a prominent position on the front page.

This was not the case for readers of the *Forverts*. Its pages were filled with news about what was happening to Jews first in Germany and then, as the Third Reich spread its grasp, throughout Europe. In a period of less than two weeks in the early summer of 1941 *Forverts* subscribers could read that the Germans were starving Jews and allowing them to die of diseases (June 30); that there were antisemitic exhibitions in cities throughout Germany (June 30); that the Romanians were slaughtering Jews (July 1); that the Nazis set Poles against the Jews (July 1); that there were pogroms in Lithuania (July 2) and Ukraine (July 3); that masses of Jews were bring arrested (July 8); that a man named Adolf Eichmann, whom the paper described as not

the war most Americans appeared to believe Europe's problems were none of their concern. Once America joined the war, its attention was focused entirely on military victory.

Of the many historical misconceptions about the Holocaust, one prominent assertion persists: the belief that the American public was unaware of the Holocaust until

only a specialist in murder but a "Nazi Haman," had been dispatched to Vilna and Kovno to "solve the Jewish problem there" (July 11); and that one-quarter of a million Jews had been "taken into slavery" (July 11). Readers were cautioned that "unbelievable as it may sound [this news] . . . is a fact."

Two elderly Jewish men reading the *Forverts* in a displaced persons' camp (Donabastior in Ulm) in Germany.

For the English-language press, what was happening to the Jews was a sidebar, a story that was ancillary to the main news—namely, the progress of the war. In contrast, for the editors of the *Forverts* and for the paper's readers, what was happening to the Jews was of primary importance. Also, in contrast with mainstream reporters, many of whom were skeptical about the stories of genocide, the editors and writers of this newspaper had no problem believing what they were hearing from Europe. The news was coming from sources they trusted both implicitly and explicitly. Moreover, the victims were their *landsleit*, people from their hometowns, and, in too many cases, their families.

For the *Forverts,* the tragedy of the death of their fellow Jews, who were their readers' parents, siblings, children, relatives, and friends, was overwhelming. It was *the* story, not one among many.

That story continued to reverberate in the *Forverts* for years, in ways few anticipated at the time. The Nazis had not only murdered six million Jewish individuals but destroyed a civilization. When they were done, the heartland of Eastern European Jewry and its thousand-year-old Yiddish-speaking civilization were no more. In time the impact on the *Forverts* would be seminal. It had been sustained for decades by waves of Yiddish speakers coming here from the old country. After some eighty thousand of the survivors— the "saving remnant"—entered the United States between 1948 and 1952, there would never be another sizable Yiddish-speaking immigration in the world.

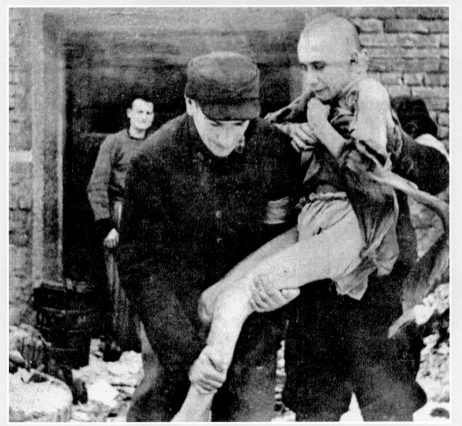

From the original caption: "A boy whose whole family perished at the hands of the Germans and who was himself consigned to death at the Auschwitz (Oswiecim) extermination camp, but the Nazis—then beating a fast retreat—did not have time to burn him. The anguished orphan, now in Lodz, is shown as he was taken out of one of the smaller crematoriums into which he had been placed by the Hitlerian pyromaniacs. The two men and the one standing behind are Jews, former inmates of the extermination camp, who were strong enough to serve as members of a medical relief unit to rescue those left in the camp and in the crematorium (the gas chambers were blown up a few days before). This picture was sent to the *Forward* by Marian Gid, our correspondent at the Nuremberg trial of the top German war criminals."

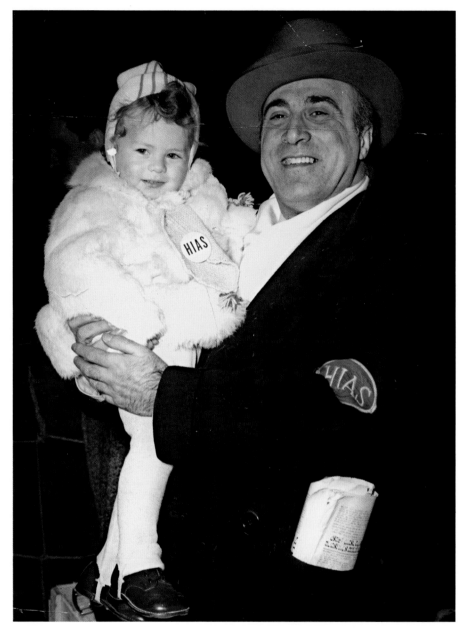

Herman Yablokoff, a prominent Yiddish actor and leader of the Hebrew Actors Union, wearing an armband of the Hebrew Immigrant Aid Society (HIAS), picking up his young nephew Motele, who had just arrived on these shores by boat.

Lighting the menorah on
the fourth night of
Hanukah, at Ellis Island.

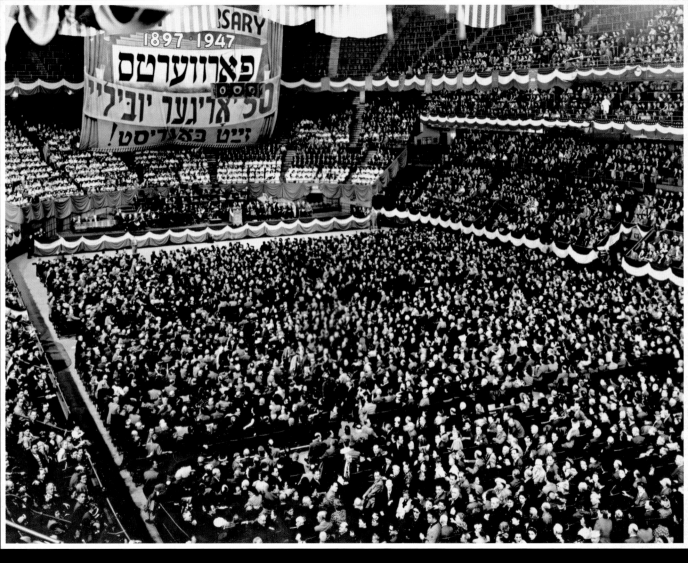

An overflow crowd of twenty thousand in New York City's old Madison Square Garden for the *Forward's* fiftieth anniversary celebration, on May 25, 1947.

THREE

1946–1973

THE END OF World War II was a time of triumph and jubilation for America, but for American Jews the joy was mixed with horror at the knowledge of what the Nazis had done. A world had been annihilated. No Jewish family was left untouched by the Holocaust; for many, the shock was too deep for anything but silence.

Almost as soon as the war was over, a new struggle arose: the battle for a Jewish homeland. The state of Israel, established in 1948, became a central fact of contemporary Jewish history, an inspiring, mobilizing event that shaped the experience of every Jew in the decades to come.

The postwar years were a time of renewal on the home front as well. Jewish families were joining the middle class and moving to the suburbs, sending their children to college in unprecedented numbers, and throwing themselves into the American mainstream. Most barriers to Jewish participation had been lowered; those that remained were battered down by a crusade of Jews and blacks marching together for civil rights. The era unleashed an explosion of Jewish talent in the arts, from novelists to musicians, from filmmakers to comedians.

Almost unnoticed, the entry of Jews into the American mainstream was draining the *Jewish Daily Forward* of its next generation of readers. Cahan died in 1951. His colleagues carried on, but the paper was entering a long decline.

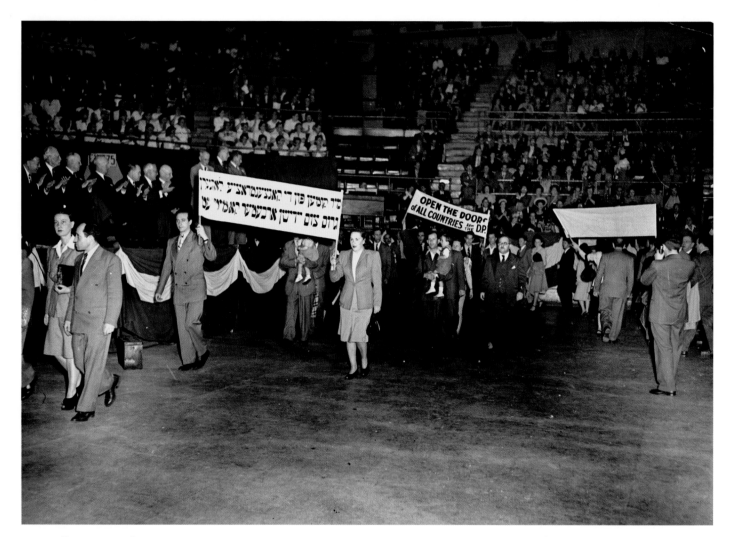

A 1947 rally to support the
Displaced Persons Act, a
congressional measure
easing immigration
quotas for postwar Jewish
displaced persons from
Europe. The bill passed in
1948.

A sign in Yiddish from the B. C. Vladeck "preventorium" at the home for children in Brunoy, France, which was critical in rehabilitating children in postwar France. Rooms were named for leaders of the Jewish Workers' Bund, fighters in the Warsaw Ghetto uprising, and soldiers who fell in the Allied liberation of France.

American guests, supporters of the Vladeck home for rescued Jewish children, in Brunoy, France (1951).

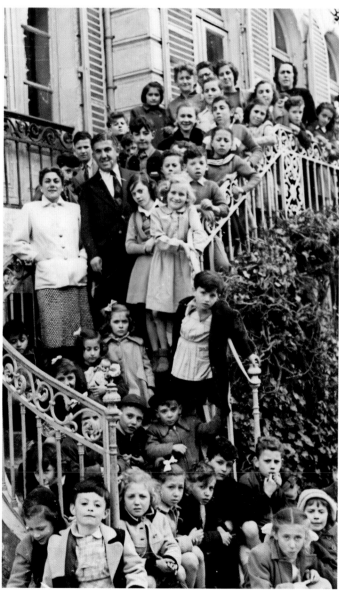

Various Jewish organizations stepped in to lend support to the innumerable children orphaned by the war. *Above*: Fanny Weinstock of Belgium, who was "adopted" by Branch 215 of the Workmen's Circle and Women's Club.

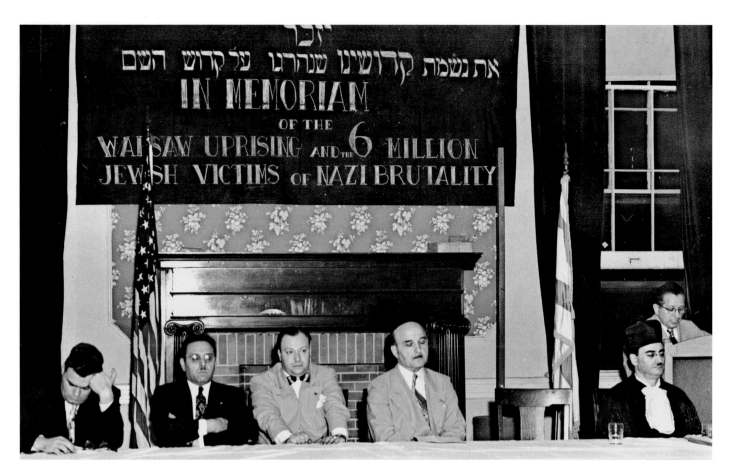

The dais at a Holocaust memorial held by the New Orleans, Louisiana, branch of the Workmen's Circle (June 1951).

The crowd at a Holocaust memorial held by the New Orleans, Louisiana, branch of the Workmen's Circle (June 1951).

The photographer Marian Gid (left) and George Biddle, the American painter and correspondent for Time-Life on the Nuremberg Trials, during a visit with George Kadish (right), a photographer who survived the Kovno Ghetto and made clandestine photos there, at the opening of the exhibition of his ghetto photographs.

After the war Jewish organizations created resettlement programs to help Holocaust survivors start new lives in America. *Right*: A refugee farmer in Lakewood, New Jersey (1951).

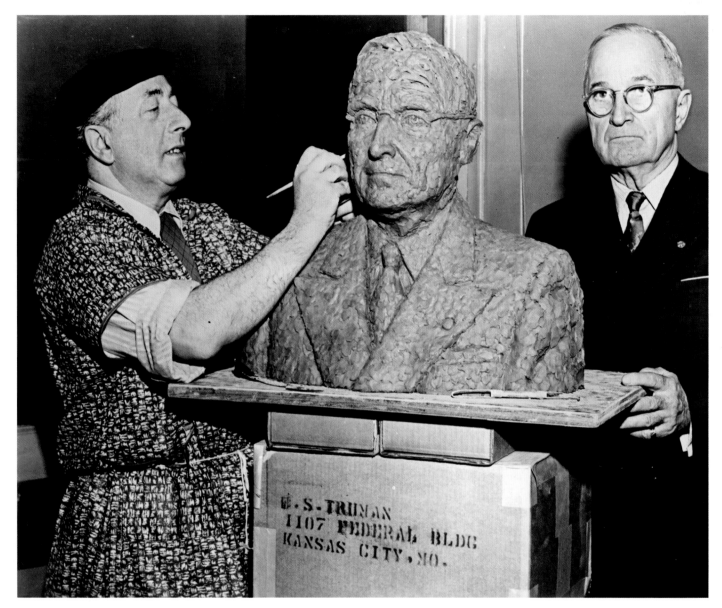

The sculptor Rene Shapshak putting the finishing touches on his bust of President Harry Truman, at the Chelsea Hotel in New York.

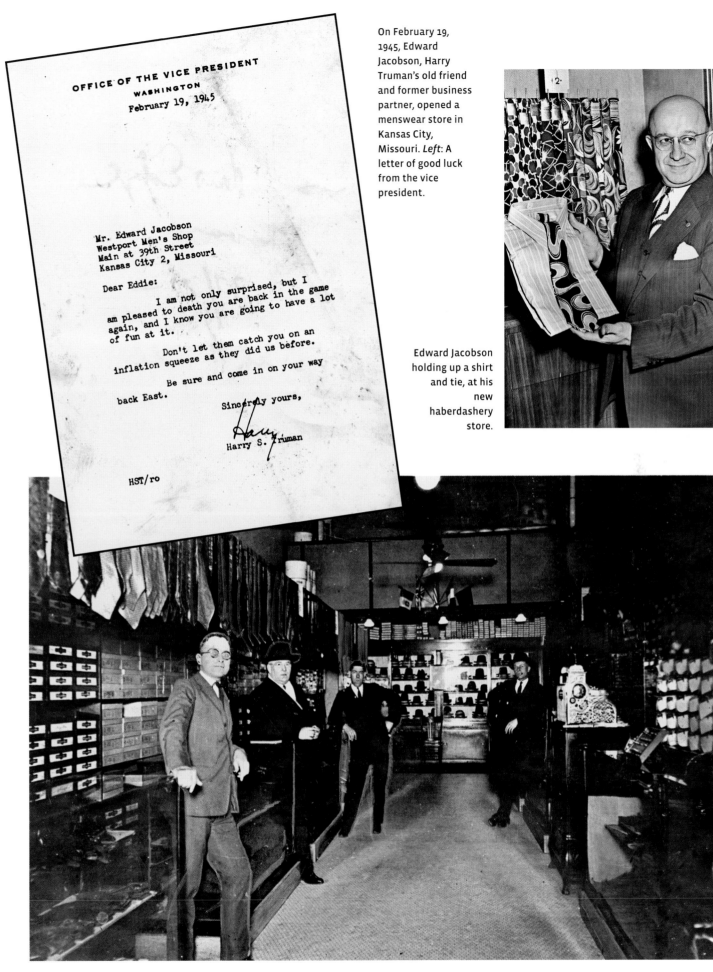

OFFICE OF THE VICE PRESIDENT
WASHINGTON
February 19, 1945

Mr. Edward Jacobson
Westport Men's Shop
Main at 39th Street
Kansas City 2, Missouri

Dear Eddie:

I am not only surprised, but I am pleased to death you are back in the game again, and I know you are going to have a lot of fun at it.

Don't let them catch you on an inflation squeeze as they did us before.

Be sure and come in on your way back East.

Sincerely yours,

Harry S. Truman

HST/ro

On February 19, 1945, Edward Jacobson, Harry Truman's old friend and former business partner, opened a menswear store in Kansas City, Missouri. *Left*: A letter of good luck from the vice president.

Edward Jacobson holding up a shirt and tie, at his new haberdashery store.

Harry Truman and Edward Jacobson in their old store at Twelfth Street and Eighth Avenue, Kansas City.

Philosopher Martin Buber,
with his class at Hebrew
University, Jerusalem
(1949).

Leibel Weisfisch, a leader of the ultra-Orthodox, anti-Zionist Neturei Karta community. The Neturei Karta, founded in 1938, refuses to recognize the establishment of any Jewish state until the Messiah arrives.

The novelist Meyer Levin, during production of the 1948 film he produced, *The Illegals*, documenting the illegal Jewish exodus from postwar Europe to British-ruled Palestine. With Levin is Tereska Torres, the film's (nonprofessional) leading lady. Levin and Torres were in the process of bringing home their sack of film, which the British had attempted to confiscate.

ISRAEL

Alan M. Dershowitz

MANY AMERICAN Jews of my generation vividly recall sitting with our parents in our living rooms, glued to our radios or our new television sets, as the roll call of the United Nations was read and the newly formed international body voted on the partition plan that led to the establishment of Israel. The Holocaust had ended. My neighborhood of Borough Park in Brooklyn had many survivors who had come from displaced persons' camps. Virtually all of us had relatives who had gone to Palestine. As winter turned to spring, we followed David Ben-Gurion's momentous announcement establishing the first Jewish state in nearly two thousand years. We knew that it would be followed by massive bloodshed. We did not know that the new state would lose one out of every hundred of

A lifeboat filled with refugees approaching the shoreline of Palestine (1947).

A Haganah illegal immigrant ship, the *Colonel Josiah Wedgwood*, nearing the shores of Palestine (1947). The banner on the right reads: WE SURVIVED HITLER / DEATH IS NO STRANGER TO US / NOTHING CAN KEEP US FROM OUR JEWISH HOMELAND / THE BLOOD IS ON YOUR HEAD IF YOU FIRE ON THIS UNARMED SHIP.

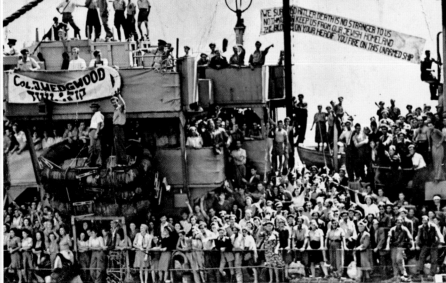

Refugee youths showing their tattooed numbers from the concentration camps.

A mother is greeted by her son, who helps her off the train, upon arrival at a detention camp in Israel.

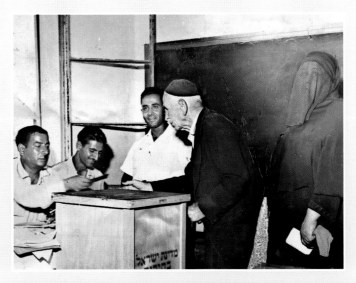

Casting votes in an Arab village, in the first Israeli election.

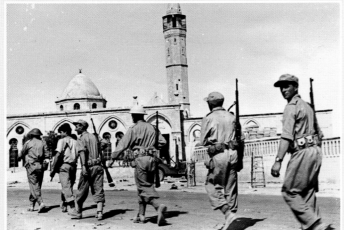

Israeli troops on patrol in Beersheba (1948).

its Jewish citizens in the war declared against it by Palestinian Arabs and surrounding Arab nations. Many of the men and women who died defending Israel had barely survived Hitler's gas chambers. Several young men and women from Borough Park went to Israel to join in the fight. My uncle stowed away on a ship to reach the new Jewish state. Another uncle helped smuggle weapons to the Haganah. A friend of my parents' lost a son in the battle. Although Israel was fifty-seven hundred miles away, as far as we were concerned the fight was next door.

Then, suddenly, Israel had won. A

Moshe Dayan, his hand extended skyward, releasing a dove in front of an Israeli flag.

period of normality quickly followed. A poor country, mostly agrarian in nature, was now engaged in an arduous struggle for economic survival. And still we felt engaged. We dropped our nickels and dimes into the blue and white Jewish National Fund boxes that we kept near our doors. For our birthdays and bar mitzvahs we received Israel Bonds and tree certificates. We read about European teenagers flocking to kibbutzim to atone for the guilt of their parents (and having a great time in the process). Support for Israel, though largely passive, was not controversial either in the United States or in Europe. Israel was a noble cause, and we were, at least vicariously, part of it.

Things began to change a bit in 1956. President Gamal Abdul Nasser of Egypt sought and received a large shipment of arms from the Soviet Union, which he said he would use to destroy Israel. A new level of danger was added to the threats from the Arab states, which had seemed mostly rhetorical until then. For Israelis the danger was all too real; Israel was already plagued by continuous terrorist attacks against its civilian population by *fedayeen*, supported by the Jordanian and Egyptian governments. Nasser's decision to nationalize the Suez Canal and close international waterways to Israeli shipping was the final straw. Israel, in coordination with France and Great Britain, struck preemptively and captured the Sinai

A set of stamps and an addressed envelope from Israel, postmarked May 16, 1948, the day after independence.

Peninsula. Suddenly Israel was on the political defensive, condemned by the international community and even by the United States. Suddenly support for Israel was somewhat controversial, despite—or perhaps because of—its military prowess.

The crisis soon passed, and support for Israel became once again the norm, both inside and outside the Jewish community. Still, the support remained more passive than active. Few American Jews made the long journey to visit Israel. The United States gave verbal support but little money and no weapons. Then, in the spring of 1967, Israel again found itself cast as the underdog. Egypt and Syria, heavily armed by the Soviet Union, began escalating their rhetoric of destroying Israel and its Jewish population. Jordan, its army trained by Great Britain, joined the chorus. In May, Egypt announced a blockade of Israeli shipping and mobilized its troops. Israel stood alone. Unable to count on American military support, Israel purchased nearly all its arms, including its air force, from the French, who were anything but a reliable ally.

I recall, as if it were yesterday, the fear many of us experienced in the weeks leading up to the 1967 War. I was a young faculty member at Harvard, where I conducted teach-ins and helped organize political and financial support for the beleaguered state. The American Jewish community in general was terrified at the prospect of another Holocaust just twenty-two years after Hitler's defeat. When the war, which finally came in June 1967, lasted only six days and ended in a decisive Israeli victory, it seemed miraculous.

In the years since 1967 a myth has arisen that American Jews began to identify with Israel only after its victory in the Six-Day War. The historical record belies the myth. There was indeed a change, beginning that year, from passive support to active identification, but it had begun in the months *before* anyone could be confident of an Israeli victory. To be sure, some American Jews basked in the vicarious glory of the subsequent Israeli victory, but many more worried along with Israelis about the prospect of defeat. I recall many friends and colleagues seeking permission to fly to Israel in the run-up to the war and in its early days, before the outcome could be known, wanting simply to be there.

Indeed, Israel's decisive victory, as much as it brought reinforced identification, also brought the opposite. The image of Israeli military prowess, coupled with its resulting occupation of the West Bank and Gaza Strip, led some Jews of the left to abandon the Jewish state, joining with radicals

Two boys from the Kiryat Amal-Tivon branch of the labor youth movement Noar Oved ve-Lomed.

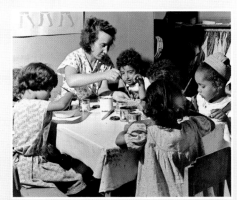

Moetzet Hapoalot, the Working Women's Council, at the children's center in Rosh Ha'ayin (1951).

munity, which came to view the Soviet Union in increasingly critical terms, and much of the activist left, which was still in the shadow of the Vietnam War and viewed anticommunism with suspicion. On the extremes of left and right, Israel came to be viewed simply as an ally of the United States, for better or worse. Israel was becoming part of the cold war.

Men inspecting an irrigation pipe in the Negev, at Kibbutz Revivim.

in Europe and elsewhere in a wave of hostility. Even in 1973, after Israel's near defeat in the Yom Kippur War, some American Jews who identified with the hard left lined up against Israel.

The alienation of the left from Israel was accelerated during the 1970s by the rise of the Soviet Jewry liberation movement. Jews in the Soviet Union, long forced into the shadows under communism, were energized by Israel's victory and began demanding their rights. The Kremlin answered with a wave of repression. In America the Jewish community responded with a outpouring of activism in support of Soviet Jews, leading to a political confrontation that stretched from Washington through Europe. This further strained relations between much of the Jewish com-

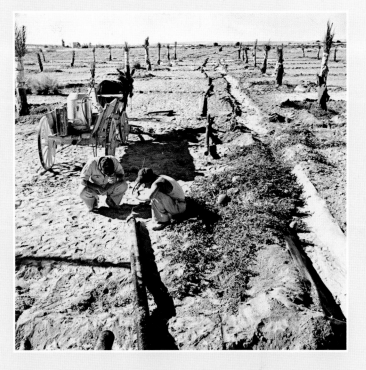

The youths of Mishmarot dancing the hora at Kibbutz Ramat Yochanan, near Haifa.

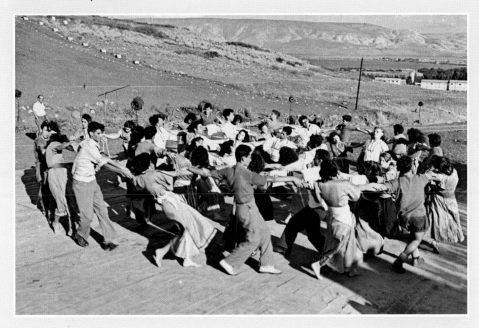

The vast majority of American Jews remained untouched by this polarization. As the 1970s progressed, most Jews remained both staunchly liberal and staunchly pro-Israel. In the years ahead the strain increased as the Israeli right became stronger and Israel assumed a more adventuristic military posture in Lebanon. The seeds for these developments were planted between 1967 and 1973, but they did not blossom until the 1980s and 1990s. The conclusion to this complex story has yet to be written.

An illustrated Hebrew
translation of Harriet
Beecher Stowe's book,
Uncle Tom's Cabin, from
the 1950s.

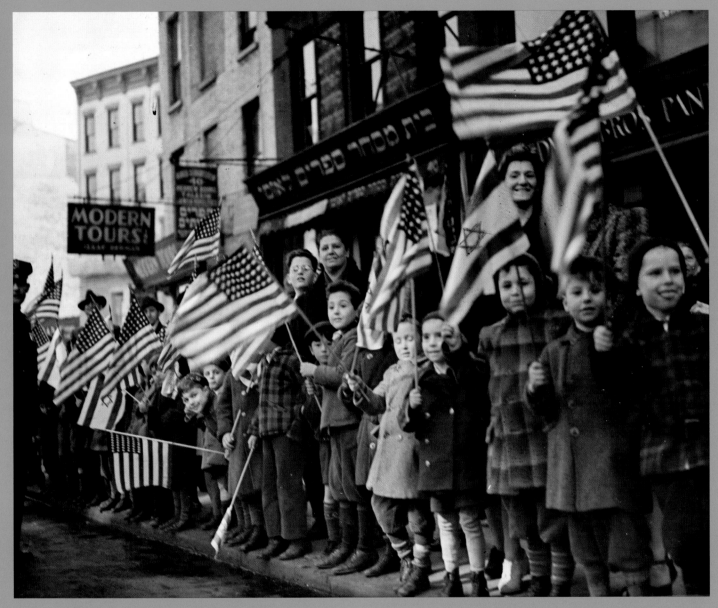

Children lining Canal
Street during a rally.

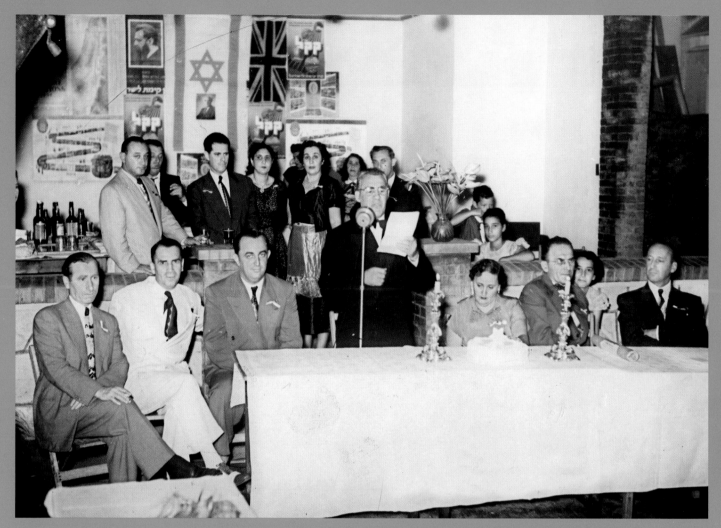

Members of the Jewish community of Port of Spain, Trinidad, pictured at a celebration marking the third anniversary of Israel's independence.

A scene from *Good Morning, Aleph*, a Yiddish dramatic poem, presented at graduation exercises at the autonomous school of the Jewish Center in Havana, Cuba (1951).

The screen and radio
favorite Dick Powell
displaying with pride his
SOS captain's badge, from
the American Jewish Joint
Distribution Committee.

Sheindele the Chazente—
Sheindele the Female
Cantor, singing at the
WEVD studio.

Samuel Malavsky and his
Malavsky Family Choir—in
promotional material (above)
and on tour in Havana, Cuba, in
1951 (below).

The twelve-year-old mathematics wiz Robert Strom who ran the gauntlet three times on the quiz show *$64,000 Question* and later added to his total on the *$64,000 Challenge*, with his briefcase of winnings (after taxes), in 1958.

Performances on the *British Album*, a radio magazine program about Hebrew literature, heard on the BBC Hebrew Service (1951).

The grand rabbai of Satmar Hasidism, Joel Teitelbaum (right), standing at the railing on the deck of the *Queen Mary* at Pier 90 in New York. From the back of the photo: "This is the only picture taken of Teitelbaum on his journey from Israel."

Adi Schilling, of South
Africa, next to a model of
an El Al Constellation
airplane. She was on the
inaugural journey of the
Constellation, flying from
Johannesburg to New
York, by way of Tel Aviv,
Athens, Rome, Paris, and
London, covering some
thirty-eight thousand
miles.

An early El Al aircraft in
flight.

Jim Braddock, the former
heavyweight boxer turned
sports director at the
Hebrew Home for Boys,
teaching youngsters how
to deal with bullies.

Chaplain Samuel Sobel conducting the Sabbath service for the Second Marine Division, aboard the USS *Rockbridge* (1952).

Captain Pleasant D. Gold, Jr., USN (center), the commander of the Boston Naval Shipyard, greeting Rabbi David B. Alpert, the chaplain of the Boston City Hospital and department chaplain of the Jewish War Veterans of Massachusetts. At right is Rabbi Abraham Kazis, the Chelsea Naval Hospital chaplain and a member of the National Welfare Board.

Jewish newsmen in Korea. At left is Moshe Medzini, United Nations correspondent for *Ha'aretz*. On the right is George Movshan, a reporter from South Africa. The two are shown in front of the Duksu Palace, a government building in Seoul.

Two army nurses in Korea, Jean Schiffman (left), of Philadelphia, Pennsylvania, and Edith Schor, of Washington, D.C., being greeted by Captain Chaplain Harry Z. Schreiner at the close of Rosh Hashanah services.

The Workmen's Circle
youth basketball team
(1947).

The Workmen's Circle
Building in Los Angeles,
California, at 5174 Pico
Boulevard.

Rudolph Halley, a Liberal Party candidate, is pictured (center) at a Brooklyn rally to stimulate the sale of State of Israel bonds (1951).

West Point cadets hold a State of Israel bond before the statue of Judah Maccabee at the headquarters building of the U.S. Military Academy. Left to right: Melvin Young, University City, Missouri; Herbert Schandler, Asheville, North Carolina; and Jerry Brisman, New York, New York (1951).

The cast of *Me and Molly*, including its star, Gertrude Berg, seen above on the examination table, donating pints of blood to Magen David Adom Laboratory. Nurse Sydelle Straus tended to Berg, while Philip Loeb, Michael Enserro, and Paula Miller waited their turns.

Many Eastern European immigrants belonged to *landsmanshaftn,* organizations of people from the same ancestral towns. *Above:* a group shot of the Elshte-Klivaner Society, with its original banner.

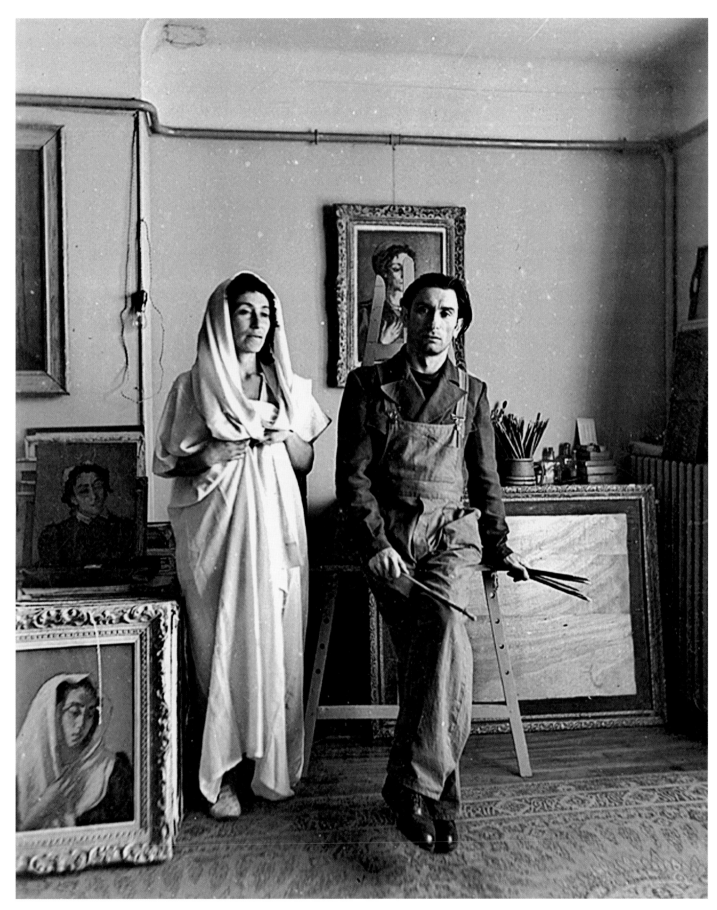

The artist Ben Tsiyon
Rabinovitch and one of his
models, in his Paris studio
(1956).

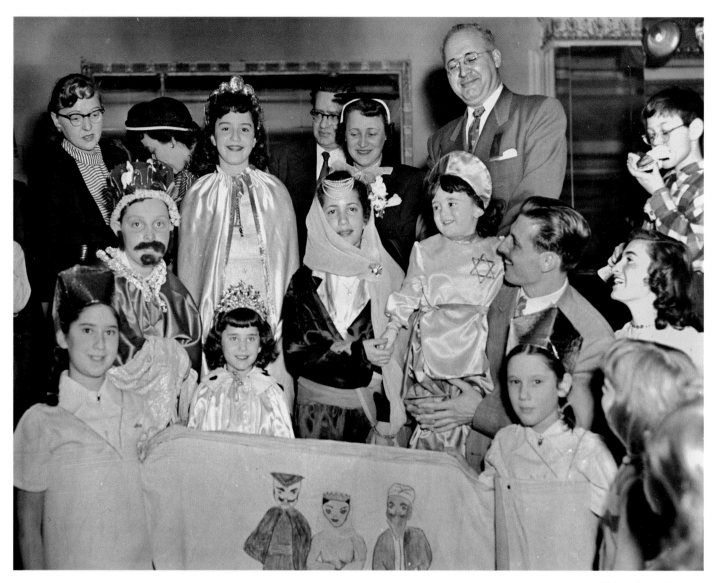

Children dressed in costumes for Purim.

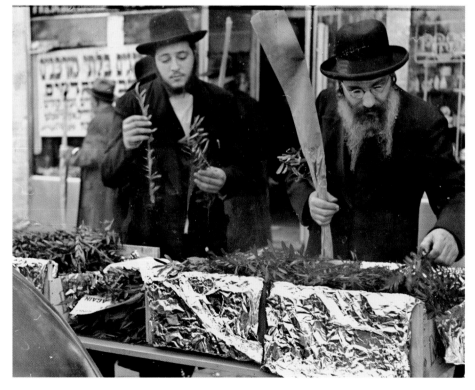

Two Hasidic men carefully choosing their lulavim before Sukkot, on the Lower East Side, New York.

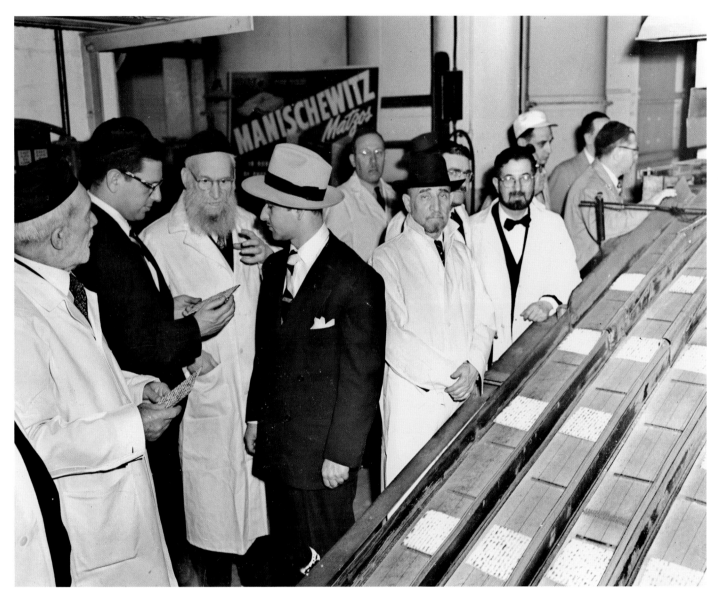

Inspecting the matzo, at
the Manischewitz bakery
in Jersey City, New Jersey
(1951).

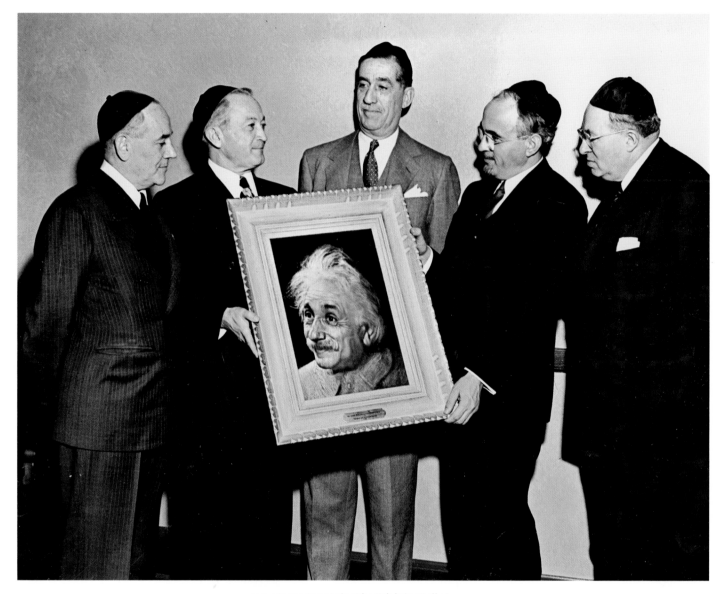

In a ceremony opening the Celebrity Hall at
Yeshiva University, Maurice Rosenfeld,
honorary deputy police commissioner and
director of the Police Department's
Coordinating Committee, presenting to
Dr. Samuel Belkin a portrait of Albert Einstein,
painted by the English artist James Butler. Left
to right: Emil N. Baar, the president of the
Brooklyn Jewish Hospital; Rosenfeld; Ralph
Samuel, the president of the Federation of
Jewish Philanthropies of New York; Belkin, the
president of Yeshiva University; and Max
Abelman, the executive director of the
Brooklyn Jewish Hospital.

UPWARD INTO AMERICAN LIFE

Jenna Weissman Joselit

MODERN AMERICAN Jewish life as we know it—the stuff of countless sermons, merciless comedy sketches, detailed sociological studies, even high-minded literature—assumed its characteristic shape and sensibility between 1946 and 1973. This, after all, was the era during which affluence and embourgeoisement steadily took hold of American Jewry, when suburbanization and a houseful of kids appealed to just about everyone; when the state of Israel was born, Conservative Judaism came of age, and modern Orthodoxy came into its own;

Sam Chester, a member of Lambda Phi Beta at Northwestern University in Chicago, holding the trophy he won in the Menorah Societies' thirtieth annual symposium contest (1951).

when Reconstructionism was full of promise, and a strikingly brand new communal consensus whose stock-in-trade was confidence rather than resignation or despair captured the American Jewish imagination.

During these years English once and for all replaced Yiddish as American Jewry's vernacular, a fate brought home by the decision of the *Jewish Daily Forward* in 1974 to sell its building on the Lower East Side, where it had made its home for three-quarters of a century, and to move to much more modest quarters on East Thirty-third Street. At the same

Little ladies and gentlemen throwing a tea party at the Gustave Hartman Home for Children, Far Rockaway, New York.

Children from the Pride of Judea Children's Home, Brooklyn, boarding a bus for their annual summer vacation at the institution's shore home in Long Beach, New York (June 1953).

<!-- gate with 1875 inscription -->

Twenty-two-year-old Vivienne Schulman looking out on new horizons as she stands in the archway of Greycourt Gates, Smith College, in Northampton, Massachusetts, from which she graduated as a French major (1952).

Water volleyball at a resort in the Catskills (1952).

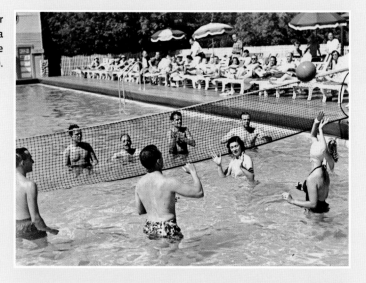

A young boy on the occasion of his bar mitzvah.

time, a wry and knowing familiarity with Jewish history gave way to a warmhearted, even downright mushy affection for all things that bore either a trace of the shtetl or a touch—just a touch, mind you—of the new nation-state of Israel. Increasingly, sentiment took the place of literacy; gesture, that of ritual.

More to the point, growing numbers of American Jews, having fought in World War II, put their faith in America. Philip Roth, whose writings during these years revealed a community to itself—not always with happy results—put it this way: "Much of the exuberance with which I and other members of my generation of Jewish children seized our opportunities after the war—that wonderful feeling that one was entitled to no less than anyone else, that one could do anything and could be excluded from nothing—came from our belief in the boundlessness of the democracy in which we lived and to which we belonged."

But how could it be otherwise? Safe and secure, well fed, well housed, well clothed, and well schooled, American Jewry could now boast handsome homes and equally handsome synagogues, where a Judaism clearly in tune with its surroundings and in touch with the needs of its constituents was taking shape. Under these new and expansive circumstances, the mass slaughter of European Jewry, not yet known as the Holocaust, was pushed to the margins of American Jewry's public consciousness while its victims, not yet known as survivors, were welcomed by some as "delayed pilgrims," as if they were but the latest in a long

A group of immigrants taking the oath to become citizens of the United States (1952).

line of immigrants that stretched as far back as the seventeenth century. Under these new and expansive and willed circumstances, some American Jews reasoned, perhaps the time had finally come to retire that old Yiddish canard about how hard it was to be a Jew.

Not just yet. For periodically during the 1960s and early 1970s American Jewry's confidence was rattled by a number of crises. The rise of black antisemitism at home, coupled, more ominously still, with the outbreak of the Six-Day War in 1967 and that of the Yom Kippur War a scant six years later, greatly unsettled many members of the community, giving rise to a growing sense of isolation and anxiety. Taken together, the two wars suggested that American Jewry's much-vaunted sense of security was little more than a chimera.

Three women holding up a mink coat at a Jewish community group event in Chicago (1952).

At a benefit dinner Welfare Commissioner Henry L. McCarthy congratulated two thirteen-year-old guests of honor from the Pride of Judea Children's Home in Brooklyn. Looking on at Brooklyn's Hotel St. George are Mrs. Max Blumberg, the honorary president, and Jacob H. Cohen, the president of the home (1951).

All the same, the community recovered its equilibrium before long, demonstrating a virtually unprecedented show of unity in response to the two Israeli wars. Yet within a few years consensus gave way to dissent and, in turn, to the splintering of community. For beneath the sunny indices of affluence—of colleges gotten into; of trips abroad and pilgrimages to Israel and, soon enough, to Eastern Europe as well; of grandchildren named Tiffany and Jason; and of substantial donations made to the UJA—one could make out a gnawing sense of cultural deracination and, more dramatically still, of loss: loss of life, loss of language, loss of patrimony. Perhaps Irving Howe put it best when, in a scathing review of *Fiddler on the Roof,* the evergreen play that made its debut in 1964, he wondered what would become of American Jewry if tidy, satisfying Broadway musicals like this one were to stand in for the messy whole of *yidishkayt*.

Howe was right to worry. But as the 1960s gave way to the 1970s, the losses to which he so poignantly alluded were translated into gains, into a series of unexpectedly positive developments that ultimately reshaped the American Jewish landscape. By then consciousness of both the enormity and the specificity of the Holocaust cast a long shadow over American Jewish life at the grass roots, transfiguring virtually everything in its wake, while on college campuses across the nation undergraduates sought out Yiddish and those who swore by it. Meanwhile Jewish day schools, once anathemized by the eagerly integrationist American Jewish mainstream, began to spring up in city and suburb alike, as did clusters of *havurot*, which offered intimate alternatives to the ambitious postwar synagogue.

No one knew it at the time, of course, but eventually each one of these developments was to recast American Jewish life, making for a community unlike anything that had come before. Once bound by tradition, be it that of religion, language, or culture, American Jews entered the 1970s both challenged and buoyed by the prospect of change.

Hotel operators in Lakewood, New Jersey, instituted a tax return filing service for vacationers. An accountant employed by the hotels follows the fun seekers, whether they are on the ice-skating rinks, golf course, or indoor pools, and fills out their income tax returns free. Here accountant George Obern goes over the figures with Bea Singer while Barbara Weiner waits her turn.

YOUNG FOLKS PARADISE

THE WILLIG-LANDES FAMILIES
PROUDLY ANNOUNCE THE OPENING OF

Parkston
HOTEL & COUNTRY CLUB

JUNE 26th

Offering for Your Enjoyment

• Olympic Swimming Pool
• Short 9-Hole Golf Course
• Championship Tennis and Handball Courts
• Free Boating and Fishing
• Superlative Entertainment
• American and Rhumba Music
• Kashruth and Sabbath Strictly Observed

Reservations Now Accepted
Livingston Manor, N.Y.—Tel. 68
N. Y. Phone TR 5-1532.

Charlows
IRVINGTON *hotel*

Tel. FALLSBURG 118

פאר דזשון
און א פרייליכען
4טען דזשולאי

מאדערן אין יעדער הינזיכט ● אלע
סאשעל און אטלעטישע אקטיוויטעטן
● נעשמאקע כשר'ע מאכלים ●
פערזענליכע אויפזיכט פון מרס. רעי
שארלאו ● קאונסעלארס פאר קינדער
ספעשעל רעיטס פאר פאמיליעס
רזאנעיבל רעיטס פאר דזשון
שרייבט פאר רעזערוואציעס

SOUTH FALLSBURG, N.Y.

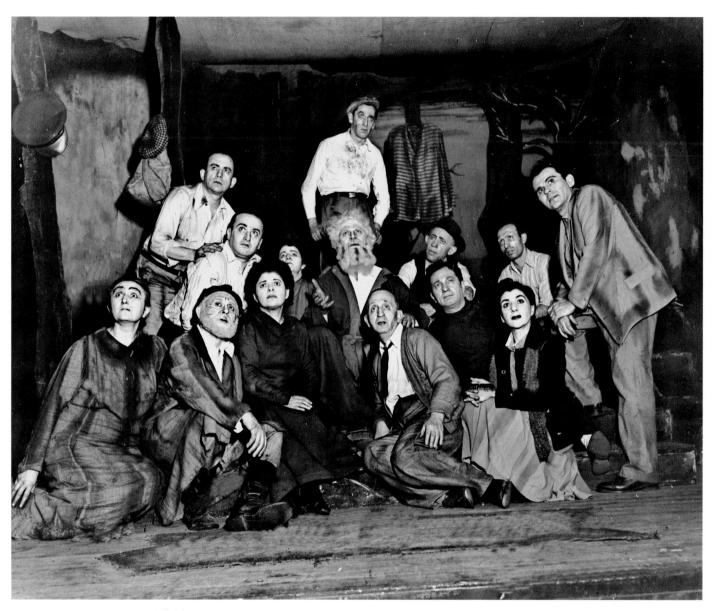

Folksbiene Yiddish
Theater actors' ensemble
photo.

On August 31, 1951,
Abraham Cahan died of
congestive heart failure.
He was buried at Mount
Carmel Cemetery, Queens,
New York.

Cosmetics magnate Helena
Rubinstein—born Chaja
Rubinstein in Krakow, Poland in
1871. On the strength of her prod-
ucts and image, Rubinstein would
become one of the wealthiest
women in America, and was later
credited by many with the inven-
tion of the beauty salon.

A woman from an African
American Jewish
community in Harlem
lighting Sabbath candles.

The Yiddish writer Melech
Ravitch, on safari in
Africa, admiring an African
native in tribal dress.

Abba Eban, representing
Israel at the United
Nations, sitting between
representatives from
Lebanon and Iraq.

Harvey Rosen (center),
secretary of the New York
Fire Department.

The graduating class of the I. L. Peretz Workmen's Circle School. Standing (left to right): May Karp; Zelda Deitsch; Ralph Lazarson, teacher; Cynthia Menken; Arlene Schneiderman. Seated: Annette Schiff (left) and Shirley Wax. Bronx, New York (1951).

Michal Harel, Miss Israel 1952. From the original caption: "Harel, a twenty-year-old beauty from Jerusalem, who also teaches kindergarten, is on tour in the United States to raise money for the UJA."

Bess Myerson, the first Jewish Miss America, 1945–1946.

The Talmudic scholar
Chaim Tchernowitz,
former chief rabbi of
Odessa and professor of
Jewish law at the Jewish
Institute of Religion,
speaking at a dinner.

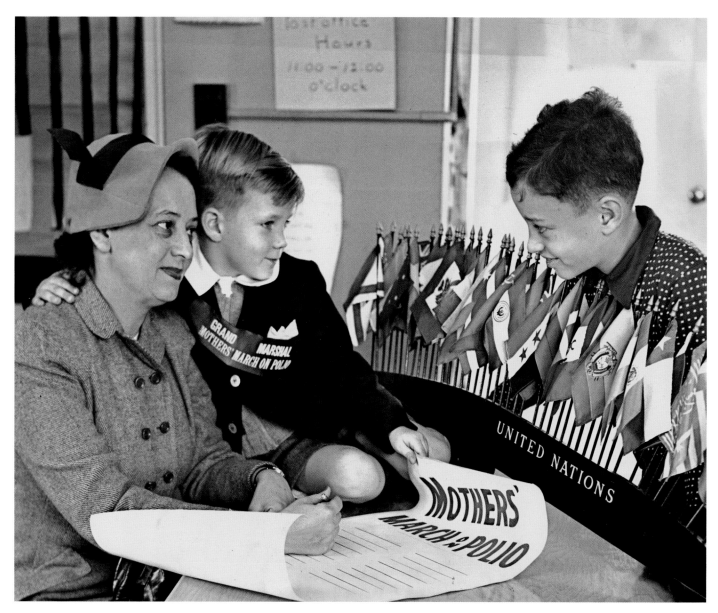

Mrs. Ralph Bunche, the wife of the noted educator and longtime undersecretary-general of the United Nations Trusteeship Division, signing up for the Mothers' March on Polio, a fund-raising project of the New York March of Dimes. With Mrs. Bunche in the picture, taken at the UN International School, Jamaica, Queens, are Michael Halloran, the grand marshal of the march, and the Bunches' son, Ralph Jr., a former polio victim.

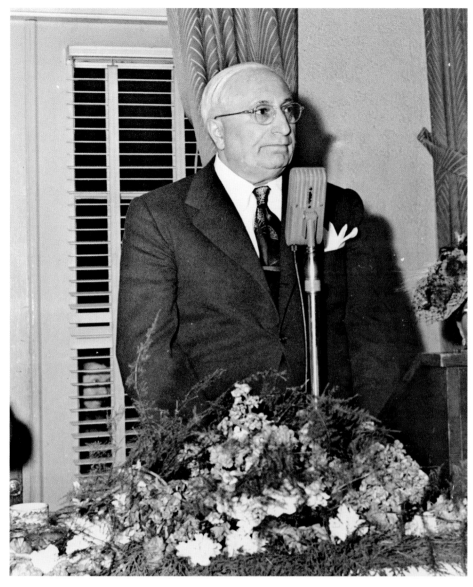

Louis B. Mayer, the film mogul and studio boss of MGM in its golden years during the 1930s and 1940s, shown here at the microphone at the Jewish Home for the Aged, in Los Angeles (1948).

Sam Goldwyn, born Schmuel Gelbfisz in Warsaw, Poland, came to America as a penniless teenager and rose to become a cofounder of MGM Studios and one of the most powerful men in Hollywood.

Sidney Lumet, shown in the
1930s, when he was a child
actor on the Yiddish stage in
New York, grew up to be
known as a master of the
cinema. Acclaimed for the
depth of his technical
knowledge, he has made over
forty films, including *Serpico*
(1973) and *Dog Day Afternoon*
(1975).

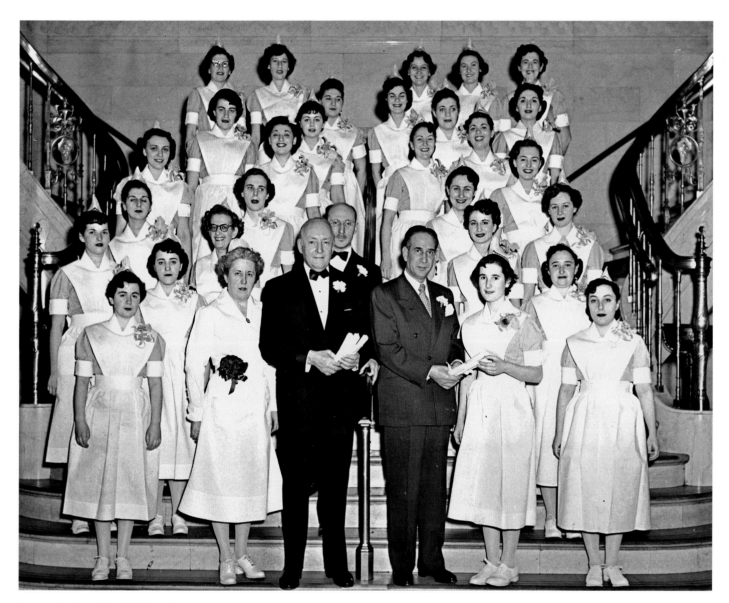

New graduates of the Beth Israel Hospital nursing school in New York. Shown with the graduating nurses are (left to right, center) Clare M. Casey, the director of nursing; Charles H. Silver, the president of Beth Israel Hospital; Dr. Maxwell S. Frank, the executive director of the institution; and Mayor Vincent Impellitteri, the principal speaker at the ceremony (1951).

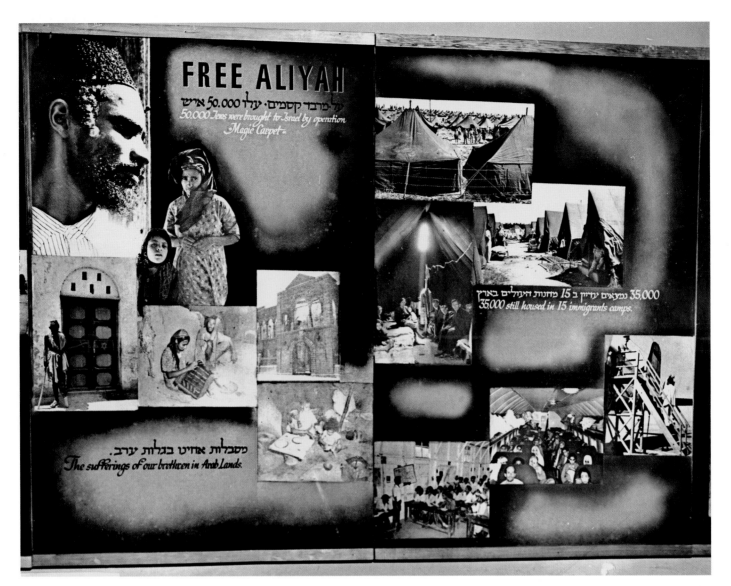

A Jewish Agency display highlighting Operation Magic Carpet, which brought fifty thousand Yemenite Jews to Israel (1951).

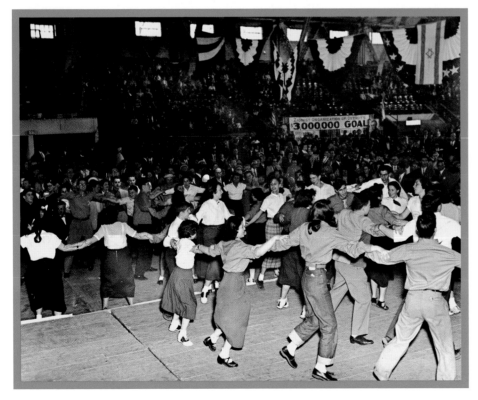

Members of Habonim Labor Zionist Youth in Detroit, Michigan, dancing the hora in celebration of Israel's third year of independence (1951).

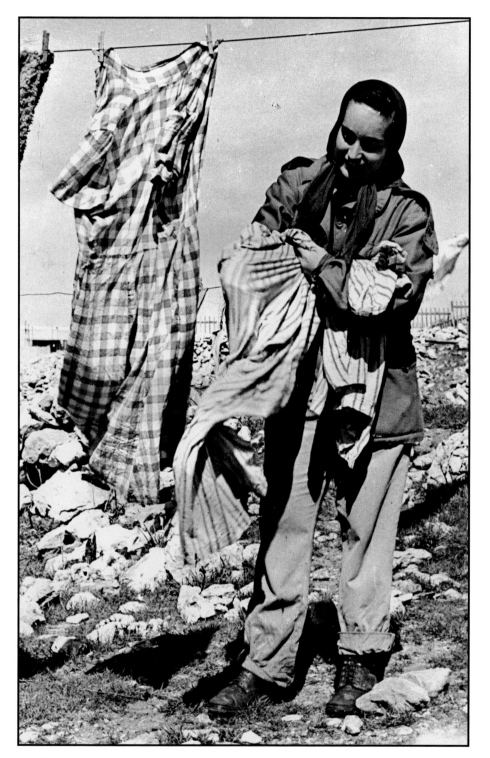

Leah Bondi, twenty-four,
from New York, hanging
clothes on a line, at
Kibbutz Sassa.

After the success of Jacob Steinhardt's exhibition at Notre Dame, the university purchased an image for its gallery by the Israeli artist titled *A Lane in Jerusalem*. In the photo: the university president, the Reverend John Cavanaugh, and the university vice-president Murphy. In the center is Henry Feferman, the president of the South Bend Federation.

A group of New York teachers who were awarded scholarships for summer courses in human relations by the National Conference of Christians and Jews. Left to right, front row: Joseph Aaron, the assistant principal of P.S. 183; Beatrice Thompson, a teacher at P.S. 2; Doris Spandau, of P.S. 61; and Dr. Sidney Rosenberg, the principal of P.S. 75, in the Bronx. In the rear center is Dr. William Jansen, of the National Conference of Christians and Jews (1953).

The actress Elizabeth
Taylor, who famously
converted to Judaism
before marrying singer
Eddie Fisher in 1959.

ADVERTISEMENTS
FROM THE PAGES OF
THE *FORVERTS*.

Abraham Dickenstein, an
oil industrialist in Texas
(1955).

Moshe Sharett, the foreign
minister of Israel, arriving at
Idlewild Airport (now John F.
Kennedy Airport) in New
York for the start of a tour
of major American cities on
behalf of the five-hundred-
million-dollar State of Israel
Independence Bond Issue.

The Mizrachi (religious Zionist) delegation to the Twenty-third World Zionist Congress, in Jerusalem. With the group is Isaac Berman, the president of Modern Tours, Inc.

SPORTS

Roger Kahn

On September 6, 1788, in the remote hill country of western Virginia, a young Jewish woman named Rachel Solomon married a veteran of General Washington's Continental army and changed the future of American sport. Rachel's groom was named John Dempsey. Their descendant William Harrison "Jack" Dempsey, born 107 years later, became the hardest-hitting heavyweight champion in the annals: fifty-three knockouts in sixty-four fights.

Jack Dempsey was proud of his Jewish heritage. He liked to say, "I'm part English, part Irish, part Indian, part Jewish—and that makes me 100 percent American." But a dark side, bigotry, rose up in 1920, the year after Dempsey won the championship. In a nasty and specious case, federal prosecutors in San Francisco charged Dempsey with draft evasion during World War I. The trial lasted eight days, and American Legionnaires crowded into the courtroom. Some maintained that Dempsey, with his black hair and swarthy complexion, was "nothing other than a shifty Levantine Jew." They said that to reporters, not to the defendant. As Ronald Reagan, a great Dempsey admirer, later remarked, "Not many people insulted Jack Dempsey to his face." After deliberating for seven minutes, the jury returned a verdict of not guilty. But the accusation itself bothered Dempsey. During World War II, at the age of fifty, he wrested a coast guard commission from FDR and hit the beach at Okinawa to defend his country.

Though Jews have starred in American sport for just about as long as American sport has existed in recognizable form, their newspaper of record didn't begin covering the field regularly until the mid-1920s. As the scholar Eddy Portnoy has noted, the intellectuals who ran the *Jewish Daily*

Forward didn't care much about sports, and ironically, their ambivalence encouraged their larger mission of assimilating Jews into America: Jewish fans were forced to read the English-language tabloids, usually the *Daily Mirror,* for their

The Brooklyn Dodgers outfielder Cal Abrams.

The Boston Red Sox catcher Moe Berg.

The Detroit Tigers catcher Joe Ginsburg.

The Hall of Fame
pitcher Sandy
Koufax.

The Cornell University
fullback Harold
Seidenberg.

The Cleveland Indians
third baseman Al Rosen,
the American League
Most Valuable Player in
1953.

sports news. In fact the *Mirror* had so many Jewish readers it occasionally printed special messages in Yiddish on the sports page.

But Jews didn't just read about sports; they played them. Lipman Emmanuel Pike batted .323 for the primordial St. Louis Cardinals of 1876 and a year later managed the Cincinnati Reds. Two of football's greatest forward passers have been Jewish: Benny Friedman, a Michigan All-American, and Sid Luckman, who went from Columbia to the Chicago Bears, where he became the first great T-formation quarterback. Many regard Benjamin Leiner as the greatest of all lightweight boxers; he fought and won his championship as Benny Leonard because, at the beginning anyway, he felt he had to hide a boxing career from disapproving parents.

The first entirely Jewish American sports icon, Hank Greenberg, hit fifty-eight home runs for the Detroit Tigers in 1938. He was elected to the Hall of Fame in 1966. Hank used to buy me lunch at the Beverly Hills Tennis Club—he had become a brilliant investor—and I always wanted to talk baseball. Large Henry—he stood about six feet four—always wanted to talk books.

Defining the impact of great Jewish athletes on the Jewish community at large is no small task. Some Jews have told me that the existence of Jewish stars makes them feel somehow more American. A more sophisticated comment came from a good Jewish Sunday softball player as he entered middle age. "Watching sports," he said, "I used to root Jewish. Now I root old."

The impact issue becomes vivid when considering two remarkable Jewish ballplayers, Sandy Koufax, the famous Dodger left-hander, and Al Rosen, an all-star third baseman in Cleveland and later the president first of the New York Yankees and then of the San Francisco Giants. Koufax told me he felt too much was made of his being a Jewish pitcher and not enough of his being "well, just a pitcher." During the 1960s, when Koufax was dominating the National League, *Time* published a long story about him. When not pitching, the magazine reported, Koufax could be found beside his portable phonograph, listening to the Mendelssohn Violin Concerto. The ethnic stereotyping infuriated Koufax, who said, "I listen to Sinatra a hell of a lot more than I listen to Mendelssohn." Later, when Koufax wrote an autobiography with Ed Linn, he eliminated all references to antisemitism, much to the dismay of Linn, who was himself Jewish and more of a sociological activist than the pitcher.

Al Rosen, the American League's most valuable player in 1953, was and is more direct. He went out for football at a Florida high school, and the coach asked why. "I love to play the game," Rosen said.

"Rosen," the coach said, "you're different from most Jews. Most Jewboys are afraid of contact."

Rosen starred in football, won boxing tournaments as a light heavyweight in the navy, and heard occasional unpleasant prattle around the major leagues. But he also found Christian teammates ready to jump at the jugulars of the (relatively few) antisemites he encountered. "I know everybody is different," Rosen told me once, "but when I was up there playing in the majors, I know how I wanted it to be about me. I wanted it to be, 'Here comes one Jewish kid that every Jew in the world can be proud of.'" The big graying man relit his pipe; intensity made the strong hands tremble.

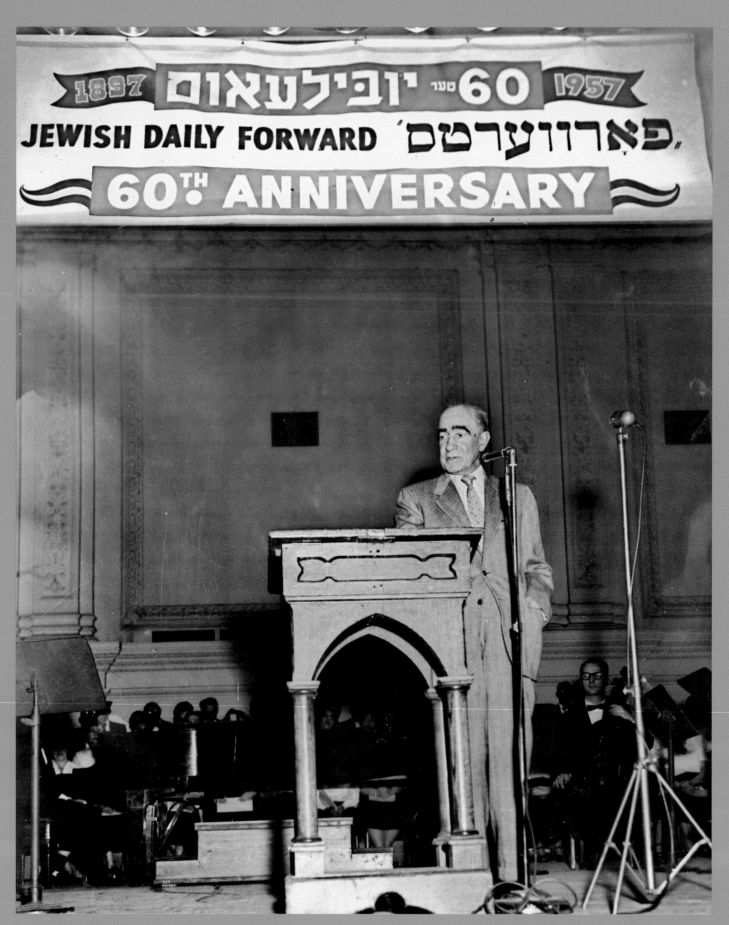

Editor Hillel Rogoff at the *Forverts*'s
sixtieth anniversary in 1957.

The overflow gathering at the Hebrew Teachers College's twenty-third commencement, the first in the new Nathan H. and Sadie S. Friedman Building at 43 Hawkes Street, Brookline, Massachusetts. In the front row (left to right) are Benjamin Ulin, the first vice-president of the Associated Jewish Philanthropies and a trustee of the college; Joseph Riesman and Judge Charles Rome, trustees. The Hebrew Teachers College is an affiliate of the Associated Jewish Philanthropies, Greater Boston.

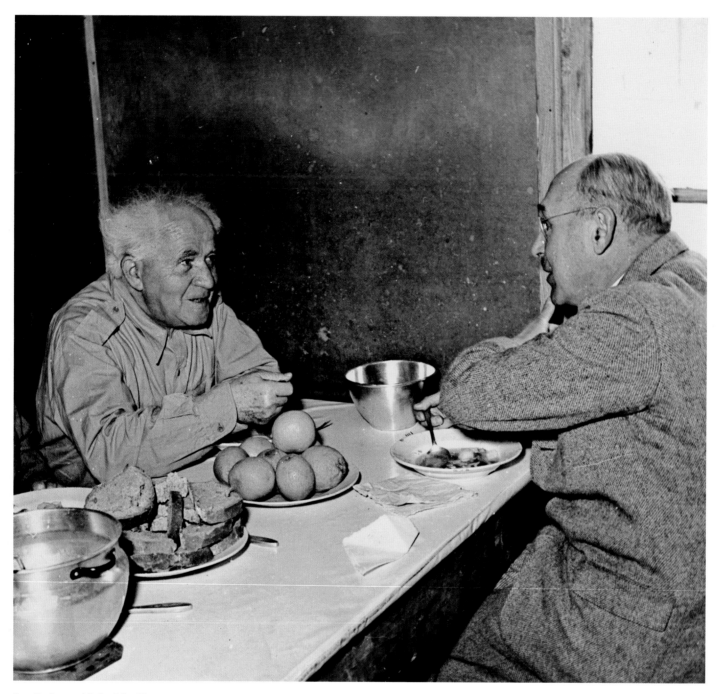

Ben-Gurion and Robert Szold
(Henrietta Szold's cousin and
a leading member of the
American Economic
Committee for Palestine)
enjoying a meal at Ben-
Gurion's kibbutz dining
room table.

Sadie Korn standing
beside the ambulance she
donated to Magen David
Adom in memory of her
husband and son (1972).

Cantors and cantorial music were popular with the American Jewish community, and the *Forverts* covered the beat assiduously. When the archive was reopened, researchers found two drawers full of detailed material on the subject, including hundreds of index cards with individual cantor profiles.

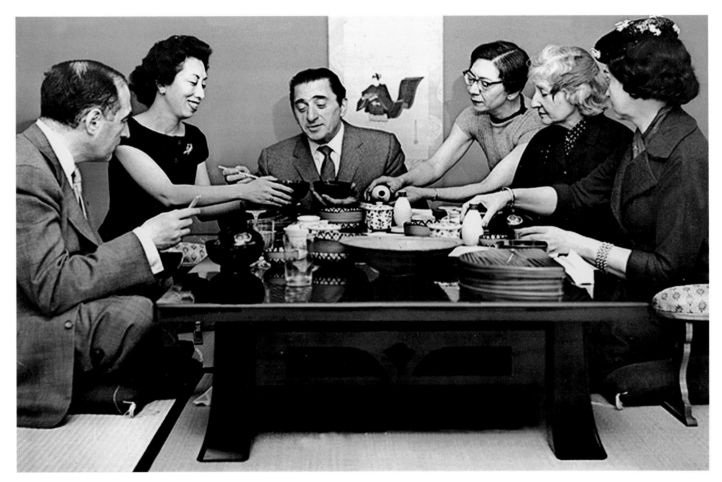

The cantor/opera singer Jan Peerce on tour in Japan with his wife (second from right) and accompanist, Warner Bass.

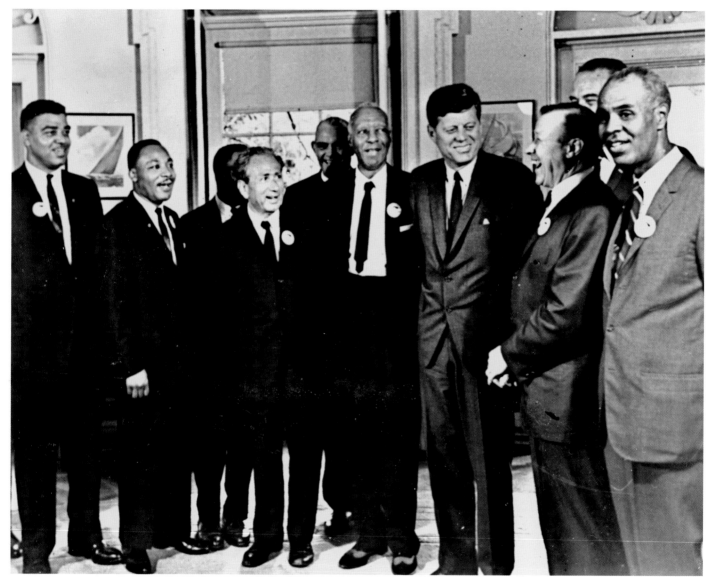

John F. Kennedy meeting with
civil rights leaders before the
1963 March on Washington.
Including, from right: Roy
Wilkins, Lyndon B. Johnson
(partly obscured), Walter
Reuther, John F. Kennedy,
A. Philip Randolph, Rabbi
Joachim Prinz, Martin Luther
King, Jr., and Ralph Abernathy.

Shortly after JFK was assassinated, the mourning bunting went up on the Forward Building (1963).

In 1904 Judge Mayer Sulzberger donated twenty-six Jewish ceremonial objects to found a Jewish museum. In 1944 Frieda Schiff Warburg, the widow of the businessman and philanthropist Felix Warburg, donated the family mansion on Fifth Avenue at Ninety-second Street (below) to house the collection. *Left*: Julius Hochman of the Joint Dress Board; Louis Hollander of the New York State CIO; Dr. Stephen Kayser, curator of the Jewish Museum; and Dr. Louis Finkelstein, chancellor of the Jewish Theological Seminary, looking at a unique sixteenth-century Torah ark from Urbino, Italy, on display at the museum.

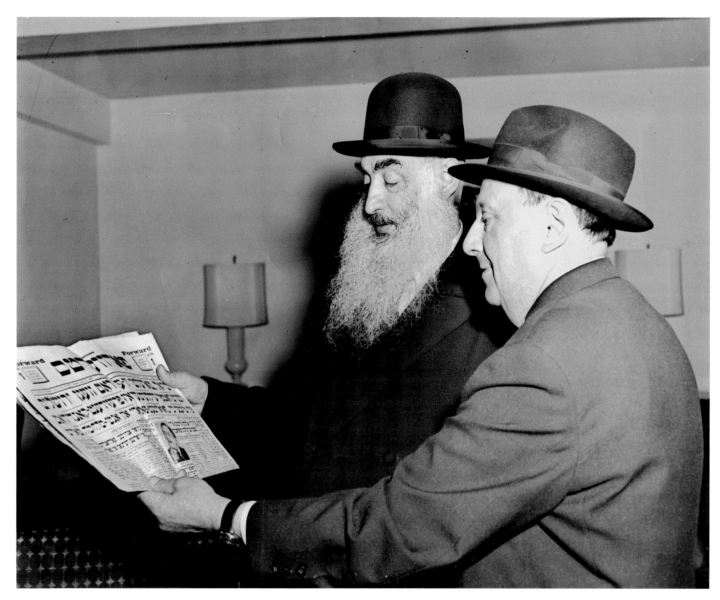

Soviet Chief Rabbi Yehuda
Leyb Levin (left), looking
at the *Forverts* headlines
with the writer Yitshak
Shmulevitsh, at the time
of Levin's historic 1968
visit to the United States,
a breakthrough gesture by
Soviet authorities.

Abraham Cahan's
centennial celebration.
Speaking at the podium is
Alexander Kahan, and
seated to the right are
Hillel Rogoff, David
Dubinsky, and Adolph
Held.

Stage shot of the Israeli
singer Yaffa Yarkoni, Tel
Aviv (1960s).

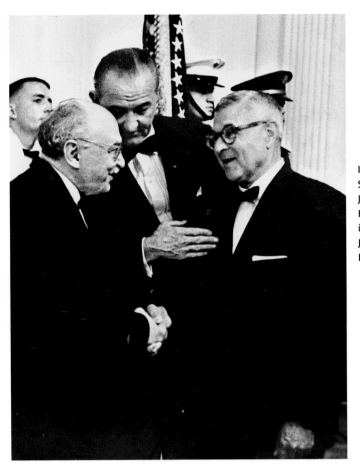

Israeli president Zalman Shazar visiting Lyndon Johnson at the White House in 1966. With them is the philanthropist and Johnson adviser Abraham Feinberg.

Israeli president Zalman Shazar and Pope Paul VI exchanging gifts at Megiddo during the pope's 1964 visit to Israel. At far right is Israeli prime minister Levi Eshkol.

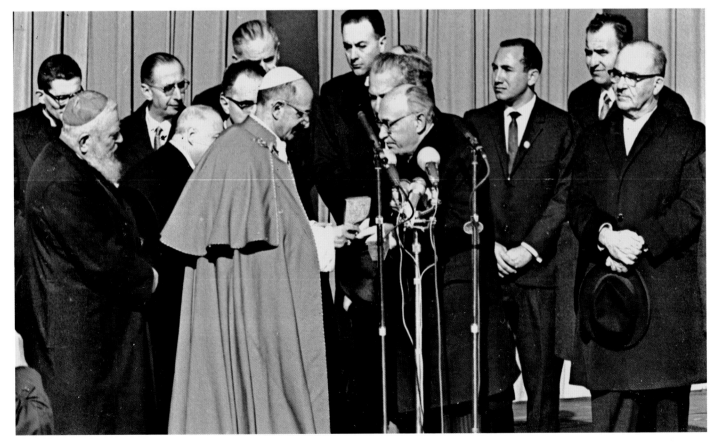

Sharm el Sheikh, in the
southern Sinai, flying the
Israeli flag after the 1967
Six-Day War.

Former Treasury secretary
Henry Morgenthau, Jr.,
shaking hands with an
admirer. To his right, in
white yarmulke, is his son
Robert Morgenthau,
future U.S. attorney and
Manhattan district
attorney.

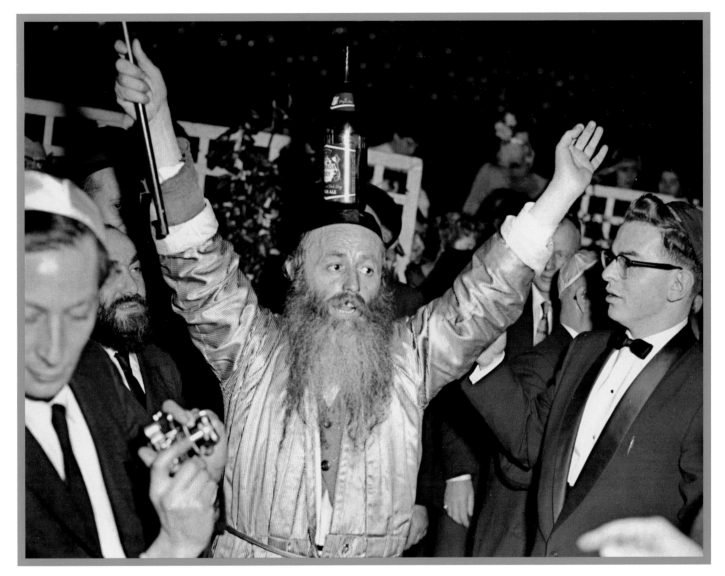

A more boisterous affair:
the bottle dance at a
Jewish wedding.

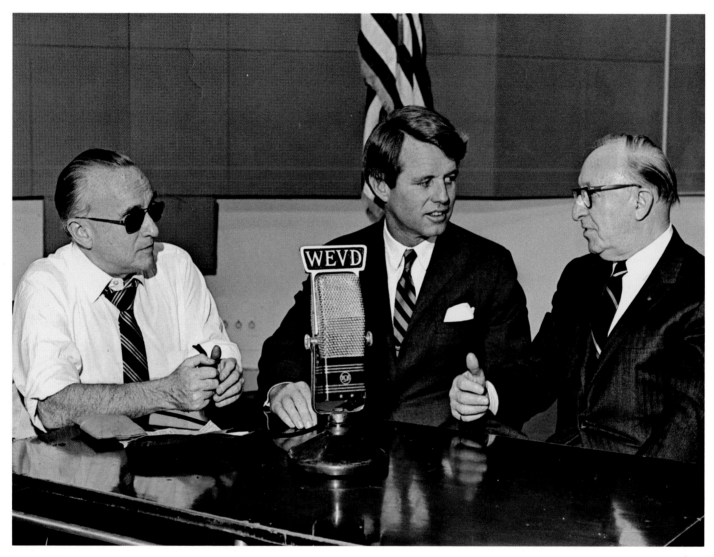

Robert F. Kennedy in the
WEVD studio a week
before his assassination.

HOLY HOLLYWOOD

Leon Wieseltier

The story of the contribution of Jews to the high culture of their host countries in the diaspora has been told many times. The more surprising story is the one about the Jewish contribution to the low culture of their surroundings. It was Heine who taught modern Germany to love its own folk poetry. But it is in America that the Jewish gift to the national mythology has been the most prodigious. Consider only the roster of the first moguls (a fine oriental term for people deemed alien) in Hollywood: Goldwyn, Laemmle, Lasky, Loew, Mayer, Zukor, Warner, Cohn, Thalberg, Selznick. Immigrants, or sons of immigrants, all. What uncanny talent for cultural intuition enabled these men to get off the boat and proceed to show America what it is? The first movie cowboy was born Max Aronson. The first movie vamp was born Theodosia Goodman. All this cultural clairvoyance is a beautiful mystery. I discovered the mystery as a lucky boy in Brooklyn, where I had no idea that the uptown black experience described in the singles of the Drifters and the Ronettes and the Crystals and the Shirelles was actually the work of a bunch of fiendishly gifted Jewish kids in the Brill Building, some of them from my own streets. How on earth did they know what Spanish Harlem felt like? This was the first argument for universalism that I ever learned.

Bob Dylan at a press conference in London (May 1966).

The prominence of Jews in entertainment is often attributed to their marginality and their victimization. Whatever this explained about Jews and entertainment once upon a time, it explains nothing now. American Jews are neither

President John F. Kennedy and Barbra Streisand at an event on May 24, 1963.

The composer Irving Berlin at his piano (August 1948).

Marilyn Monroe and husband Arthur Miller driving in a Thunderbird on their way to Connecticut shortly after they were married.

Neil Simon (left) and Mike Nichols after a performance of *The Odd Couple*.

marginal nor victims. It is no longer suffering that makes them need to laugh. They must find a new excuse, and when they fail to find one, they pretend that the old excuse is still good. This is one reason why American Jewish culture is increasingly a culture of commemoration.

The happiest Jews in the world are the ones who have no basis for morbidity but continue to feel morbid.

The relationship of suffering to laughter is famously complicated. For the ancient rabbis, laughter was the cause of suffering. They warned that the wages of *leitzanut*—clowning or joking (or scoffing, as if they had foreseen the enormous quantity of negative energy that would attach to so much Jewish comedy)—would be hardship, damnation, and even the end of the world. Everybody's a critic. Eventually the explanation was reversed, as we came to believe that hardship, damnation, and the end of the world are the causes of our jokes. But this too is an assault on the possibility of pure play. Neither of these accounts of the relationship of suffering to laughter emancipates Jews for lightness. When somebody described Groucho Marx as the "symbolic embodiment of all persecuted Jews for two thou-

sand years," he retorted, "What sort of goddamned review is that?" A mixed review, I would say.

By the grim measure of Jewish history, inner suffering is a luxurious kind of suffering; but still it is no less real than outer suffering. The security of American Jewish life should not require that American Jews become moronically content and grateful. The psychic wounds out of which much American Jewish entertainment is made cannot be denied. And yet much of this entertainment has lacked the force, the integrity, of genuine darkness. Lenny Bruce was anguished. But Woody Allen? He is merely needy.

The neediness of many of the American Jewish men who have achieved stardom is deeply unattractive. From Woody Allen to Larry David, American popular culture has rewarded American Jewish men for an interminable narcissism and an incomprehensible fear of women. To extenuate their own nastiness, they paint a nasty world. They ask two questions of the universe: "What do I want?" and "What do women want?" Neither of these questions is fundamental or terribly interesting. The male heroes of American Jewish entertainment—not all of them, but a striking number of them—have been curiously lacking in character, as if character were incompatible with rebellion or amusement. *Portnoy's Complaint* is preternaturally funny and a masterpiece of "voice," but the fictional clinical document is itself a nonfictional clinical document. We may not be as big as people who fortify themselves against persecution, but we need not be as small as people who fortify themselves against frustration.

And over in the other corner, Zero Mostel. Against all the witty, horny analysands, there is the spiritual power of the meshuggener. He is the rarest, and the only really free, Jew in the business.

American Jewish entertainment is made by, and for, mere ethnics. But we are not only ethnics. Jews demean themselves when they regard themselves only from the standpoint of ethnicity. They reduce Jewish identity to a collection of cherished quirks, to a sentimental anthropology. And the ethnic interpretation of the Jewish difference also leads to a kind of internal relativism, according to which all expressions of Jewishness are equally valuable. You love Maimonides, I love

Woody Allen and Ursula Andress at the Twentieth Royal Film Performance, in the Odeon, London (March 1966).

Philip Roth revisiting places where he grew up in Newark, New Jersey (December 1968).

knishes, and cheerfully we are Jews together. Except that the disappearance of Maimonides would damage us, and our children, much more grievously than the disappearance (*lo aleinu*!) of knishes. We are not what we eat. We are what we think. I am not saying that we always need the high and never need the low. Our culture, like every culture, must also be a system of enjoyments. So eat, eat. But we must retain a hierarchical assessment of our possessions. Loving the low must not have the effect of elevating it into the high. (Where, then, would we relax?)

Zero Mostel (right), as Max Bialystock, and Gene Wilder, as Leo Bloom, in Mel Brooks's 1968 film *The Producers*.

Relaxation is so foreign to the Jewish tradition that it could be enforced only by being sanctified. We permit ourselves to rest when God permitted himself to rest. Some rest!

The pride of the Jewish community about its contribution to show business still displays an old apologetic tone. Behold our success, our influence! But in this instance we are boasting about our indispensability to some of the shabbiest and most shallow features of American life.

The Jews always take on characteristics of their host culture. Why should the Jews in America be any different? America is addled by entertainment, and so are America's Jews. The cultural and even moral authority that American Jewry has granted to its actors and singers and comedians is ludicrous, a community-wide laxity. Could it be that Jewish popular culture waxes as Jewish high culture wanes? In no community in the history of the diaspora has Jewish high culture—I mean Jews knowing Jewish texts and Jewish traditions in Jewish languages—melted away as much as in America, and here we are pointing with pride to . . . Larry David. It adds up.

Why would you make fun of something about which you know nothing? To squash the obligation of knowledge, I guess. But a wicked joke about what one truly knows: there is no pleasure quite like it.

We recoil from some stereotypes, and we revel in other stereotypes. The indefatigable but smothering Jewish mother, the noble but exhausted Jewish father, the angry and ambitious and aroused Jewish son, and so on: these too are stereotypes. A portrait of Jewish life is not finer or truer or smarter because Jews produce it. (And not everything that a Jew expresses is a Jewish expression.) Our self-images can be just as crude and injurious as other people's images of us.

It is redundant to celebrate popular entertainment in America, since so much of it already consists in a celebration of itself, and the same is true of Jewish popular entertainment. It does not need more worship.

The unimportant things in life are also important. That is perhaps the best defense of the centrality of entertainment in America. To which the reply must be made: The important things are also important.

The entertainer Sammy
Davis, Jr.

The actor Fyvush Finkel.

Leo Rosten, the author of
The Joys of Yiddish.

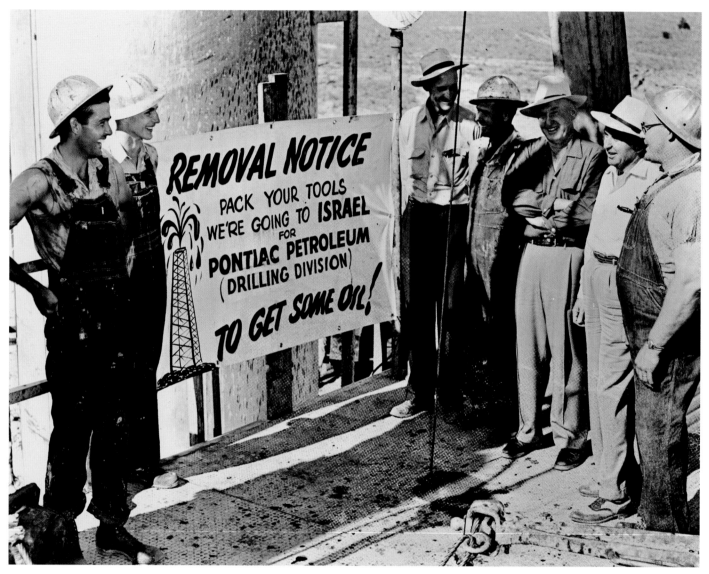

Laborers standing with
administrators at the site
of an oil well in the field.

RAISE FUNDS FOR YOUR ORGANIZATION!

RAYMOND ARIEL—LAWRENCE TOPPALL PRESENT

YiDDLE WITH A FiDDLE

OPENS OCTOBER 24

WITH AN ALL STAR CAST.

THE NEW MUSICAL IN ENGLISH WITH A "YIDDISH FLAVOR"
Based on the 1936 popular Yiddish film by Joseph Green
starring MOLLY PICON

THE BIGGEST HIT TO OPEN ON BROADWAY NOW AVAILABLE FOR GROUPS

BOOK NOW

BOOK & LYRICS
ISAIAH SHEFFER

MUSIC
ABRAHAM ELLSTEIN

DIRECTOR
RAN AVNI

CHOREOGRAPHER
HELEN BUTLEROFF

TOWN HALL 123 West 43 Street
NEW YORK, NY 10036

FOR INFORMATION:
CALL: (212) 563-4721

אבאנירט דעם „פֿאַרװערטס"

Mounted copy of
advertisement for a
Broadway musical in English
based on a movie in Yiddish,
Yiddle with a Fiddle.

Irving Howe, born Irving Horenstein, a member of the legendary New York intellectuals. Howe, a professor of literature at CUNY, was also an editor of Yiddish literature whom many credit with introducing Isaac Bashevis Singer to English-speaking audiences.

The New York
congresswoman and
activist Bella Abzug.

The prime minister of Israel (1969–1974) Golda Meir and the future New York City mayor Ed Koch.

Two Israeli police officers conducting traffic in Times Square as a New York police officer stands in the center and observes stoically.

Rally outside
Congregation Kehillath
Jeshurun, New York, to
protest the hanging of
nine Iraqi Jews on spying
charges (January 1969).

Seventy-fifth anniversary group
portrait of members of the
Forward Association, Workmen's
Circle, and the *Forward*
newspaper. From left: Paul
Rubinstein, Irving Fogel, Dr.
Samuel Silverberg, Ho Sobotko,
and the editor Shimon Weber.

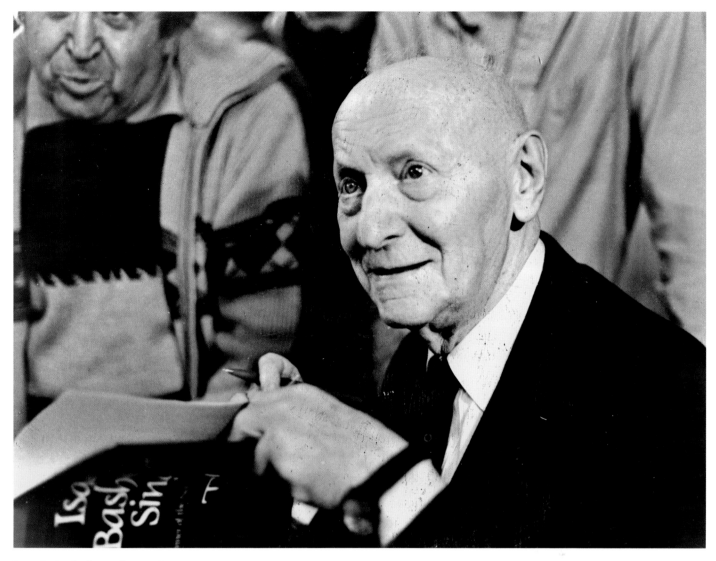

Isaac Bashevis Singer, the novelist and short story writer who in 1978 became the only Yiddish author to win a Nobel Prize in Literature. Singer was brought to America by his brother, *Forverts* staff writer Israel Joshua Singer, and editor Abraham Canan, who tasked him with everything from advice columns and journalism to short stories and serialized novels. Even after he earned renown and was sought by editors at *The New Yorker*, *Harper's*, and *Playboy*, among others, Singer always first published his work in the Yiddish paper.

Although Singer was beloved by readers and critics, some within the Yiddish world resented his dark portraits of Eastern Europe and viewed his decision to translate his work into English as a betrayal of Yiddish. Many believe that Singer's contemporary Chaim Grade (left) was more deserving of acclaim.

The singer Hanna Ahroni
seated on a military jeep
with five Israeli soldiers.

The Israeli transport minister and future prime minister Shimon Peres presenting his book *David's Sling* to the New York City mayor John Lindsay (1970).

The Four Bursteins, a troupe composed of the famed actor Pesach'ke (Paul) Burstein, his wife, Lillian Lux, and their twin children, Michael and Susan, made a name bringing "classical Jewish opera" to Yiddish-speaking enclaves of South Africa, South America, Europe, Australia, Israel, and the United States. *Right*: Lux and Burstein in a song-and-dance pose (1960).

An overview of the dais and ballroom at the *Forverts's* eightieth
anniversary banquet in 1977.

FOUR

1974–1989

I N 1 9 7 4 T H E *Jewish Daily Forward* moved out of its historic
building on East Broadway, lowering the curtain on an era.
But another era, one of the stormiest in Jewish history, was
just beginning.

The Yom Kippur War in October 1973 had brought the world to
the brink of nuclear confrontation. In its wake came a series of
shocks—the Arab oil embargo, the Islamic Revolution in Iran, the
Lebanon War—that placed the Middle East and Israeli security at
the top of the world's agenda.

Jewish concerns became central to the U.S.-Soviet cold war too,
thanks to a mass American mobilization on behalf of Russian Jewry.
In 1974 activists won congressional passage of a measure, the
Jackson-Vanik Amendment, that made U.S.-Soviet trade relations
dependent on Soviet Jewish emigration rights. American Jews
seemed to be perpetually at the center of the storm, in a near-
constant state of political alert.

Within the community it was a time of ferment. Powerful social
forces like feminism were changing the face of Judaism; 1974 saw
the ordination of the first woman rabbi, Sally Priesand. As barriers
between Jew and non-Jew fell away, there was an explosion of
interfaith marriage, prompting a host of nontraditional Jewish
responses from easing the rules of conversion to accepting children
of non-Jewish mothers as Jews. The changes created unprecedent-
ed strains between Orthodoxy and other wings of Judaism.

Amid the turmoil the Yiddish *Forverts* fought a rearguard action
to maintain its audience. In 1983 the paper cut back to a weekly
publication schedule and launched a weekly English-language sup-
plement that it hoped would appeal to the new generation.

Members of the International Union of Electricians (IUE), the New York City Central Labor Council (NYC CLC), and the International Ladies' Garment Workers' Union picketing outside the Salvation Army.

New York City Mayor David Dinkins presenting Jewish children's games (January 31, 1991).

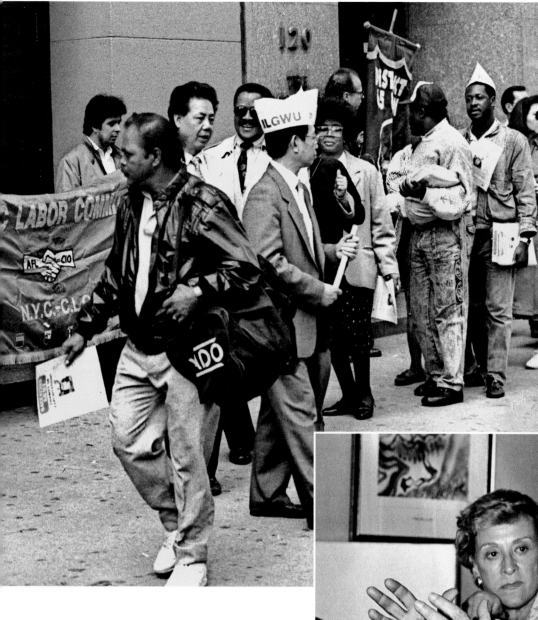

Yitzhak Shamir, Israel's prime minister from 1983 to 1992, in side profile, with unidentified woman.

The mayor of Jerusalem, Teddy Kollek, speaking, flanked to his left by Senator Joseph Lieberman; Dr. Norman Lamm, the president of Yeshiva University; and philanthropist Ludwig Jesselson, in front of a model of the Old City of Jerusalem.

Two Hasidic boys in front
of a sign that reads, in
part: ON EAGLES' WINGS.

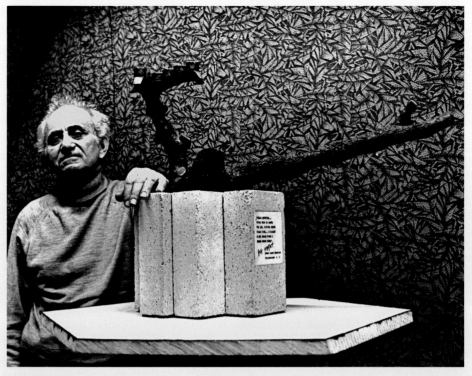

The sculptor Efrim Levit
and his model of a
monument dedicated to
Jews killed under Stalin's
regime (March 1991).

Morning Hebrew
lesson. Two little girls on a
bed look at a book in
Hebrew (March 1991).

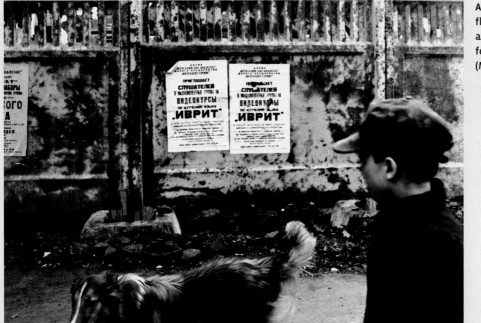

A boy and his dog pass by flyers on a wall advertising video courses for the study of Hebrew (March 1991).

The artist Anna Zilberman posing in front of one of her paintings.

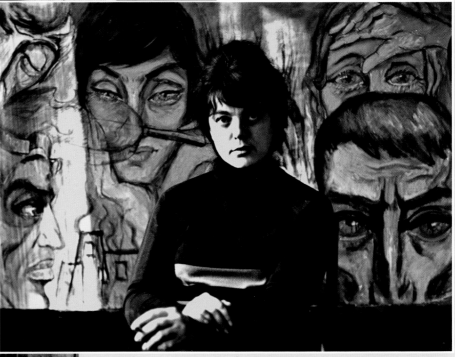

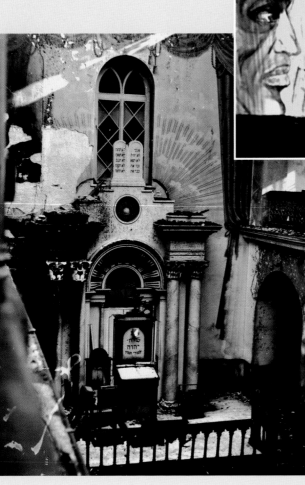

View of a synagogue in Odessa that was ruined by fire in October 1972.

Learning Talmud at a synagogue in Odessa (March 1991).

Headstone in a Jewish cemetery (March 1991).

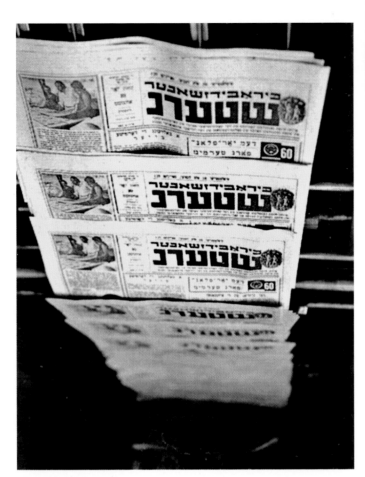

Elie Wiesel accepts an award from Samuel and Judith Pisar, as Benjamin Meed looks on. Meed and his wife, Vladka, and the Pisars are survivor leaders active in Holocaust remembrance.

A press run of the *Birobidzhaner Shtern*, the daily Yiddish-language Communist newspaper published in the Jewish Autonomous Region, Soviet Union. *Below*: a modernist newstand.

POLITICS

Nathan Glazer

TOWARD THE END of the 1960s the political face of the American Jewish community began to change. The passionate activism that had been devoted to unions and to civil rights now developed a new focus: defending Israel.

The shift was the result of several converging factors. The turbulence of the 1960s, while initially attractive to many Jews, began to raise alarms as the New Left took an increasingly antidemocratic turn, blacks turned in large numbers from civil rights to black power, and American cities erupted in violence. By the late 1960s the black power movement was showing signs of overt antisemitism, leading to an open break between black and Jewish leaders. Organizations like the American Jewish Committee, which had been in the forefront of civil rights and other liberal causes for decades, now began questioning their alliances. Its prestigious monthly magazine, *Commentary*, championed the new spirit of caution and doubt. Edited by Norman Podhoretz, it evolved from a liberal journal into a standard-bearer of what became known as neoconservatism.

No single event, however, affected the political complexion of the Jewish community more deeply than the Arab blockade of Israel in May 1967, leading up to the Six-Day War. For a month Israel was isolated and seemingly at the mercy of neighboring states that openly threatened to annihilate it. The specter of another genocide coming barely two decades after the Holocaust, while the world once again stood silent, was emotionally shattering.

Israel won the war, of course, but the trauma of the isolation and fear in the weeks before the war lingered for years. Jewish liberals lost whatever illusions they might still have had about the Soviet Union, which had allied itself with Israel's worst enemies. Growing sympathy for the

Senator Daniel Patrick Moynihan of New York presenting Chaim Herzog, the president of Israel, with a copy of the Senate resolution he sponsored in 1987, demanding repeal of the 1975 UN resolution equating Zionism with racism. Moynihan and Herzog served as their countries' UN ambassadors in 1975. Flanking them are Lester Pollack (right) and Rabbi Michael Miller (left), head of the New York Jewish Community Relations Council.

Palestinian cause among American radicals forced Jewish leftists to reconsider their loyalties.

Across the ocean, Jews in the Soviet Union itself, silenced by decades of Communist repression, experienced a new awakening after the Six-Day War and began demanding the right to practice Judaism and to leave for Israel. Their struggle inspired American Jews to rally in support, and by the early 1970s the cause of Soviet Jewish freedom had a mass following.

In October 1973 Israel was again threatened with defeat when Egypt and Syria launched a surprise attack in the Yom Kippur War. The casualties of the war were stunning for

President Ronald Reagan meeting with a delegation of Orthodox Israeli Knesset members.

Left to right: Morris Abram, the chairman of the Conference of Presidents of Major Jewish Organizations; Moshe Arad, Israeli ambassador to the United States; Howard M. Squadron, the chairman of the National Committee for Israel's Fortieth Anniversary; and Malcolm Hoenlein, the executive director of the Presidents' Conference, presenting Vice President and Mrs. George H. W. Bush with a signed etching by the Israeli artist Amram Egbi, in Washington on May 24, 1988.

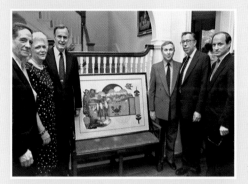

Israel; in less than three weeks of warfare they matched, as a percentage of its population, American losses in ten years of war in Vietnam. Israel survived, but it was severely shaken and was becoming more and more dependent on the United States. With the Soviet Union firmly aligned with Egypt, the administration of Richard Nixon put its full weight behind Israel. At the height of the war the Nixon administration promised Israel $2.2 billion in aid, both to help Israel replenish its military stocks and to send Moscow a signal of American determination. The aid figure became an annual norm, eventually rising in the 1980s to $3 billion. American financial and diplomatic support became the life's blood of Israel. American Jews threw their full weight into securing the United States–Israel alliance through lobbying, financial support for political candidates, and every other tool of modern politics.

For the next three decades those three themes—identification with Israel, close alignment with Washington, and intense hostility toward Moscow—defined American Jewish political activism.

Jewish political activism in this period represented a paradox. American Jews had come into their own during and after the New Deal, and they remained loyal Democrats. But in the decades that followed the Six-Day War, Washington was governed almost continuously by Republican presidents. There was one brief Democratic interregnum when Jimmy Carter, a southern Christian governor, became pres-

ident in 1977. Jews did not warm to Carter; he was not quite their kind of Democrat. But neither did American Jews warm to Republicans, and the feeling was mutual. Republicans had long been seen as the party of isolationism abroad and elitism and exclusion at home.

Although most Jews did not notice it at first, the Republican Party was changing. President Nixon had named a Jewish refugee from Germany, Henry Kissinger, his secretary of state. He had stood up to the Russians during the Yom Kippur War and escalated aid to Israel into the budgetary stratosphere. Still, many Jews remained suspicious. Kissinger, after all, was a master of realpolitik, a far cry from the idealism that had been American Jews' watchword for decades. Jewish liberals, still a majority within the community, disliked Kissinger's handling of the Vietnam War. Some were angry that he had stopped General Ariel Sharon from destroying a surrounded Egyptian Army, even though Kissinger was convinced that sparing Egypt the humiliation it had suffered in 1967 could increase the chance for peace. Most Jews distrusted Kissinger's postwar shuttle diplomacy, which brought Egypt and Israel into a sort of dialogue and may have paved the way to the most striking change in Israeli-Arab relations in this period: Egyptian president Anwar Sadat's visit to Jerusalem in 1977 and the peace signed between Israel and Egypt under the sponsorship of President Carter in 1979.

Many Jews were resentful too of what they saw as Kissinger's obstructionist role in the Soviet Jewry struggle. In 1974 Jews were working hard for congressional passage of the Jackson-Vanik Amendment, sponsored by a hawkish Democratic senator from Washington, Henry Jackson, which made U.S.-Soviet trade relations dependent on Soviet liberalization of Jewish emigration. Kissinger actively opposed the amendment, seeing it as a threat to his policy of U.S.-Soviet détente. The amendment passed Congress, nearly unanimously, representing a high point in Jewish political activism and sending a signal around the world that American Jews were a political force to be contended with. But the struggle further embittered relations between Kissinger and the Jewish community leadership.

Nevertheless, things were changing there too. The neo-

conservative movement, which had begun in the 1960s with a handful of intellectuals like Podhoretz, Irving Kristol, and me, was beginning to spread its wings. (It should be noted, though, that neoconservatism in the 1970s and 1980s concerned itself primarily with domestic issues, like affirmative action; it later morphed into a movement that dealt entirely with foreign policy, defined as a tougher attitude toward the Soviet Union. I was not identified with this later neoconservatism.) In 1972, when Nixon was running against the dovish senator George McGovern, Milton Himmelfarb wrote in *Commentary* that a McGovern victory would be bad for Israel. (I wrote another article disputing him and supporting McGovern.) Elliot Abrams, an ambitious young Harvard Law School graduate, organized a Democrats for Nixon advertisement in 1972, and a number of well-known Jewish intellectuals signed it, most prominently Kristol and Gertrude Himmelfarb. Abrams and other ambitious young activists went to work for a handful of hawkish Democratic senators, such as Jackson and Daniel Patrick Moynihan, who were making anticommunism respectable once again. By 1980, when Ronald Reagan ran for president, he was able to secure fully 40 percent of the Jewish vote. No less significant, the Democratic incumbent,

Carter, won only 49 percent of the Jewish vote. This was the first time since World War I that a Democrat had won less than half the Jewish vote.

It would be a mistake to suggest that Jews became Republicans at the end of the their political journey. They remained overwhelmingly liberal on issues of domestic policy, from taxes to abortion rights to church-state separation. Most continued to vote for Democrats; indeed, George H. W. Bush, running for reelection in 1992—just a year after his successful war against Iraq—received only about 12 percent of the Jewish vote, the lowest of any Republican since Barry Goldwater in 1964. Jews continued to vote solidly Democratic throughout the 1990s and into the next century. In Congress all but two of the Jewish senators and all but one of the two dozen Jewish House members were Democrats.

But if Jewish politics had not become conservative, it had at least become more complicated. Neoconservatives, while still a minority, played an outsize role in national affairs and in the internal debates of the Jewish community. As for the left, its continuing fascination with the Palestinians and third world revolutionaries made it an unpalatable ally.

One must note that during this period, as in the years since, one great issue in American Jewish politics, prejudice and discrimination, had simply disappeared. It was the most natural thing in the world to expect Americans, waiting on long lines for gasoline and paying more for it in 1973 and 1974, to blame the Jews—after all, it was the Yom Kippur War that had sparked the crisis—but they didn't. Even the arrest in 1985 of Jonathan Pollard, an American Jew who had been spying for Israel, failed to touch off a noticeable wave of antisemitism. On the contrary, Jews had entered every corner of American society by 1990. There were ten Jews in the U.S. Senate, enough to form a prayer minyan. Jews were showing up as deans and presidents of exclusive universities that had discriminated against Jews as recently as the 1950s. Antisemitism had simply disappeared as a major issue in Jewish life.

A rally for Soviet Jewish rights organized by New York trade unions. Fourth from the left, in shaded glasses directly under the teachers' union banner, is the *Forward*'s general manager, Harold Ostroff.

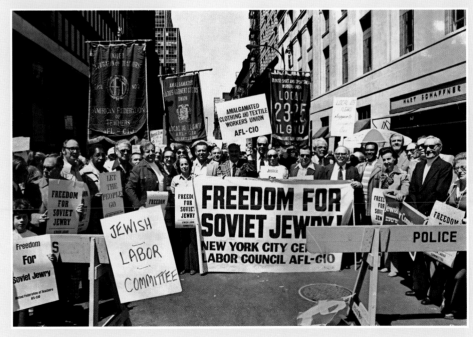

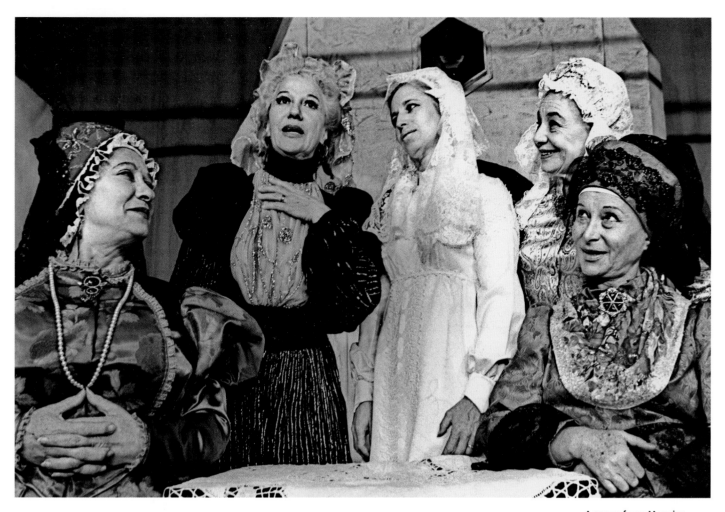

A scene from Maurice Schwartz's stage adaptation of I. J. Singer's novel *Yoshe Kalb* at the Eden Theatre. Actresses include Reizel Bozyk (far left), Miriam Kressyn (second from left), and Shifra Lerer (far right).

The Yiddish stage veterans Miriam Kressyn (left), Molly Picon (center), and Seymour Rechtzeit (right) at a celebratory dinner.

An Orthodox Jewish boy
getting a slice of pizza in a
kosher pizza shop in
France.

The Danish ambassador Peter D. Dyvig, at the site of the planned United States Holocaust Memorial Museum, marks the arrival of the *02*, the boat that saved the lives of seven hundred Jews in the famed Danish boat rescue during World War II. Seated (from right) are Leo Goldberg, of New York, who was rescued during the Danish operation; the Swedish ambassador, Anders Thunborg; and the U.S. Holocaust Memorial Council chairman, Harvey M. Meyerhoff.

From 1986: a visual of a neo-Nazi computer game, with Adolf Hitler's face displayed onscreen. The rise of computers and the Internet gave an unexpected and alarming boost to previously scattered extremist groups.

Mayor Ed Koch, members of his administration, and members of the New York Holocaust Memorial Commission and Museum of Jewish Heritage reviewing the final design for the museum and memorial. Left to right: James Polshek, architect; Herbert P. Rickman, mayoral adviser; Doran Gopstein, New York City Law Department; George Klein, cochairman, museum and memorial; and David Altshuler, executive director.

Workers at Liberty State Park in Jersey City, New Jersey, putting the final touches on the Liberation Monument, a fifteen-foot-high, two-ton statue of an American soldier carrying a concentration camp survivor to freedom, which was formally dedicated at the park on May 30, 1985.

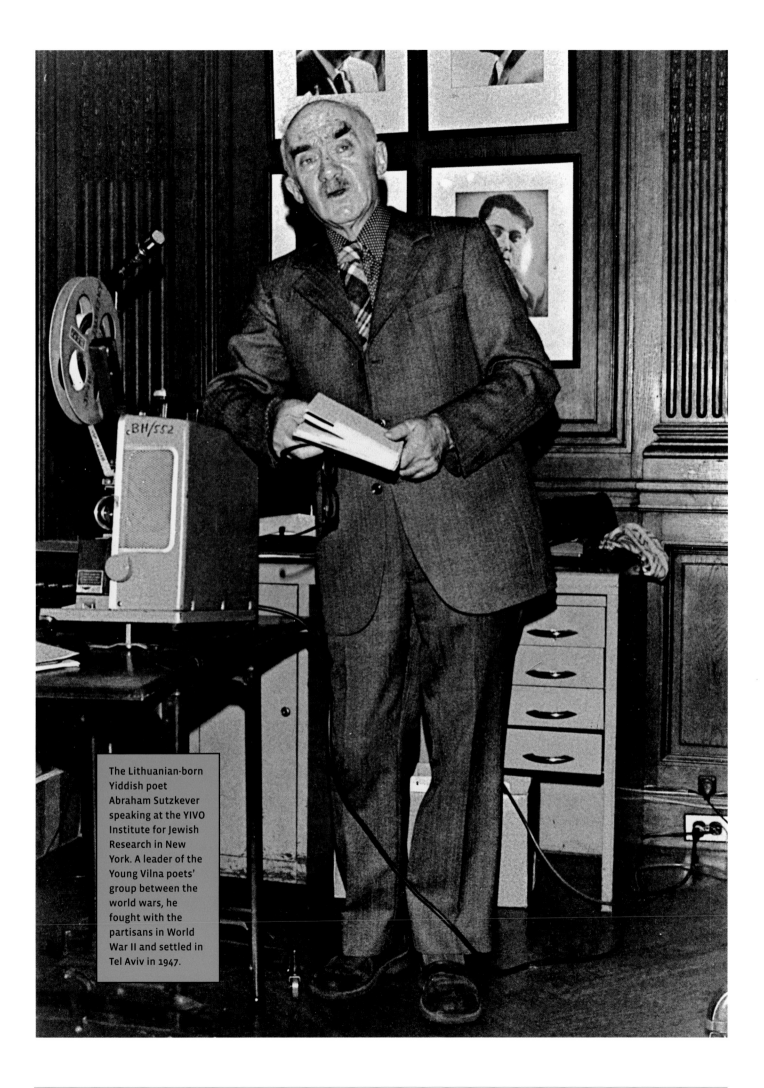

The Lithuanian-born Yiddish poet Abraham Sutzkever speaking at the YIVO Institute for Jewish Research in New York. A leader of the Young Vilna poets' group between the world wars, he fought with the partisans in World War II and settled in Tel Aviv in 1947.

Governor Mario Cuomo meeting constituents in Albany, New York.

WEVD's Art Raymond interviewing the New York politician Elizabeth Holtzman.

Brooklyn congressman (and future senator) Charles Schumer addressing a public affairs forum for senior citizens, sponsored by an arm of New York's Federation of Jewish Philanthropies (January 1990).

Joseph Greenstein, aka the Mighty Atom, the world-famous strongman and wrestler.

Rosh Hashanah card, written in Yiddish and Russian, from the board of the Rovno Yiddish Cultural Association. Published in 1989, the final year of the Communist regime, the card wishes a happy year to readers, their families, and "our socialist homeland." Note Soviet-mandated, phonetic Yiddish spelling in Hebrew words *mishpokhe*, *sholem*, and *brokhe*.

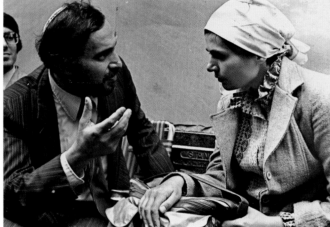

During the 1982 hunger strike on behalf of the imprisoned Soviet dissident Anatoly (later Natan) Sharansky, Rabbi Avi Weiss of the Hebrew Institute of Riverdale comforted Sharansky's wife, Avital. Thousands participated in the weeklong vigil, coordinated by the Student Struggle for Soviet Jewry.

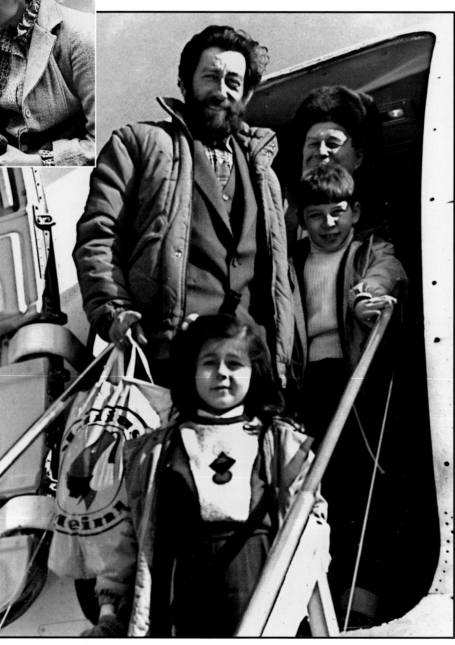

Soviet immigrants, smiling as they exit an airplane.

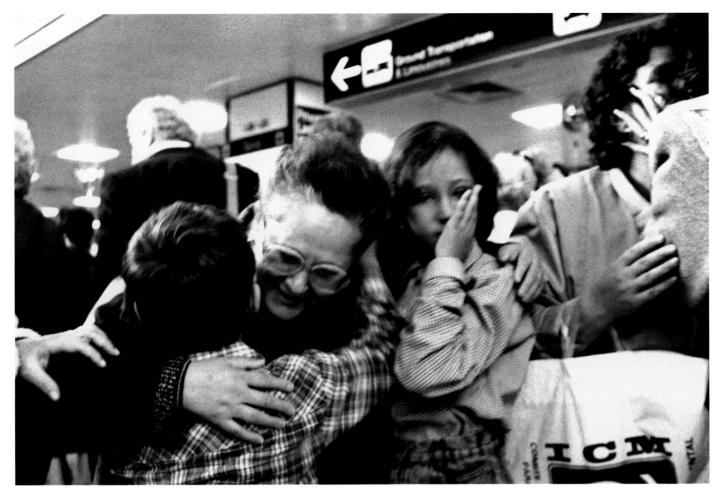

Soviet immigrants, upon arrival in airport.

Natan Sharansky (seated at right) in Israel following his 1986 release from Soviet prison.

JEWISH IDENTITY

Paul Zakrzewski

IF A SINGLE MOMENT could be said to capture the increasing alienation from communal life many American Jews experienced in the second half of the twentieth century, then it might belong to the thirteen-year-old hero of Philip Roth's incendiary story "The Conversion of the Jews." Alone on the synagogue roof, Ozzie Freedman spots the epic yet meaningless figure of his rabbi on the street below: "A voice rose from the center of the crowd, a voice that, could it have been seen, would have looked like the writing on a scroll. 'Oscar Freedman, get down from there. Immediately!' Rabbi Binder was pointing one arm stiffly up at him; and at the end of that arm, one finger aimed menacingly. It was the attitude of a dictator, but one—the eyes confessed all—whose personal valet had spit neatly in his face."

Merryl Goldberg blowing baritone sax while James Guttmann strums bass, part of the Klezmer Conservatory Band, based in Boston and New York in the 1980s.

Sally J. Priesand, America's first female rabbi, being ordained in Cincinnati, Ohio, on June 3, 1972, by Dr. Alfred Gottschalk, the president of Hebrew Union College–Jewish Institute of Religion.

For many American Jews, the 1970s and 1980s represented a period of intense assimilation into American life and a detachment not only from the culture of the big synagogue, the so-called Edifice Complex, but even more broadly from their Jewish identities. And at the close of this era there were numbers to prove it. A survey conducted in 1990 by a major Jewish philanthropic association, the Council of Jewish Federations, showed that half of all Jews entering wedlock in the five previous years had married non-Jews; of those interfaith couples, fewer than one-third

The New York Havurah on a Sabbath retreat at Camp Ramah in Nyack, New York, in 1976. One of the numerous informal prayer fellowships that emerged from the 1960s counterculture, the Havurah met on Jewish holidays and once a month on the Sabbath for prayer, study, and communal pursuits.

were raising their children in the Jewish faith. Community planners knew that intermarriage was on the rise, but few imagined the proportion was so high. At this pace, some researchers suggested, American Jewry was headed for disappearance within a generation or two.

At the same time, and perhaps in response, these decades also began to see a genuine counterculture and its transformation of contemporary American Jewish identity. Jolted out of their apathy by the possibility of Israel's demise during the Six-Day War, antagonized by the antisemitism surging in radical circles, but most of all infused by the liberation politics of the women's and gay rights movements and the search for spirituality and Eastern mysticism, many younger Jews searched for more authentic ways to reclaim their identity, even when "authenticity" didn't necessarily equate with tradition. Although never more than a minority in the community, many of the people active in these various movements later took on key leadership roles in various fields of Jewish life.

Indeed, while some trends suggested a move away from religious practice, others hinted at a move back—at least in a do-it-yourself way, to echo the subtitle of *The First Jewish Catalog,* the era's unofficial bible. This 1973 how-to guide eschewed elaborate Talmudic arguments for a folksy approach that mixed loopy, psychedelic doodles with practical steps to living a Jewish life. It taught readers how to celebrate the Sabbath, travel to Israel, create a Jewish

library, and even crochet a yarmulke, all the while encouraging them to "plug in wherever you want." Which is more or less the same spirit that animated the popular *havurah* (fellowship) movement of the time. These small study and prayer groups were proposed as an egalitarian, nonhierarchical alternative to the conventional synagogue; members had a hand in creating and leading services, which might include meditation, chanting, or the incorporation of poems and other nonliturgical texts.

Some of the leading proponents of this transformation were gurus like Shlomo Carlebach and Zalman Schachter-Shalomi. The former, a highly charismatic singer descended from a Polish Hasidic dynasty, first propelled himself to notice in the 1950s, recruiting "spiritual vagrants" for Rabbi Menahem Mendel Schneerson. By the 1970s, however, Carlebach had long abandoned the Lubavitchers for his own highly original, if controversial, methods. Better known to adoring fans as the Singing Rabbi, he appeared at concerts that were ecstatic affairs in which he interspersed original melodies (of which he wrote hundreds) with Hasidic stories and a generous helping of *yidishkayt*. Meanwhile, Schachter-Shalomi, also the product of a Hasidic yeshiva training, began to incorporate the Jewish mystical tradition into his teachings during a psychedelic period in the 1960s. Two decades later he went on to help found the Jewish Renewal movement, whose innovations included chanting prayers in English (with traditional Hebrew cantillation), meditation during services, and the introduction of spontaneous movement and dance.

The era also brought with it a search for roots, as increased activism on behalf of Soviet Jews and a new level of identification with the Holocaust—not to mention the

enormous popularity of the 1977 miniseries *Roots*—caused many third- and fourth-generation Americans to cast a longing look back to their own Eastern European origins. Both Yiddish-language and Jewish studies programs sprang up at camps, universities, and Jewish community centers across the country. But one of the most interesting cultural trends happened not in classrooms but in clubs, with the klezmer revival. Once the staple of early-twentieth-century immigrant musicians, this instrumental music had become little more than borscht belt fodder by the 1970s, when it was discovered by a new generation of Jewish players steeped in rock, country, and jazz. "It dawned on me that if I'm looking for a spiritual and musical path, I'm born Jewish, it was handed to me, so this is something I should explore," explained the eponymous founder of the Andy Statman Klezmer Orchestra, one of a handful of groups credited with the revival of this "Jewish roots music."

In short, it was a time of experimentation and eclectic observance.

Perhaps nowhere were these experiments more marked than in the Jewish feminist movement, which reflected both the struggles and the victories in the larger fight for women's equality. Since the early 1970s Jewish feminists had taken it upon themselves to rewrite male-centered liturgy, create more inclusive blessings, rediscover biblical heroines, and invent new rituals (or else uncover old rituals, such as Rosh Hodesh) that could be imbued with a particular female point of view. Yet it didn't escape the notice of many that, as Rachel Adler pointed out in an early essay, "The Jew Who Wasn't There," there existed a fundamental disparity between a tradition that revered the role of girls and women yet excluded them from religious public life.

Shlomo Carlebach, the Hasidic troubadour, performing in the 1970s.

The tide began to turn in 1972, when Hebrew Union College ordained the first female rabbi, Sally Jane Priesand. The same year members of a study group called Ezrat Nashim barged into Conservative Judaism's Rabbinical Assembly, urging an end to gender bias, though it took more than another decade for the Jewish Theological Seminary to ordain its first female rabbi.

There's no doubt that these changes will go on to feed future movements, including Jewish Renewal, neo-Hasidism, even the current craze for Kabbalah. Yet they also revealed major fault lines in Jewish communal life, as countercultural Jews collided with those who found in their exuberant innovation only more evidence of the long slide toward assimilation.

Music legend Johnny Cash (center), dressed in black, and his wife, June Carter Cash, with representatives from El Al airlines.

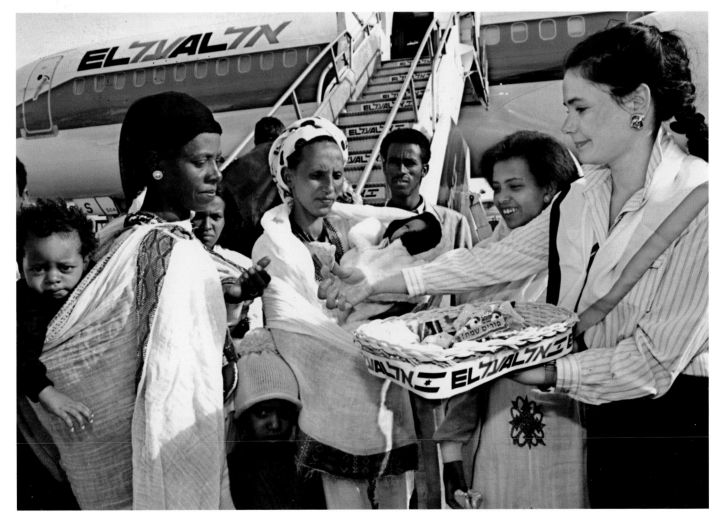

Ethiopian immigrants receiving Purim treats as they enter Israel.

Berger's 'Bridegroom'
Page 11

What Bothers Dole
Page 6

Shabtai
Page 13

BULK RATE
U.S. POSTAGE
PAID
NEW YORK, N.Y.
Permit No. 1556

פֿאָרווערטס

Volume LXXXXIV,
No. 30,768

FORWARD

FOUNDED APRIL 22, 1897

New York City
May 25, 1990

In New York City,
Eastern New Jersey
& Long Island;
$1 beyond a 40 mile
radius of NYC.

75
cents

LETTER FROM THE EDITOR

Dear Friend:

When our parents and grandparents arrived in America, they discovered a unique newspaper-the *Jewish Daily Forward*. The paper fought for their rights and dignity as working immigrants. It helped them sort out the personal and religious crises triggered by the challenges of the American frontier. It lifted their spirits by offering fiction and belles lettres by some of the greatest writers of the century. One of the *Forward's* staffers—Isaac Bashevis Singer—went on to win the Nobel Prize. Published in Yiddish, the *Forward* gained a daily circulation of nearly a quarter of a million copies. The *Forward* was called the greatest newspaper of its time.

The *Forward* broke some of the most important stories of the century. In the 1920s, it moved to the forefront in the battle against communist control of America's labor movement. In the '30s, the *Forward* received early warnings of Stalin's secret approaches to Hitler—a plot that led to the infamous 1939 pact that set the stage for World War II, the *Forward* printed some of the earliest dispatches bearing news of the terrible fate engulfing European Jewry. The murder of the Yiddish-speaking population of Europe would have meant the death of the *Forward* itself but for the perseverance of the paper's proprietor, the Forward Association, Inc. It has continued to publish the *Forward* in Yiddish as a weekly, keeping alive the dream of a truly independent, national Jewish newspaper in America.

• • •

Today the *Forward* is taking a major step for the future. With this issue, the *Forward* begins publishing in English. The Forward Association will continue to publish the Yiddish paper. But it is teaming up with a group of investors committed to assembling an editorial team of national caliber to bring out the *Forward* as an independent newspaper in the American language so many of our parents and grandparents came to and love. News bureaus have been opened at Washington, New York, Moscow and Jerusalem and

Israel Faces Wider Violence

Arab youths wave the outlawed Palestinian flag during a demonstration in an eastern suburb of Jerusalem, following last Sunday's slaying of seven Gaza Arabs at an Israeli intersection.

A.P.-WIDE WORLD WIREPHOTO

Slaying of Palestinians Spurs Intifada Revival And New Israeli Fears

By ROY ISACOWITZ
FORWARD STAFF

TEL AVIV — The outpouring of Palestinian violence that followed the slaying of seven Arab laborers by an Israeli in Rishon Lezion Sunday has sparked fears here that the 29-month-old intifada has re-erupted — and is spreading to Arab villages within Israel and even to Jordan.

Tensions continued high throughout the week, and many Palestinians appeared convinced that Israelis could "kill them without the government, or any other body, being able to defend them," in the words of one of Israel's most respected military analysts, the author and journalist Ze'ev Schiff.

This week's violence included riots and confrontations between Palestinians and Israeli troops throughout the West Bank and the Gaza Strip, as well as violent demonstrations within Israel proper by Israeli Arab citizens. In Jordan, a lone gunman opened fire on a busload of French tourists, shouting "Gaza martyrs" to protest the Rishon killings. Three Jordanian Palestinians were killed last Tuesday in clashes with Israeli troops.

The unrest among Israel's Arab citizens was some of the worst since the founding of Israel. Most commentators described it as "spontaneous combustion," reflecting both outrage at the Rishon killings and continued hostility to the Jewish state.

A senior Israeli security official said, however, that the rekindling of the intifada was at least partly the fruit of patient groundwork by Arab activists in the territories.

Separately, Gen. Dan Shomron, the military chief of staff, insisted the army was determined to keep the peace and was ready to maintain its reinforced presence in the territories for as long as necessary.

However, Mr. Schiff, the journalist, warned that it was a mistake to believe that the intifada was running out of steam, as several senior military men have maintained recently, based on the army's success in curbing the large-scale street demonstrations and its ability to enforce curfews.

The massive outburst of unrest following the massacre, Mr. Schiff said, showed the existence of a "large quantity of latent explosive which needs only one spark to

Dinkins Appeals for Mosaic

By JEFF BENKOE
FORWARD STAFF

NEW YORK — With a "Town Hall" meeting at the Cathedral of St. John the Divine that fully reflected the "gorgeous mosaic" imagery that Mayor Dinkins often evokes, his administration took a symbolic step Tuesday toward defusing the racial and ethnic tension wracking the city. The mayor now faces the task of galvanizing local leaders — civic, religious, labor and political — into maintaining the momentum to restore relative calm.

An array of leaders, including Governor Cuomo, N.Y. Board of Rabbis president Myron Fenster,

Cardinal O'Connor, Schools Chancellor Fernandez, Hospital Union chief Dennis Rivera and Teachers Union president Sandra Feldman, joined thousands of others at the Manhattan rally.

Rabbi Fenster, recalling the "raw barbarity" of the Nazi era, said: "Then as today there are the healers, the helpers, the pious, the righteous. Let us pray in this hour of reconciliation that this rally strengthens our mayor and all of us so that we can seek peace."

Mr. Dinkins implored New Yorkers to put aside personal prejudices and keep the city from drowning in racial hatred and intolerance. "This is the time to come

together to create a wave of energy and unity so powerful that it could wash away the hate and the hurt," the mayor told the packed sanctuary, his voice echoing.

Governor Cuomo, full of emotion, his fists in the air, denounced the Bush administration for federal budget cuts that have led to deep deficits on both the city and state levels. New Yorkers should raise a "great chorus" to President Bush, the governor said: "Read our lips — we need your help, and we are entitled to it."

The rally came as the agony of the Bensonhurst murder trials continued; following the conviction of one suspect and the acquittal of another on the most serious of the charges, more trials are scheduled stemming from the slaying last year of Yusuf Hawkins, a black teenager killed by a group of white teenagers in the Brooklyn neigh-

New Violence Erupts

E. German Chief To Visit America And WJCongress

De Maiziere Offers Apology For Votes of Former Regime

By MICHAEL KALLENBACH
SPECIAL CORRESPONDENT

BERLIN — East Germany's new prime minister expanded his campaign of German-Jewish reconciliation this week by accepting an invitation to come to America as a guest of the World Jewish Congress.

Prime Minister de Maiziere, in a letter to the WJC president, Edgar Bronfman, also said he considers the United Nations General Assembly resolution equating Zionism with racism a mistake. He said he deplored the decision by the former Communist regime to vote for the resolution.

"East Germany considers the undifferentiated condemnation of Zionism as a form of racism as not helpful for making peace in the

The first issue of the *Forward*, May 22, 1990.

FIVE

1990
AND BEYOND

I N 1990 THE Forward Association, the newspaper's non-profit holding company, decided to remake the English-language supplement as an independent, high-profile weekly newspaper committed to the same crusading journalistic spirit as Cahan's *Forverts*. Led for its first decade by Seth Lipsky, a veteran of the *Wall Street Journal*, the *Forward* quickly established itself as a uniquely authoritative source of news and opinion on Jewish affairs. Where Cahan's mission had been to help Jewish newcomers find their way into America, the new *Forward* aimed to show Americans the way back into the Jewish world.

The new paper appeared at a moment of global transition. The fall of the Berlin Wall seemed to usher in an age of boundless possibilities. As democracy took root in Eastern Europe, Israel and the Palestinians signed what promised to be a historic peace accord. The *Forward* covered it all with a lively, independent eye that won it a growing following.

In Yiddish, meanwhile, the *Forverts* was reinventing itself for the new era. In 1998, a new editor was brought from Israel: the Kishinev-born Yiddish novelist Boris Sandler. He led a team of editors who were, like him, members of the post–World War II baby boom, educated in Yiddish and at home in the world.

At the dawn of the new millennium, many of the hopes of a decade before were proving tragically elusive. The Israeli-Palestinian peace process collapsed in violence in September 2000; a year later terrorists launched spectacular attacks on New York and Washington. A new era was emerging, but it seemed marked more by threats than promise. The *Forward*, now edited by J. J. Goldberg, a veteran of Israeli and American Jewish journalism, has continued to cover the new age as it covered everything before: unblinkingly, in the language of its readers, never losing faith in the future.

The new old neighborhood: Abandoned decades before by most of its Jewish inhabitants, at the start of the 1990s the Lower East Side—now in the heart of Chinatown—began to feel the effects of the city's gentrification. One of the most intriguing features of the area's revival was a deep strain of nostalgia for its past. The Forward Building, seen here draped in a Chinese sign reading "Jesus Lives—Jesus is the way," was named a national landmark (and eventually sold to a developer of multimillion-dollar condominiums).

Capitalizing on the neighborhood's new cachet for the hip and young, Lansky's Lounge, a bar and nightclub, opened in a room adjoining the legendary kosher dairy restaurant Ratner's. Both the club and the restaurant, which originally opened in 1905, finally closed their doors in 2002.

An old street advertisement for Schapiro's, America's oldest kosher winery, which opened on the Lower East Side in 1899. The company moved its wine cellars and retail facilities to upstate New York in 2001 but maintains offices on Rivington Street in the old neighborhood.

Many of the synagogues on the Lower East Side have become churches.

Mourners and supporters
of Meir Kahane—the rabbi
and activist known for his
support of a theocratic
theory of a "Greater
Israel"—at a memorial
service after his
assassination (1990).

A commemoration at the site of the Babi Yar massacre in Kiev, Ukraine, where in 1941 the Germans murdered approximately one hundred thousand Jews in a ravine.

From the original caption: "A sign in Russian and Hebrew on the main street of Nizhny Novgorod points the way to the city's only synagogue. The sign marks a drastic change from the days when Jews could only gather and pray in secret" (1993).

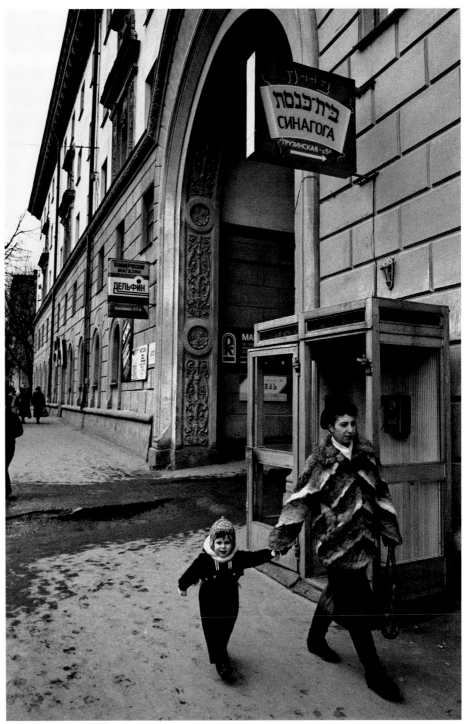

Cuba's oldest synagogue, dating back to 1914, closed in 2000. Its nine Torah scrolls were transferred to one of Havana's two remaining synagogues, the Orthodox Templo Adath Israel. Nine-tenths of Cuba's fifteen thousand Jews left after the Communist Revolution in 1959.

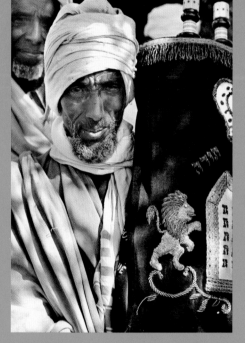

An Ethiopian Jewish priest.

From the original caption: "An old man in the Jewish quarter of Damascus peers out of a doorway. Beside him is a poster of President Assad, whose anti-Jewish edicts restrict Syria's Jews from living in their country in freedom and keep them from emigrating in peace" (1994).

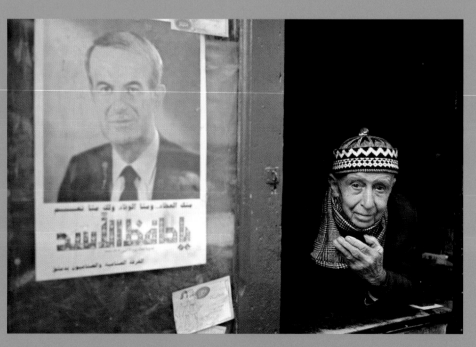

From the original caption: "Fiona Hallegra stands in a courtyard in the Jewish section of Cochin, India. Ms. Hallegra dreams of emigrating to America, where she hopes to find a husband and employment in her profession, social work" (1993).

Pigeons perching atop a concrete menorah outside the subway station that serves Rio de Janeiro's Jewish neighborhood.

Rabbi Avi Weiss, after being
arrested for protesting the
presence of a Catholic church on
the site of the Auschwitz-Birkenau
death camp in Poland (1995).

A Jewish star atop Ahavas
Israel Synagogue in
Greenpoint, Brooklyn,
with the New York skyline
behind it.

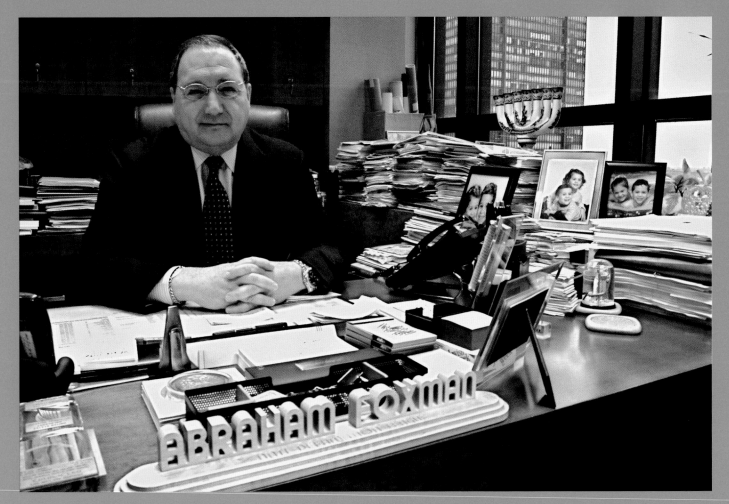

Abraham Foxman, the
national director of the
Anti-Defamation League.

Edgar Bronfman, the
president of the World
Jewish Congress.

David Harris, the executive
director of the American
Jewish Committee.

Orthodox Jews in
Brooklyn, on an outing
to Coney Island during the
intermediate days of the
Passover holiday.

An illustration by famed
cartoonist Ed Koren.

Jewish New Yorkers
protesting the treatment
of the Kurdish minority in
Saddam Hussein's Iraq in
the 1990s.

A "kosher gym," a health
club catering to Orthodox
Jews.

Throughout the 1990s the *Forward* covered the growing preoccupation with all things Jewish in European places where there are no longer any Jews, like this souvenir stand in Cracow, which offered bearded icons, yarmulkes, and a wooden klezmer.

Handmade *shmurah* matzo from Shatzer's, a Hasidic baker in Brooklyn, ready for delivery before Passover.

Congressional Record

United States
of America

PROCEEDINGS AND DEBATES OF THE 105th CONGRESS, FIRST SESSION

Vol. 143 WASHINGTON, WEDNESDAY, JULY 30, 1997 *No. 110*

Senate
100 YEARS OF THE FORWARD

Mr. MOYNIHAN. Mr. President, on July 22, 1997, the *Washington Post* contained a moving tribute to the *Forward*, a New York City journalistic tradition currently celebrating its centennial year.

The Members of the Senate are probably aware of the *Forward's* magnificent history; this daily Yiddish newspaper once enjoyed a daily circulation of over 250,000. It did its job of helping new arrivals assimilate and become Americans so very well, that its original readers' descendants can now enjoy the newspaper's superb English language edition, while a wave of new immigrants are being introduced to the nuances of American life by the newspaper's Russian edition.

The *Forward's* legacy lives on, not only in its three current editions, but with the tens of thousands of families whose ancestors learned about this country in the pages of Abraham Cahan's remarkable publication. On May 22, New York Mayor Guiliani hosted a reception at Gracie Mansion to mark the one- hundredth anniversary of the *Daily Vorwaert's* first issue. I sent a message to this reception which was reprinted in the *Forward's* Yiddish, English and Russian editions:

I have long believed that the Forward renders an invaluable contribution to American society. Your dynamic newspaper should be appreciated by all who cherish our national heritage of respect for intellectual creativity and journalistic integrity. Even those of us who couldn't enjoy A Bintel Brief in the original were long ago aware of the *Forward's* power to captivate, educate and inspire. Your vigorous English edition is a worthy companion to the historic Yiddish Forward.

Please accept my great congratulations on this magnificent milestone. With my best wishes to the "gold standard" of ethnic journalism.

The *Forward* has played a significant cultural and educational role in its first century and I trust that the members of the Senate join me in wishing similar success to the three editions that so ably carry on the historic Forward tradition.

Mr. President, I ask that the text of the *Washington Post* article on the *Forward's* centennial be printed in the Record.

The material follows:

[From the Washington Post, July 22, 1997]

New Voices for a New Century--
Newspaper of an Exodus
Speaks a Language
Its Children No Longer Hear, but Reaches
Out in Others

(By John M. Goshko)

S8380

In 1997 the *Congressional Record* took note of the *Forward*'s hundredth anniversary.

An abandoned Jewish-
owned factory building
near the old Jewish
cemetery in Vilna.

At a spiritual summit in
northern India, Rabbi
Zalman Schachter-Shalomi
explained the Kabbalah to
the Dalai Lama.

A cherry picker rented by
Chabad-Lubavitch
Hasidim to light their
"world's largest menorah"
on Fifth Avenue in New
York City.

Plaque in New York's Riverside Park, placed in 1947 at the site of what was to be the nation's first Holocaust memorial. Bureaucratic and design disputes delayed construction for decades, until it was finally abandoned in favor of the Museum of Jewish Heritage–Living Memorial to the Holocaust at Battery Park.

A man looks out from a synagogue in Brighton Beach, Brooklyn.

Alpha Epsilon Pi, the
Jewish fraternity, at
Rutgers University.

The Diamond District on
Forty-seventh Street, New
York.

The Beastie Boys, three Jewish boys who became America's first successful white rap act, popular throughout the 1980s, 1990s, and beyond. From left: Mike Diamond, Adam Horovitz, and Adam Yauch.

In 2003 New York senator Hillary Rodham Clinton joined with members of the New York Board of Rabbis and the Jewish Educators Network to present three Torahs sent to Iraq and Kuwait to help Jewish soldiers stationed there observe the high holidays.

President Bill Clinton.

The comedians Billy Crystal (left) and Alan King.

The singer and actress Bette Midler at the Stella Adler Awards in 2001.

Marilyn Michaels, Sid Caesar, and Lainie Kazan at the National Foundation for Jewish Culture Awards.

The actress Fran Drescher at the Albert Einstein College of Medicine Women of Achievement Awards luncheon.

The comedian Jerry
Seinfeld at the fiftieth
anniversary of Howard
Rubenstein, Inc. at Tavern
on the Green.

**From Charles Miller's
series of Jewish boxers.**

Revival

J. J. Goldberg

EARLY IN 1994 Senator Jesse Helms, the conservative North Carolina Republican, submitted legislation to Congress to safeguard a child's right to "constitutionally protected prayer" in public school. The Senate easily approved the measure the following February, but in mid-March two dozen senators were prepared to reverse their position, following a furious lobbying campaign by Jewish organizations. American Jews by tradition are zealots on church-state separation, viewing it as an essential safeguard of their minority rights. Helms's amendment was taken to be a direct threat.

Israeli bomb squad removing bodies after a Palestinian suicide bomber exploded himself on an early-morning bus (2003).

Helms responded with a tactic that was ingenious even by the standards of Washington infighting. He arranged for the new vote to take place on March 25. The Passover holiday began that night, and the Senate's ten Jewish members were all headed home for their family Seders. With one-tenth of the Senate gone for the holiday, Helms believed his amendment was assured passage.

The maneuver was a minor event at the time, unnoticed by any but the main players. It wasn't even successful. The Jewish senators managed to rearrange their flights and show up for the vote. Helms lost.

In a way, though, the Helms amendment could be seen as a signpost in American Jewish history, showing in the starkest way possible how far Jews had come into the American mainstream by the 1990s. Never before had any society opened its doors so wide to Jewish participation. Nowhere before had Jews enjoyed greater esteem among their fellow citizens; nowhere had Jews enjoyed greater influence and ability to shape the circumstances of their lives as a diaspora community. Indeed, a time traveler from the Jewish past visiting America in the 1990s might have been forgiven for thinking he had stumbled into the Messianic Age. In 1994 two of the nine justices of the United States Supreme Court were Jewish, as were four of the fourteen members of President Bill Clinton's cabinet and virtually all of the administration's senior Middle East policy makers.

Marchers protesting the imprisonment of Jonathan Pollard, the former U.S. Navy intelligence officer who was given a life sentence in prison after he pleaded guilty and was convicted on one count of spying for Israel.

Barely a month after Jesse Helms's 1994 Passover gambit, official Washington turned itself out for a three-day gala to mark the opening of the federal government's newest and shiniest cultural monument, the United States Holocaust Memorial Museum, a $150 million institution commemorating the mass murder of European Jews by Nazi Germany during World War II.

Embracing Jews was not just a Washington thing. America's top-rated television program during much of the 1990s was *Seinfeld*, a comedy about a young Jewish man who sat around in a New York apartment schmoozing with his friends. The show's eponymous star, the genial Jerry Seinfeld, was repeatedly named in surveys as America's best-liked individual. By the end of the decade one of the biggest stars in pop culture, Madonna Ciccone, raised Catholic, had publicly taken on the practice of a form of Judaism known as Kabbalah, touching off a craze of kosher food and Jewish ritual among Hollywood celebrities.

In the world at large the 1990s were a decade of near-millennial optimism. The decade had begun with the fall of the Berlin Wall and the collapse of the Soviet Union. More than one million Soviet Jews, cut off from their heritage for three generations, streamed out of the former Communist empire over the next decade to find new homes in the state of Israel. Israel itself reached a peace agreement in 1993 with the Palestine Liberation Organization, promising to

end the world's most intractable conflict. The signing ceremony on the White House lawn, with its historic handshake between Yitzhak Rabin and Yasser Arafat, was broadcast live around the planet and watched by billions.

The launch of the English-language weekly *Forward* in 1990 was perfectly timed to cover these events up close. The Jewish community was maturing and deepening its role in national life. With the increased clout, the community needed an independent press that could keep the public informed and hold the leadership accountable. The *Forward*, nearly uniquely on the national scene, played that role with intelligence and sophistication. Almost as soon as it began publishing, it became required reading.

Despite all the good news, many of the Jewish community's leaders and activists were gripped by a sense of foreboding as the 1990s proceeded. Interfaith marriage rates were soaring, and communal affiliation rates were plummeting. Jewish leaders feared that for all their individual success, American Jews were in danger of disintegrating as a group. Then, as the new millennium dawned, American Jews were confronted by a daunting new challenge—or, as some insisted, the return of a very old one—in the explosive rise of Islamic terrorism. The mayhem first erupted in Israel and the Palestinian territories, where a violent uprising began in September 2000. A year later, in September 2001, the front line was moved to America, with spectacular terrorist attacks on New York and Washington. Just a decade after the fall of communism, the era of peace that beckoned in the 1990s seemed more distant than ever.

In the months that followed, the administration of President George W. Bush declared a global war on terrorism, taking a series of strategic decisions, including the 2003 invasion of Iraq, that proved bitterly divisive. As debate intensified and positions became increasingly polarized, Israel and its advocates were once again at the center of the storm. Many critics of the administration charged that America had gone to war in Iraq for Israel's sake, not America's. Many pro-Israel activists responded by rallying around the administration and identifying with its policies, which they saw as essential to Israel's survival. A casual observer viewing the policies and agendas of the major Jewish advocacy organizations might have concluded that Jews had finally moved to the right. The dominant voice that was heard in the land was that of the hawk.

The grave of the Lubavitcher rebbe Menachem M. Schneerson, Old Montefiore Cemetery, Queens, New York.

The Hasidic reggae superstar Matisyahu.

The Garment Worker, by the sculptor Judith Weller, placed by the philanthropist Jack Weiler outside his World Apparel Building on Seventh Avenue in Manhattan's Garment District.

Most Jews, however, remained unmoved by the panic. Optimism continued to reign on the streets of the Jewish community, if not in its boardrooms. Surveys showed too that Jews continued to take pride in their Jewish heritage, were eager to pass it on to their children, and were largely unconcerned about the rise of intermarriage. Indeed, American Jews were wearing their Judaism as a badge of pride to a degree that would have been unimaginable to earlier generations. Hollywood, which had once hidden any sign of its Jewishness, began flaunting it, releasing major films on themes like the Holocaust and intermarriage and scoring box-office hits. Jewish ritual art, from candlesticks and spice boxes to hand-woven prayer shawls, became big business. Even a humble art form like traditional Jewish wedding music became a popular culture craze, repackaged and updated as klezmer fusion. And a growing minority of the Jewish community was turning toward ever more traditional observance. The Brooklyn-based Lubavitch Hasidic sect became, improbably, the fastest-growing wing of Judaism, despite the death in 1994 of its charismatic grand rabbi, Menahem Mendel Schneerson. Reform Judaism, the most liberal of the major Jewish denominations, was also experiencing steady growth; that was due at least partly to the influx of tens of thousands of interfaith families seeking a connection to Judaism and a religious education for their children. If intermarried families were lost to Judaism, nobody had told the families.

Entering its second century, the *Forward* has remained committed to the optimism of its founders and of its readers. It reports on the dangers, as it always has, and tells the stories of those who speak out. But it also gives a voice to Jews who strike out in new directions and build new forms of community and culture. Above all, the *Forward* seeks to bring together those diverse strands and create a public square where Jews can listen to each other—and become a community.

Rabbi Shmuley Boteach (left), best known as the author of *Kosher Sex*, talking with the music producer Russell Simmons (right) after the rabbi debated the Reverend Al Sharpton (center) in 2001.

The former secretary of state Henry Kissinger and radio personality Dr. Ruth Westheimer at the Appeal of Conscience Awards. Behind them is Chancellor Gerhard Schroeder of Germany.

Former New York mayor
Ed Koch.

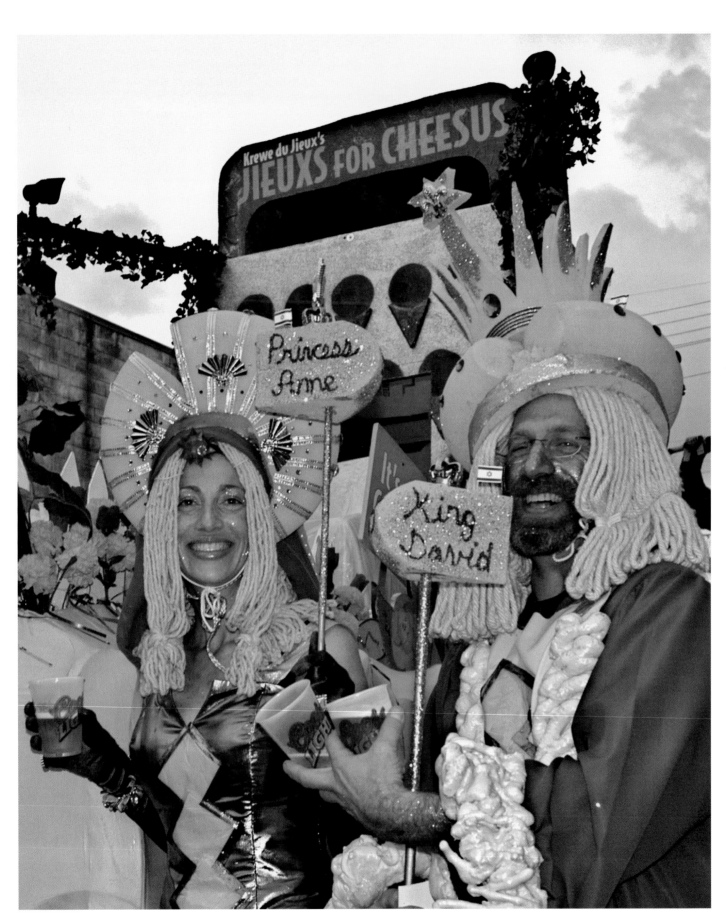

The Krewe du Jieux parade
at Mardi Gras, New
Orleans.

Uninhibited dance party,
or rave, in Israel.

Rabbi Jacob Goldstein, the Lubavitch Hasidic leader and chief chaplain of the New York National Guard, on duty near what would soon become known as Ground Zero, September 11, 2001.

Selection from Art Spiegelman's "In the Shadow of No Towers," a monthly feature published in the *Forward* (2002–2003).

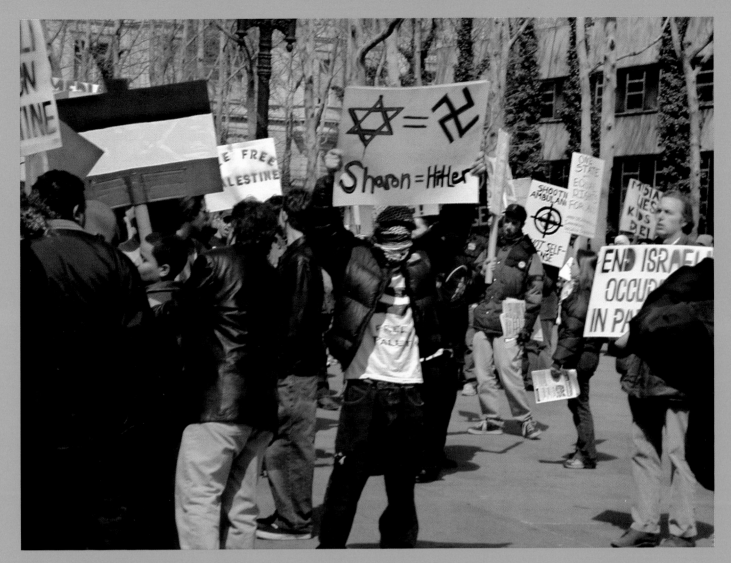

Pro- and anti-Israel
demonstrators facing off
on the streets of New York
(2003).

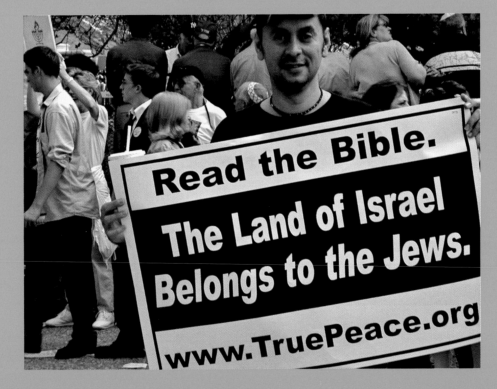

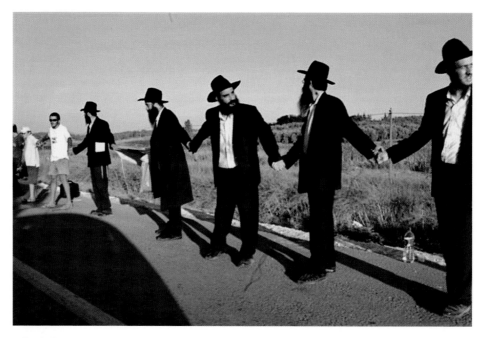

Lubavitcher Hasidim and
sandaled sabras joining
hands to protest Prime
Minister Ariel Sharon's
plan to disengage from the
Gaza Strip (2005).

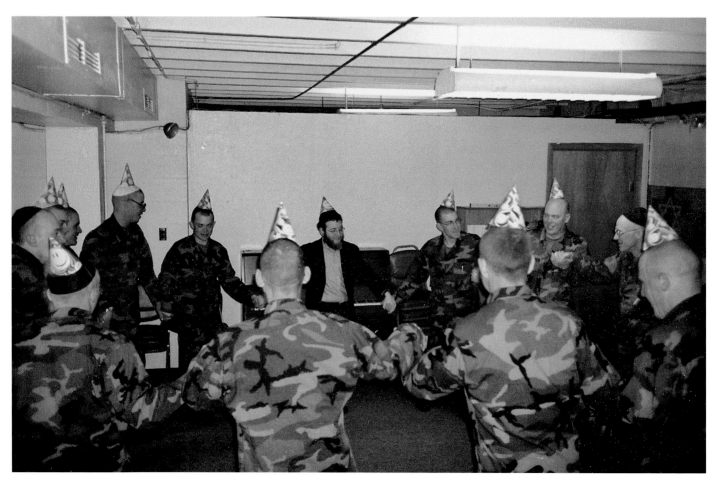

The Chabad Lubavitch
rabbi Yisroel Newman with
American soldiers, during
his stint as a part-time
rabbi at Fort Knox (2005).

An apartment building in
Williamsburg, Brooklyn,
where every balcony has a
sukkah.

Bark Mitzvah, a fad among some pet owners in the twenty-first century.

In 2003, residents of the Hasidic village of New Square, New York, said they heard a carp speak in Hebrew. The fish reputedly claimed to be the soul of a deceased Canadian Hasid.

Madonna at the 2003
release party for the
Kabbalah Centre tome *The
72 Names of God:
Technology for the Soul.*

The world champion
sprinter Zhanna
Pintusevich-Block of
Ukraine.

A kosher bakery in Little Odessa, the Russian Jewish enclave in Brighton Beach, Brooklyn.

Brighton Beach Avenue, under the elevated subway tracks.

Latino food workers in Los Angeles, including Jesús Osuna of Doheny Kosher Meats on Pico Boulevard, have acquired a knack for kosher cooking.

A synagogue in New
Orleans, flooded after
Hurricane Katrina
(September 2005).

Second Avenue Deli,
iconic kosher eatery,
closing its doors (2005).

Cartoon by Roz Chast,
published on February 4,
2005.

The current home of the
Forverts and the *Forward*,
on East Thirty-third
Street—Sholom Aleichem
Place.

Photo Credits

p. 6 Forward Association; p. 12 Julian Voloj; p. 15 Julian Voloj; p. 20 Forward Association; p. 22-A Forward Association; p. 22-B Forward Association; p. 22-C Forward Association; p. 22-D Forward Association / Harry Lopatin; p. 24-A Forward Association / Menachem Kipnis; p. 24-B Forward Association; p. 25-A Forward Association / Foto Zychlinski; p. 25-B Forward Association; p. 25-C Forward Association; p. 26-A Forward Association; p. 26-B Forward Association; p. 27-A Forward Association / M. Kipnis; p. 27-B Forward Association / Alter Kacyzne; p. 28 Forward Association; p. 29 Forward Association; p. 30-A Forward Association / New York City Police Department, 1936; p. 30-B Forward Association; p. 31-A Forward Association; p. 31-B Forward Association; p. 32-A Forward Association / Sobelman Syndicate; p. 32-B Forward Association; p. 33 Forward Association / Brown Brothers Studio; p. 34-A Forward Association; p. 34-B Forward Association; p. 35 Forward Association; p. 36 Forward Association / Palestine Photo; p. 37-A Forward Association / Ben Hador; p. 37-B Forward Association / Alter Kacyzne; p. 37-C Forward Association; p. 38-A Forward Association / Committee for the Defense of Revolutionists; p. 38-B Forward Association / Weltrundschau; p. 39 UNITE HERE Association, Kheel Center, Cornell University; p. 40 dOra-[Vienna] Wien Arthur Benda; p. 41 Forward Association; p. 42 Forward Association / Kalart; p. 43 Forward Association; p. 44-A Forward Association / Kalart; p. 44-B Forward Association; p. 44-C Forward Association; p. 44-D Forward Association / Kalart; p. 45 Forward Association / Harry Rubenstein; p. 46-A Forward Association; p. 46-B Forward Association; p. 46-C Forward Association; p. 47 Forward Association; p. 48-A Forward Association; p. 48-B Forward Association; p. 49 Forward Association; p. 50 Forward Association; p. 51-A Forward Association; p. 51-B Forward Association; p. 51-C Forward Association; p. 52-A Forward Association; p. 52-B Forward Association / Robert A. Maier; p. 53 Forward Association; p. 54-A Forward Association / M. Sunshien; p. 54-B Forward Association; p. 55 Forward Association; p. 56 Forward Association; p. 57 Forward Association; p. 58 Forward Association; p. 59-A Forward Association; p. 59-B Forward Association; p. 60-A Forward Association; p. 60-B Forward Association; p. 60-C Forward Association; p. 61-A Forward Association / Kalart; p. 61-B Forward Association; p. 61-C Forward Association; p. 62 Forward Association / Irving Berkey; p. 63 Forward Association / Irving Berkey; p. 64 Forward Association; p. 65 Forward Association; p. 66-A Forward Association; p. 66-B Forward Association; p. 68 Forward Association; p. 69 Forward Association / Baumgarten Studio; p. 70 Forward Association; p. 71 Forward Association / G. Eisner; p. 72-A Forward Association; p. 72-B Forward Association; p. 73-A Forward Association; p. 73-B Forward Association; p. 74 Forward Association; p. 75 Forward Association / Gabriel Moulin; p. 76 Forward Association; p. 77 Forward Association; p. 78 Forward Association; p. 79 Getty Images; p. 80-A Forward Association / Leo Forbert; p. 80-B Forward Association; p. 81-A Forward Association; p. 81-B Forward Association / Harold Stein; p. 81-C Forward Association; p. 82 Forward Association; p. 83 Forward Association / M. Kipnis; p. 84-A Forward Association; p. 84-B Forward Association; p. 85 Forward Association; p. 86 Forward Association / Rudolf Hatzold; p. 87 Forward Association; p. 88 Forward Association / Ben Primack; p. 89 Forward Association / Atelier Edith Barakovich; p. 90-A Forward Association; p. 90-B Forward Association / Alter Kacyzne; p. 91-A Forward Association; p. 91-B Forward Association; p. 92 Forward Association; p. 94 Forward Association; p. 95-A Forward Association; p. 95-B Forward Association; p. 96 Forward Association; p. 97 Forward Association; p. 98-A Forward Association / Alter Kacyzne; p. 98-B Forward Association; p. 99 Forward Association / Herbert S. Sonnenfeld; p. 100-A Forward Association; p. 100-B Forward Association; p. 100-C Forward Association / Kalart; p. 101 Forward Association; p. 102 Forward Association; p. 103 Forward Association / Lumiere NY / Brenon and Morgan Associates; p. 104 Forward Association / Courtesy YIVO Institute for Jewish Research; p. 105-A Forward Association / Courtesy YIVO Institute for Jewish Research; p. 105-B Forward Association; p. 106-A Forward Association; p. 106-B Forward Association; p. 106-C Forward Association; p. 107 Forward Association / Alter Kacyzne; p. 108-A Forward Association / Near East Relief Agency; p. 108-B Forward Association; p. 109 Forward Association; p. 110-A Forward Association; p. 110-B Forward Association; p. 111 Forward Association; p. 112 Forward Association; p. 113-A Forward